BRITAIN FROM THE AIR

BRITAIN FROM THE AIR

MICHAEL SWIFT AND GEORGE GRANT

PRC

Published in 2004 by
PRC Publishing Ltd,
The Chrysalis Building
Bramley Road, London W10 6SP

An imprint of Chrysalis Books Group plc

ISBN 1 85648 561 7

Printed and bound in Singapore

Acknowledgements
All the aerial photography for this book, including the images on the
front and back covers, was kindly supplied by Sealand Aerial
Photography, Chichester, West Sussex, with the following exceptions:

© Weatherstock for pages 6–7 and 23
© Angelo Hornak/Corbis for pages 8–9
© Adam Woolfitt/Corbis for pages 86 and 181
© Ralph White/Corbis for page 111

Note on Counties
Dividing Britain into counties used to be easy; they were recognisable,
historic areas and everyone knew in which one they lived. Today it's all
different. Since 1974 when local government reorganisation saw county
boundaries change, old counties disappear and new ones appear, regular
changes have taken place. Today Britain has counties, unitary authorities,
and a host of new names to contend with. Some counties, such as Middlesex,
only exist as postal areas. We have tried to negotiate this difficult path by
sticking to the commonly accepted - usually postal - counties, except in
Wales where the creations of the most recent reorganisation are followed.

CONTENTS

The British Isles are part of the landmass of continental Europe, although today they are separated from the mainland physically by 22 miles of water—the English Channel. Britain is also separated from Europe by a feeling, shared by island races throughout the globe, of being apart, isolated by the seas. Despite this separation—or, perhaps, because of it—the residents of the British Isles have proved themselves to be among the most innovative and influential in the history of mankind. The influence of these peoples can be found throughout the world in the dominance of the English language and in the tenets of British law and democracy, tenets which continue to be dominant in North America, in much of sub-Saharan Africa, in Australasia and the Indian sub-continent.

Overleaf: Cranborne Chase, Dorset
A royal hunting ground, until the reign of
James I, of about 100 square miles of forest,
Cranborne Chase today is a mixture of
woodland and open chalk downland on the
Wiltshire-Dorset border. The pretty village of
Tollard Royal in the heart of the Chase
contains King John's hunting lodge.

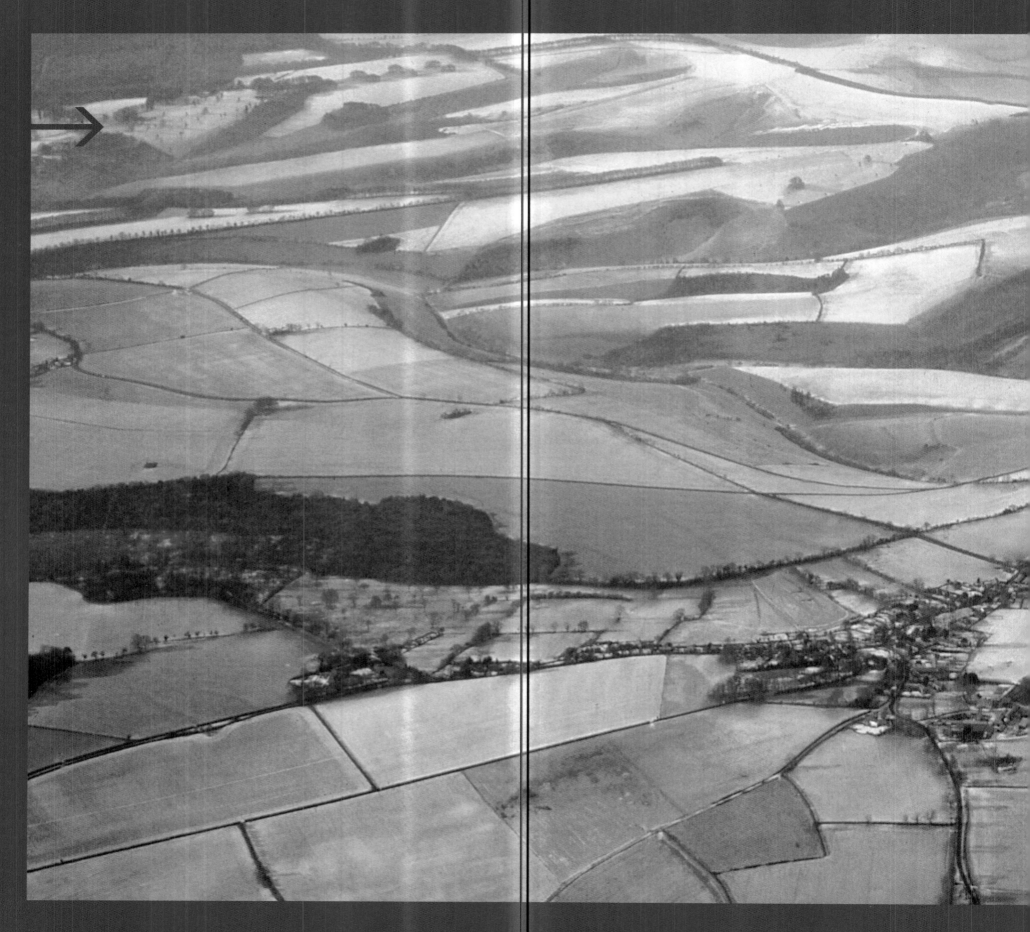

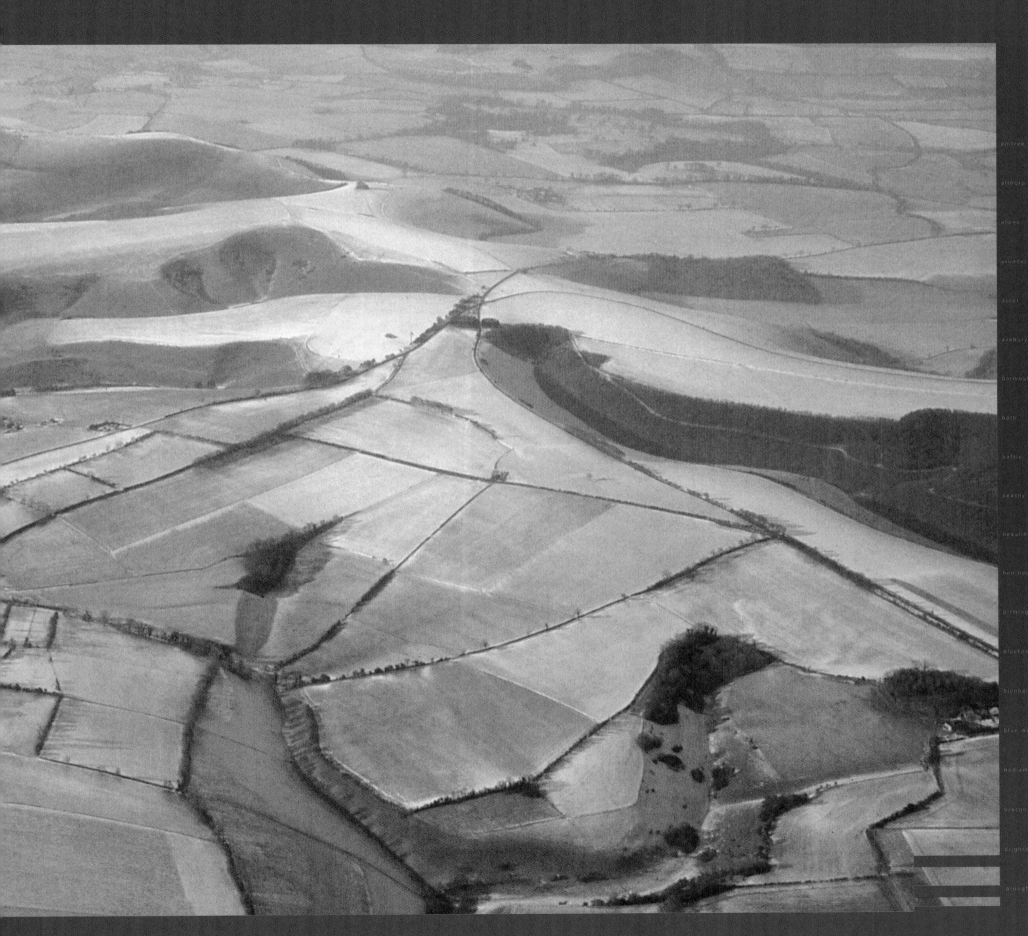

aintree

althorp

alwen

arundel

ascot

avebury

barmouth

bath

battle

beachy head

beaulieu

ben nevis

birmingham

blackpool

blenheim

blue water

bodiam

brecon beacons

brighton

broughton

BRITAIN FROM THE AIR

Introduction

· · · · · · In a brief introduction it is difficult to convey the complexity of British history. While it might be easier to look at this long and involved history as that of the single country known to the world as the United Kingdom of Great Britain and Northern Ireland, this would be fallacious. Although the history of the disparate peoples that form the British are interwoven, it is only in recent centuries that union has come. Scotland was a separate realm until the union of the two crowns with James I (of England; he was James VI of Scotland) in 1603 and the Act of Union itself only dates from 1707. Wales fell under English domination earlier, in the Middle Ages, but even the concept of a single realm of England only dates back a thousand years.

Physically, the islands have not always been isolated. It is only within the last 10,000 years, since the end of the last Ice Age, that the land bridge that once connected Britain to Europe was severed. The influence of the Ice Age continues to this day, as the southernmost parts of England gradually sink whilst the mountains of Scotland and northern England get higher.

It was over the land bridge that the first settlers migrated westwards. Prehistoric man found the British landscape to be dominated largely by forest—something difficult to believe today as only a small percentage of the British landmass is formed of ancient forest—but in the prehistoric era, the migrants would have found a land heavily forested, where wolves and other predators were common and where life could be 'nasty, brutish and short'.

These early settlers were primarily hunters; it was only gradually that the natural fecundity of the land would be exploited. The earliest evidence for human life in the British Isles dates back to 60,000BC, but it is only much later that the presence of settlers can be evinced through structures visible from the air. Successive waves of migrating people moved to Britain; these included the Windmill Hill people, who were responsible after c. 3000BC for the construction of the various tombs and standing stones of places such as **Avebury Ring**. [Locations mentioned in the Introduction and highlighted in bold are illustrated in the book. See contents page for location of photograph.] Around 2000BC a further group of migrants, the so-called Beaker people, arrived; it was this group that was responsible for perhaps the best-known of all British prehistoric monuments, **Stonehenge**.

After the Stone Age other groups migrated to Britain during both Bronze and Iron ages; these included the Celtic tribes, whose culture still influences much of the British Isles (in particular Cornwall, Wales, Scotland and Ireland). One of the Celtic tribes, the Brythons, arrived some 300 years before the birth of Christ; it is from this name that 'Briton' is derived. The British Isles were a centre of the metal trade, and in the last centuries of the pre-Christian era trade links were established with the Mediterranean cultures.

It was to be one of these cultures—Rome—that was to dominate the history of the British Isles for the next 500 years. The first Roman incursions—under Julius Caesar—occurred in 55 and 54BC. However, these were no more than raiding parties and it was not until AD43, during the reign of the Emperor Claudius, that the Roman legions returned and established much of the British Isles as a part of the Roman Empire. Many of the native British tribes welcomed the invaders and adopted a Roman life-style; others, however, sought to repel the Romans. Of these, the most famous was Boadicea (or Boudicca), the leader of the Iceni.

It was during the period of Roman occupation that many of today's most important settlements were established. Urbanisation was a common trait through much of the empire as was the need to provide secure defensive bases. Towns and cities such as Colchester (Camuldonum), **York** (Eboracum), **London** (Londinium) and **Bath** (Aquae Sulis), all have their origins in settlements established or developed under Roman control. Many of them still have significant Roman remains today—such as the baths at Bath and the town walls at Colchester. Much more dramatic are the remains of Hadrian's Wall, between Newcastle and the Solway Firth, and its associated forts, such as Housesteads. **Hadrian's Wall** was built from about AD122 as a defensive measure to protect the north of the Roman province of Britannia from the Pictish tribes in Caledonia (Scotland). This was one of two major defensive barriers; the other, the Antonine Wall, was built between the Firth of Forth and the Firth of Clyde, but Hadrian's Wall is generally regarded as marking the northernmost point of Roman control within the British Isles. The Romans controlled all of England and Wales, but rarely dominated Scotland and never sought to control Ireland (Hibernia).

It was during the period of Roman occupation that Christianity was first introduced to the British Isles, although the Anglo-Saxon invasions saw much of the country revert to paganism with Christianity concentrated solely in Ireland. The period of Roman occupation was one of considerable civilisation in Britain, with Britannia proving to be one of the most wealthy of the Roman provinces. However, the gradual eclipse of Roman power on the mainland of Europe was mirrored by increasing tension between Roman Britain and the inhabitants of the rest of the islands. As it became clearer that Rome was no longer willing or able to defend Britannia, so the native British chiefs took the route of inviting foreign mercenaries—Angles, Saxons and Jutes—from northern Germany and southern Scandinavia to assist in the defence of the country.

This was to be a road that led to ruin for the native Celtic tribes. Whilst the mercenaries were initially willing to come simply to fight, such was the wealth of the country that the mercenaries soon became settlers, forcing the existing tribes either into servitude or to flee to the outlying parts of the British Isles. The last Roman legion left Britain in AD410, and by the middle of the same century Anglo-Saxon settlement had begun to take root. The new settlers eventually established seven kingdoms—East Anglia, Essex, Kent, Mercia, Northumbria, Sussex and Wessex—to replace the earlier Roman divisions. These names are still familiar today, either as regions or counties of England.

The invading Anglo-Saxons did not, however, have everything their own way. The native British tribes did fight and inflict several notable defeats upon the invaders. It was at this time that King Arthur was believed to have been active, defeating the Anglo-Saxons at the Battle of Mons Badonicus early in the 6th century AD. Throughout Britain there are numerous sites with Arthurian connections, although it is difficult to distinguish myth from reality. These locations include **Glastonbury**, believed by many to be the location of Isle of Avalon, and **Tintagel Castle**, said to be the home of Merlin.

The period after the departure of the Romans and before the later Norman Conquest is known as the Dark Ages. Whilst Roman Britain had been civilised, Anglo-

Saxon Britain was less sophisticated; evidence suggests that many of the former Roman towns were largely abandoned or allowed to deteriorate. With Paganism having displaced Christianity, the British Isles were no longer linked to the Catholic church; the surviving Christians in Ireland developed away from the Catholic mainstream, a fact which was to have consequences later when Christianity was restored to England, Scotland and Wales.

The restoration of Christianity in Britain was the result of two distinct movements of missionaries. In AD563, St Columba established the monastery on the island of Iona, off the west coast of Scotland, from where missionaries set off to bring Christianity to the kingdoms of northern England and Scotland. From Rome in AD596, Pope Gregory, inspired by the sight of captured young Anglo-Saxon slaves ('Not Angles but Angels,' he was reported to have commented), sent the first Catholic missionaries to England under St Augustine. Despite the latter's doubts, he reached Kent where the slow process of converting the Anglo-Saxon kingdoms of southern England start. Augustine's efforts were assisted by the fact that the Kentish King, Ethelbert, had married Bertha, a Christian princess from Europe. The capital of the kingdom of Kent was at Canterbury and Augustine was able to rebuild a Roman era church as a place of worship. Today **Canterbury Cathedral** is the mother church of the whole Anglican communion—the Archbishop of Canterbury is known as the Primate of All England—although the cathedral that stands today was the result of rebuilding from the late 11th century onwards.

With two distinct Christian strands influencing missionary work in the British Isles, it was inevitable that controversy would arise. The major problem was over the date of Easter, since the Celtic Christian church from Ireland and the Catholic church had different methods of calculating this most important of all Christian festivals. It was not sensible to maintain both traditions and at the Synod of Whitby, in AD664, it was decided that the traditions and customs of the Catholic church would prevail.

The final centuries of the first millennium were dominated both by the gradual emergence of a single Anglo-Saxon kingdom in England—dominated by Wessex—and by further threats of military strife from mainland Europe. The new invaders were the Vikings from Scandinavia. As with their Anglo-Saxon predecessors, these new invaders initially arrived for plunder, raiding parties harrying the coast and destroying monasteries and other places of wealth, before heading back across the North Sea with their booty of slaves and valuables. It was as a response to these Viking raids that the single Anglo-Saxon kingdom, under Egbert of Wessex, emerged in the first decades of the 9th century AD. It was only as a united force that the Anglo-Saxons were able to take on the Vikings militarily and inflict defeat upon them. Famous as the monarch who burnt the cakes during AD878 when he was forced to hide at Athelney in Somerset from the marauding Viking army, King Alfred led the Anglo-Saxon armies to victory over the Vikings in battles at Eddington and Chippenham. These successes led to the Peace of Wedmore and a subsequent treaty which divided England in two; southwest of a line from Chester to London, Anglo-Saxon power was guaranteed, whilst north of the line the Vikings held sway. The Viking-controlled area became known as the Danelaw and the Scandinavian influence still survives today in numerous place and street names throughout this part of England.

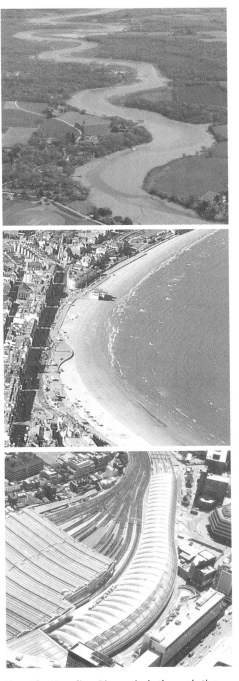

Top: The Beaulieu River winds through the New Forest down to the Solent (see page 36).

Centre: Weymouth's glorious golden sands and seafront (see page 186).

Above: Waterloo station (see page 131).

Following the treaty there was a period of relative calm between the two factions; however, during the last decades of the 10th century Viking forces again started raiding. At this time the Anglo-Saxon king was Ethelred the Unready—his name was not a reflection of his lack of preparedness but more a reflection of his lack of strong advisers (reed=Anglo-Saxon word for advice). In order to fight the Viking onslaught, Ethelred introduced the first general tax to be levied. After the Norman Conquest in 1066, this tax became known as the Danegeld.

Such was the Viking domination of England in the early years of the 11th century that for 26 years—from 1016 to 1042—the country was ruled by Danish kings. The first of these was Canute, who is today best remembered as the monarch who bade the tide not come in and failed to stop it, in order to prove to his advisers that even kings were unable to stem the forces of nature.

After the interlude with the three Danish kings, in 1042 the crown of England reverted to an Anglo-Saxon—Edward the Confessor. For the next quarter century until his death in 1066, Edward was to dominate England. He developed strong connections with another branch of the Viking empire—the Normans in northwest France—and brought over many Norman artists and advisers. It was during Edward's reign that Westminster Abbey was founded, in 1065, with the intention that the new church would his place of burial. Norman craftsmen were employed in its construction, although the church that survives today is primarily the result of construction work after the Norman conquest; indeed, parts of the west front were not completed until the 18th century.

Edward's connections with mainland Europe were to have profound consequences for the British Isles. During one of the regular visits to Normandy by the leading Anglo-Saxons of the time, Harold Godwinson, one of Edward's leading earls, and his shipmates were, following a shipwreck and rescue, forced to swear an oath, it was alleged, whereby they agreed to support the claim of William, Duke of Normandy, to succeed to the English throne. Whether this oath was ever sworn is now lost in the mists of time; nonetheless, William's interest in the throne was clear. However, unlike the modern principle of inheritance, the throne in Anglo-Saxon England did not necessarily pass from father to son or daughter. Instead, on the death of the king, the leading earls gathered to select the new monarch; if Harold had sworn this oath, he was doing no more than agreeing to support William in any such process. Other candidates would also have their supporters.

In the event, following Edward's death in early 1066, the English throne was offered to and accepted by Harold. This greatly offended William of Normandy, who resolved to invade England and claim what he believed he had been promised—the throne of England. It would, however, take him several months in order to put together an invasion fleet and during this period Harold was to face another threat to his power. Supported by his own brother Tostig, the Vikings under Harold Hardrada invaded northern England, forcing Harold to march his army northwards at a time when he was expecting the major threat to come from France. In the event, Hardrada and Tostig were defeated at the Battle of Stamford Bridge, to the east of York, but at the moment of victory, King Harold received the news that he had been dreading—William had landed at Pevensey on the south coast.

Harold's army marched southwards and drew up against William close to Hastings. The Battle of Hastings, on 14 October 1066, will always be remembered as one of the seminal points in British history. William's victory and Harold's death, with an arrow through his eye, are well-known and recorded in the Bayeux Tapestry; the Norman victory was, however, by no means certain and William had reason to be grateful to a breakdown in the discipline of Harold's army for his ultimate success. Close to the location of the battle, **Battle Abbey** was established in 1094, endowed by William to give thanks for his victory.

Wining the battle was but part of the war. Following on from his victory, William had both to spread Norman power through the realm and also to establish strongholds from which this power could be exercised. Initially, for speed and ease of construction, many of these castles were built from wood on earth mounds—known as motte and bailey castles—but towards the end of the 11th century the Normans undertook the construction of many massive stone keep—at places like **Rochester, Colchester, Norwich** and **Windsor**. Of the castles built at the time, the most famous is the Tower of London. Although many of these castles have undergone significant changes in the past 900 years, in particular the rebuilding of Windsor Castle in the 19th century, they would still be recognisable to their Norman builders.

In the period after his invasion, William gradually extended Norman power throughout England. The conquest was not without continued opposition, and William was forced to undertake military action against many parts of the country. Some 20 years after the invasion, in 1087, the depredations wrought on many areas of the country were reflected in the number of manors recorded in William's survey of the country as 'waste'. This survey survives as the Domesday Book, probably the first survey ever undertaken of landownership in England; it showed that by this date most of the land was controlled by Norman lords, followers of William, although a few native Anglo-Saxon landowners remained. Many of the most aristocratic families in Britain owe both their arrival in the realm and also their position to the Norman Conquest; trusted lieutenants were granted territory as payment for support but also as a guarantee that they would exercise control over the area concerned. This land ownership is reflected in a large number of place names, such as Montgomery and Beaulieu, and the way in which the English language adopted words derived from French—such as beef and pork; until well into the Middle Ages French was the language of the court and of the aristocracy, although Latin remained the most important language in ecclesiastical circles. That there was friction between the conquered and victors is undoubted but later novels such as Sir Walter Scott's *Ivanhoe* paint a romantic picture of inter-community tensions.

A further consequence of William's victory was that it brought England into a realm that was, in part, a vassal of the French crown. William nominally owed allegiance to the French king for his French territories and between 1066 and the mid-16th century when Queen Mary lost England's final possession on mainland Europe (Calais), the crowns of England and France were regularly at war. English power was at its zenith during the reign of Henry II, when as part of the Angevin Empire, the king of England controlled most of France, the French monarch being left ruling over a small region around Paris. Today, the only remnants of the once massive realm inherited by the mediaeval monarchs are the Channel Islands where the British monarch is still, properly, to be regarded as Duke of Normandy.

In addition to their massive programme of castle construction, the close relationship between the Normans in England and their relations on the continent brought a dramatic growth in church building and a revival in monasticism. It was in the years after the Norman invasion that many of the leading cathedrals were started or rebuilt. In Norfolk, for example, the bishopric serving the region was translated to Norwich from Thetford, where a new cathedral was started in the last decade of the 11th century. At **Exeter**, the Normans extended an earlier church that had become the seat of the bishop under Edward the Confessor when the see was transferred from Crediton; today, the west towers are the most obvious element of the 12th century Norman work visible from the air. **Ely**, surrounded at this period by the undrained Fen country, was, under Hereward the Wake, one of the centres of Anglo-Saxon resistance to the Norman invasion; the existing church was raised to cathedral status in the early 12th century and again much rebuilt thereafter. Ely cathedral was to suffer a major collapse in February 1322 when the Norman crossing tower collapsed; it was replaced by the lantern that is today one of the crowing glories of English ecclesiastical architecture.

In addition to the revolution wrought on the English church by the reforms following the Norman conquest, the new barons were also great benefactors of monasteries. The early Middle Ages saw a massive expansion in monastic life—the Cistercians, the Benedictines, the Cluniacs and so on—and England, along with the rest of the British Isles, was not immune from this growth. There had been a tradition of monastic life prior to the conquest and even after 1066 the English pattern of monastic cathedrals—such as Ely, Durham and Canterbury—remained. It is from the period after the Norman Conquest that many of the most famous monastic foundations date. There were a number of reasons why this occurred. To contemporaries, the founding of a monastery was a guarantee that prayers would be said for the souls of the benefactors; at a smaller scale, the many chantry chapels constructed during the Middle Ages were also a reflection of concern for one's eternal soul. There was also an increasing belief in pilgrimage to places associated with saints—such as Canterbury (particularly after the murder of Thomas Becket in 1170 by four knights acting, they believed, on the instructions of King Henry II)—or religious relics. Throughout the length and breadth of the country, religious houses were established. These included **Fountains Abbey** in Yorkshire, which was founded in 1132, Rievaulx Abbey, founded in 1131, and **Bury St Edmunds**. Many of these abbeys grew to become amongst the most wealthy landowners in the country; a wealth which was ultimately to lead to their downfall. The numerous abbeys and monasteries dating from this era became centres of learning and much of our knowledge of the period comes from monks and their writings.

Whilst the period immediately after the Norman Conquest saw the new regime gradually confirming its power over England, it would not be long before acquisitive eyes were cast over the rest of the British Isles.

13

Scotland and Wales

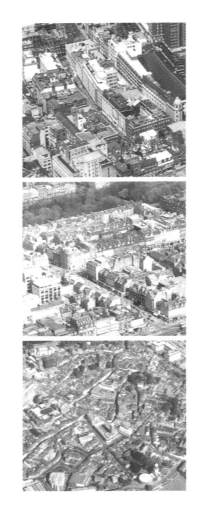

North of the border, in Scotland, the process of creating a single state had occurred contemporaneously with that of England. In the three hundred years prior to the Norman Conquest in England, Scotland had evolved from the gradual merger of four distinct ethnic groups. The first of these was the Picts. These were the native British tribes that had inhabited the area before the arrival of the Romans. The name Pict was derived from the Latin, portraying them as painted men. Initially this referred to all the native tribes of the British Isles, but latterly came to mean those in Scotland alone. The Picts controlled the area north of the Forth-Clyde corridor. The second major group were the Scots; these were Celts from Ireland who had migrated to Scotland in the 6th century. The Scots were particularly powerful in the Western Isles and in the western part of the Scottish mainland. By the mid-9th century, the Picts and Scots were united under a single monarch, Kenneth MacAlpin, whose kingdom of Alba was based on Scone (near Perth). The area today known as the Lowlands—between Edinburgh and the border—was occupied by the Britons. Until the collapse of Roman power, these tribes were pro-Roman and it was the threat of Viking attack in the early 10th century that allowed the then King of Scotland, Constantine II, to extend the power of the Scottish throne to the south. The final constituent ethnic group was represented by the Angles, who, migrating northwards, established themselves in the border country. These disparate races were unified for the first time by Malcolm II of Scotland during the second decade of the 11th century.

Just as the gradual unification of Scotland into a single realm paralleled developments in England, the re-emergence of Christianity was also contemporary. The major figure in Scottish Christianity was St Columba, who migrated from Ireland in the mid-6th century and established the monastery on the isle of Iona from which missionaries departed to bring the faith to mainland Scotland and England.

In Wales, the history prior to the Norman conquest is similar to that elsewhere in Britain. the native tribes—the Brythons—came under attack from Irish (Goidelic) invaders. The country was divided between the two and, during the period when the Anglo-Saxons were conquering England, war was fought between these two tribes. In the event the native Brythons were to prove victorious in North Wales. It was in the 6th century AD that Christianity returned to Wales, often through the activities of hermit-like figures; their lifestyle is reflected in the number of places today called Holy Well. One of these missionaries was Dewi, or David, who has subsequently become the Patron Saint of Wales.

Following their triumph over the Goidelics, from the late 6th century onwards, the Brythons were faced by invasion from the east; the pagan Anglo-Saxons, having successfully subjugated the native tribes in England, moved westwards. Defeated in several battles during the early years of the 7th century, the Brythons in Wales—the name comes from the Anglo-Saxon *Wealas* (foreigners)—were separated from their brethren in the northwest of England (Cumbria) and southwest England (Devon and Cornwall). It is at this time that the border between England and Wales, as it exists today, was largely delineated, a fact demonstrated in the late 8th century by the construction of Offa's Dyke between Wales and the Saxon kingdom of Mercia.

As elsewhere, Wales suffered from the Viking raids of the 9th and 10th centuries, but unlike England and Ireland, where the Vikings settled, Wales was relatively free from Viking occupation. Much of this was the result of the power of Roderick the Great of Gwynedd who, before his death in AD879, had united Wales under his rule. Unfortunately, the next century was to see the country divided into five smaller principalities (Gwynedd, Powys, Deheubarth, Ystrad Tywi and Brycheiniog). These fiefdoms fought amongst themselves, often allying themselves with the neighbouring Anglo-Saxon warlords. It was against this background that the Norman invaders sought to extend their power in the years after 1066.

The Middle Ages

The 12th century in England saw the rise of the Plantagenet monarchs, when Henry I's grandson became Henry II in 1154. Under Henry II England's power in France reached its apogee, with control over Brittany, Gascony, Guyenne, Normandy, Anjou, Poitou and Touraine. Although the Plantagenets were to rule England until 1399, the period marked the gradual loss of their French territory. It was during the reign of Henry II that one of the warring factions in Ireland invited Henry's army over, thus starting the long involvement of England (and, later, Great Britain) in the history of that troubled island. Henry II was succeeded by his son, Richard I (Coeur de Lion—Lionheart). For much of his reign, Richard was absent from his kingdom, as he was one of the leaders of the Third Crusade that sought to wrest control of the Holy Land back from the followers of Islam; Richard was later forced to defend his French territory from the French king. In his absence, his brother John acted as regent and it is during this period that the legend of Robin Hood and the Sheriff of Nottingham appears.

In 1199, during one of his campaigns in France, Richard was killed during a siege. He was succeeded by John, during whose reign England lost control over Anjou and Normandy. In England the powerful barons forced John to sign one of the great documents of English history—the Magna Carta—in 1215 at Runymede (near Windsor). The charter guaranteed the rights of the barons and was one of the first moves towards the gradual reduction of royal power. The 13th century was marked by increasing tension between the monarch and the powerful barons, culminating in a civil war between the then king (Henry III) and the barons led by Simon de Montfort. De Montfort's forces were eventually defeated at the Battle of Evesham in August 1165, during which de Montfort was killed, but, by that date, the principle of a parliament—albeit highly limited in representation—had been established.

Whilst English power in France was on the wane, the 13th century saw greater efforts towards the consolidation of English control over both Wales and Scotland. The dominant figure in the campaign against both nations was Edward I, king from 1272 until 1307. Nicknamed 'Hammer of the Scots', Edward's armies brought English victory in Wales and significant advances in Scotland. The conquest of Wales occurred towards the end of the 12th century and, in order to cement this victory, Edward built a chain of castles to impose control. It is from this period that

Top Left: London, Piccadilly Circus (see page 124).

Centre Left: The regular plan of the New Town of the Scottish capital of Edinburgh which was laid out in the 18th century.

Below Left: Built on a loop of the River Severn, Shrewsbury is beautiful medieval city (see page 172).

Overleaf:
Above Left: Glastonbury, Somerset.
The ruined abbey in the Somerset town of Glastonbury was one of the most important pilgrim shrines in Britain. A Celtic church was founded here, where Joseph of Arimathea legendarily brought the Holy Grail and where King Arthur and Queen Guinevere were buried. The church, and later abbey, was added to by Saxon kings and flourished until suppressed in 1539.

Above Right: Dartmoor, Hay Tor, Devon.
Dartmoor in Devon is a large area of high hills and bare moorland formed by a hard granite mass. The region is distinguished by outcrops of bare rock, often weathered into strange shapes, known as tors. The double peak of Hay Tor, in the east of Dartmoor, rises 1,490ft above sea level.

Below Left: Oxford, Oxfordshire.
Oxford's standing as a centre of learning is unquestioned across the world. See page 149.

Below Right: Edinburgh, Lothian, Scotland.
The Scottish capital of Edinburgh is divided in two: the medieval old town with its closely packed tenements and atmospheric wynds (alleyways) and the regular plan of the New Town laid out in the 18th century with its squares and crescents. The railway line runs along the valley of Princes Street Gardens which separates the two districts.

hampton court

harlech

heathrow

hoover building

humber

ironbridge

kenilworth

keswick

kew gardens

leeds

land's end

lincoln

liverpool

loch ness

london

longleat

longships lighthouse

ludlow

lulworth

lyme regis

maiden castle

malmsbury

manchester

the castles at **Caernarfon** (begun 1283), **Caerphilly** (begun 1268), **Harlech** (begun 1283) and **Pembroke** (rebuilt in the late 12th century) date. It was in 1301 that Edward I declared that his eldest son was 'Prince of Wales' and the tradition that the eldest son (and presumed heir) of the monarch is made Prince of Wales continues to this day, with HRH Prince Charles having been invested with the title at a ceremony held at Caernarfon Castle in 1969.

North of the border, in Scotland, English power had waxed and waned since the Norman Conquest. Nominally independent, Scottish King William I had sworn an oath of fealty to the English king in 1174 but Anglo-Scottish relations were marked more by regular border skirmishes and war than by peaceful co-existence. Earlier in the 12th century King David I of Scotland had endeavoured to conquer the English counties of Cumberland, Westmoreland and Northumberland, but he was defeated and killed at the Battle of the Standards. It was only at the Treaty of York, in 1237, that the border as delineated today came into existence. Later in the 13th century, following the death of Queen Margaret, there were 13 claimants to the Scottish throne. King Edward I of England was invited to adjudge which of the claimants would succeed; he selected John de Balliol, who responded by swearing a further oath of fealty to the English king.

However, relations between Edward I and John de Balliol quickly deteriorated and the latter abdicated. Edward I assumed the Scottish crown and undertook a major military campaign throughout Scotland in 1296. It was at this time that the famous Stone of Scone was pillaged and sent to England. The Scots, rejecting the power of Edward, rebelled; one of the leaders of this rebellion—whose career was immortalised in the film *Braveheart*—was William Wallace, who was eventually to be captured and executed for treason in 1305. Despite this setback, a resurgence of Scottish power under a new leader, Robert the Bruce, led to the famous victory at Bannockburn in 1314 over the new English king, Edward II. Robert the Bruce established himself as the recognised king of Scotland and, by the time he died in 1329, he was acknowledged king by both the Papacy and the English. Following his death, however, Edward III attempted to re-establish English pre-eminence and it was only with the first of the Stuart monarchs, Robert II, in 1371 that stability was again restored. The next centuries in Scotland are marked more by internal strife between the monarch and the nobility rather than external wars with the English.

Reverting to England, Edward II—a controversial king with a somewhat scandalous private life—was deposed and murdered in 1327. He was succeeded by Edward III who attempted to fulfil his claims to the throne of France. Initially successful in the Hundred Years' War (1339–1453), the English achieved notable victories at Crécy (1346) and Poitiers (1356). At the latter, the French king was captured and held to ransom. One of the most important English leaders was Edward's son, the Black Prince; following his death, England's military position deteriorated with the loss of all French territory with the exception of Gascony and the area around Calais. One thing that did force a cessation of hostilities was the arrival in 1348–49 of the Black Death. Britain—as Europe—was to lose a substantial part of its population: up to a third leading to a shortage of labourers and a rise in prices. Many historians cite the Black Death as having killed off the feudal system for these reasons.

The end of the 14th century witnessed further instability in England. The costs of the war against France meant that taxation rose steeply, causing resentment amongst the population. This resentment was reflected in the Peasants' Revolt of 1381, led by Wat Tyler and John Ball. Initially the king, Richard II, appeared to be sympathetic to the grievances expressed by the rebels, but the threat to the established order was such that ultimately some 1,500 were executed. Richard II was another weak monarch and was the last king of the Plantagenet line. Following Richard's death in 1399, the throne passed Henry IV, the Duke of Lancaster, who had led a rebellion against the king and had taken him prisoner.

Henry VI was the first of three kings from the House of Lancaster. He was succeeded by his son, Henry V, in 1413. Henry V was a soldier-king who took his claim to the throne of France to the battlefield and was ultimately to be crowned king of France in Paris. It was during Henry V's reign that the great victory of Agincourt was achieved, a victory immortalised by William Shakespeare and later in Lawrence Olivier's stirring wartime film of the play. However, whilst Henry V regained much of the territory lost by England in the preceding centuries, his early death, again killed during a siege, meant that the throne passed to his one-year-old son, Henry VI. Although Henry VI was also crowned king of France, internal problems in England meant that defence of this territory proved impossible and by the middle of the century all of England's French possessions, with the exception of Calais, had been lost. It was during the reign of Henry VI that one of the great public schools of England, **Eton College**, was founded in 1440.

With a one-year-old on the throne, factionalism ran rife at the English court. This was the background to the civil war of the mid-15th century known as the War of the Roses. The war, fought between the houses of York and Lancaster—whose emblems were white and red roses respectively—was to lead ultimately to a Yorkist victory when Edward, Duke of York, defeated the Lancastrian army at Towton in 1461 and succeeded to the throne. Edward was to reign until 1483; at his death, the young prince Edward V succeeded. Edward V was never crowned and his fate, as one of the two Princes of the Tower, has never been conclusively proved. According to the less than objective William Shakespeare, the young princes were murdered on the orders of their uncle, Richard, Duke of Gloucester. What is certain, however, is that Richard was crowned king, reigning for two years as Richard III until renewed civil war saw him defeated and killed at the Battle of Bosworth in 1485.

The victor of Bosworth, Henry Tudor, was to become King Henry VII; the new dynasty was to launch a century of change on England. The new monarch was a shrewd politician and manipulator who managed to bring stability to the country after a century of internal strife. He united the houses of Lancaster and York through marriage and helped to restore the finances of the crown. His eldest son was, symbolically, called Arthur; however, the promise of the young prince was cut short by premature death and, in the event, it was to be Henry's second son, Henry VIII, who succeeded to the throne in 1509.

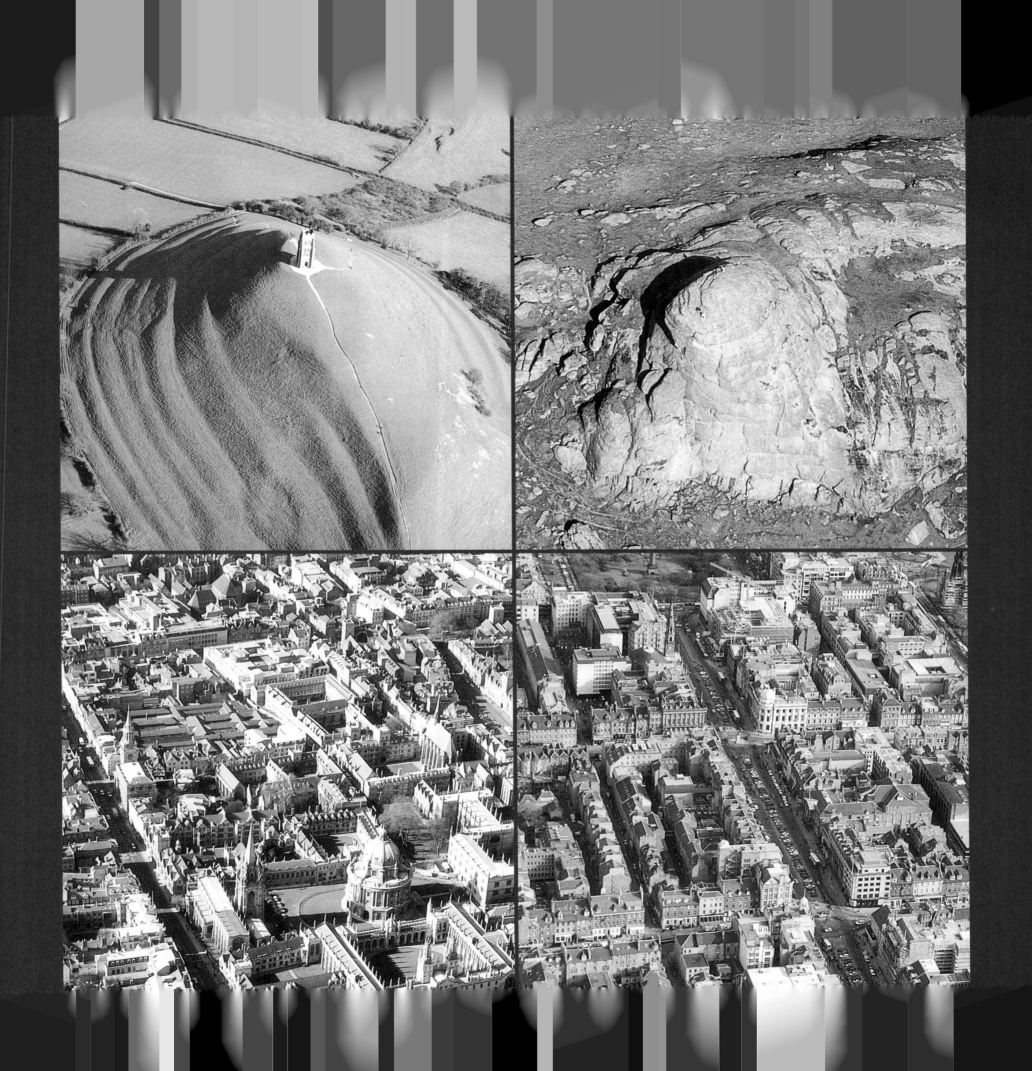

Renaissance and Reformation

The early years of the 16th century marked a period of change throughout Europe. The renaissance was revolutionising art and architecture, whilst the first stirrings of the Reformation were beginning to be felt. It was inevitable that England would be affected by these movements. Initially, Henry VIII was seen as a great supporter of the established Catholic church—the Pope conferring on him the title 'Fidei Defensor' (Defender of the Faith) for writing a pamphlet attacking Luther. However, the king's desire for a male heir was paramount. The War of the Roses was still in living memory as was the desire to ensure a strong—male—succession to the throne. Henry's first wife, Catherine of Aragon, was Arthur's widow; she had produced a daughter—the future Queen Mary—but no son. Henry petitioned the Papacy for the marriage to be annulled; this caused the initial breach between Rome and the English crown and was to cost Sir Thomas More his life—a story brought graphically to life through Robert Bolt's screenplay for the film *A Man For All Seasons*.

Ultimately, Henry was to have six wives and was succeeded by his only son, the sickly Edward VI in 1547. By that date, the landscape of England had been changed. The Renaissance had brought a revival in learning, reflected in the number of colleges established in the ancient universities of Oxford and Cambridge. It was at this time that **Christ Church College** was founded by Cardinal Thomas Wolsey in Oxford; it was also Wolsey who started work on the building of the great palace at **Hampton Court**, which passed to Henry VIII on Wolsey's fall from favour. Henry VIII's lavish lifestyle resulted in the prudence of his father being wasted; in order to improve royal finances again, Henry VIII launched an attack against the wealth of the church, in particular by the appropriation of the land and assets of the abbeys and monasteries with which England was so well endowed. It was the Dissolution of the Monasteries, which started in the late 1530s, that resulted in the destruction of many of the most famous religious houses in England. Today, the ruins of abbeys such as **Fountains**, are the result of Henry's policy. The great monastic-cathedrals, such as **Gloucester** and **Worcester**, were not spared; the churches survived but were stripped of their monks.

Despite all of Henry's endeavours for a strong succession, Edward VI was to survive but six years on the throne. He was succeeded by his half sister, the Roman Catholic Mary, who cemented her power by marriage to Philip II of Spain. It was during Mary's reign that England's last possession in France—Calais—was finally lost. Mary, however, was to reign only five years and was succeeded in 1558 by Elizabeth, the daughter of Henry VIII and his second wife, Anne Boleyn.

The reign of Elizabeth—'Good Queen Bess' or the 'Virgin Queen'—was to be a watershed in English history. It was the age when many of the great landed estates became formally established; relative peace at home allowed the new magnates, such as the Cecil family at **Burghley** and the Marquis of Bath at **Longleat**, to build great country houses designed for domestic comfort rather than for defence. Abroad, Elizabeth's adherence to the Protestant faith meant that the country was isolated from and threatened by the Catholic monarchies of France and Spain: the latter launched an intended invasion in 1588—the Armada—which was to be defeated through a combination of English seamanship and diabolical weather . It was under Elizabeth that the first real steps were taken that led England (and later

Great Britain) to become the greatest imperial power since the days of Rome. It was an age of literature—with figures such as Shakespeare born at **Stratford-on-Avon**—and learning, as all the arts, such as architecture and music, flourished.

However successful Elizabeth was, she never married and the succession at her death in 1603 was again in doubt. In the event, the crown passed to James VI of Scotland, the son of Elizabeth's cousin Mary, Queen of Scots. Mary had been forced to flee her native Scotland as a result of factional strife and took refuge in England. Unfortunately, she connived in a number of plots against Elizabeth and was executed in 1587 at Fotheringay Castle in Northamptonshire.

With James VI of Scotland becoming James I of England a new dynasty was established. It is important to note that, at this stage, England and Scotland remained separate countries united by a common crown. It was not until the Act of Union in 1707 that the single realm was established. Under James there was relative stability; whilst nominally a Protestant, he was sympathetic to the Catholics, although this was not enough to prevent a number of Catholic plots, most notably the Gunpowder Plot of 1605 when Guy Fawkes and his fellow conspirators sought to blow up parliament.

James I died in 1625 and was succeeded by his eldest son, Charles I. Charles was perceived as being more pro-Catholic, particularly as he had married a Catholic, Henrietta Maria of France, who had brought her faith and priests with her. Religion was but one area of controversy during Charles's reign; from 1629 until 1640 he ruled without parliament, raising taxation—such as the widely unpopular Ship Money—without authorisation for his overseas ambitions and being guided by a number of favourites whose roles were disapproved of by the leading politicians of the period. As the 1630s progressed, so the royal finances deteriorated and opposition to the irregular taxation increased. In 1640 Charles was forced to recall parliament; the struggle over the next two years cost Thomas Wentworth, Earl of Strafford, one of Charles's leading advisers, his life and was ultimately to lead to the outbreak of the English Civil War.

The Civil War, which lasted from 1642 until the defeat and ultimate execution of Charles I in 1649, divided families. It was a conflict between the ruling class as to who had ultimate control, monarch or parliament. The latter's victory ensured that no longer could monarchs claim to rule by 'Divine Right' as Charles and his predecessors had claimed.

Initially the Cavaliers, as the pro-Charles faction were known, were successful; it was only with a radical overhaul of the parliamentarian army under Oliver Cromwell and the creation of the New Model Army that the Roundheads proved victorious. For the next 11 years there was no monarch; Oliver Cromwell acted as Lord Protector of the Commonwealth although he was offered, and declined, the throne. At his death in 1658, his son, Richard, succeeded him as Lord Protector. However, by this date moves were afoot to invite Charles's son, Charles, to regain the throne. In 1660, amidst much ceremony, the Restoration took place and Charles II took the throne; he was to rule for the next 25 years. His reign was notable for many things, but particularly the recurrence of the plague that had killed so many in Europe in the mid-14th century and the Great Fire of London, in 1666. The latter destroyed much of the City of London, including the original **St Paul's Cathedral**. The new St Paul's, constructed to the design of Sir Christopher Wren (one of the leading scien-

tists of the period whose work also included the **Sheldonian Theatre** in Oxford with its huge hung ceiling), was built from 1675 to 1711.

Like his grandfather, Charles II was sympathetic to the Catholics but he was astute enough to ensure that his sympathies did not weaken his hold on power. His brother, who succeeded in 1685 as James II, however, lacked this astuteness. More overtly pro-Catholic, opposition quickly grew. The first flash-point, the Monmouth (James's half brother) rebellion in the West Country, was unsuccessful and what was left of the defeated force was either hanged or deported in Judge Jeffries' 'Bloody Assizes'. However, by 1688 the leading peers of the realm were united in their opposition and invited William, Prince of Orange, to take over. William, related to the Stuart dynasty through his marriage to Mary, became king as a result of the so-called 'Glorious Revolution' that saw James II overthrown. The Stuart family retained its claim to the throne and led two attempted rebellions—in 1715 and in 1745 under Bonnie Prince Charlie. It was during the latter campaign that the last battle to be fought on British soil, Culloden, occurred in 1746.

The 'Glorious Revolution' brought a guaranteed Protestant succession to the throne of Great Britain. Following William and Mary, came Anne and, after her death in 1714, the first Hanoverian—George I, Duke and Elector of Hanover. The Georgian period (from 1714 to 1830) is noted for its stability—in spite of wars against France and the American Revolution—and during these years Britain witnessed a massive expansion in its overseas empire and in its domestic wealth. It was during this period that many of the great country houses that dominate the landscape were either built or rebuilt—examples included **Blenheim Palace**, built for the Duke of Marlborough after his defeat of the French forces of Louis XIV at the Battle of Blenheim in 1704 to the designs of John Vanburgh, Castle Howard, also built to the designs of John Vanburgh and most familiar today as the setting for the television series based on Evelyn Waugh's novel *Brideshead Revisited*, **Chatsworth**, rebuilt from the 1680s and later, and **Petworth**, rebuilt from 1688 onwards. Much of this building work was undertaken as a means of displaying the ostentatious art and sculpture brought back to the British Isles from France and Italy as a result of the 'Grand Tours' taken bythe sons of the wealthy.

If the construction of great country houses was one result of the relative stability at home, the Industrial Revolution was another. During the 18th century there became apparent the first elements of the growth of technology that was to see Britain become the 'workshop of the world' in the 19th century. The harnessing of steam power, first developed at the end of the 17th century, allowed for steam-operated pumps to provide drainage of mines. The first steam locomotives were developed in the early years of the 19th century and this allowed for the growth of the railway industry. It was in the early years of the 18th century that iron was first smelted with coke—previously it had required charcoal—at Coalbrookdale in Shropshire and from this grew up a large iron industry in the Black Country, in Yorkshire and elsewhere. Perhaps the greatest monument to the pioneering work of the earliest iron founders can be found at **Ironbridge** in Shropshire, the location of the first ever bridge constructed from iron. The increased production of iron allowed for its use on many of the early wagonways and in the construction of the new factories that were to bring the Industrial Revolution to the textile industries of the north of England.

Overleaf:
Inextricably linked to the legend of King Arthur since Geoffrey of Monmouth's writing in the 12th century, Tintagel fulfils every requirement of legend in its impressive setting and with its romantic ruins. There's little to support its links with the Celtic King Arthur, however, as the castle dates back to c. 1145 and the reign of Henry I; but there certainly was a Celtic monastery on the peninsula from the 6th century AD, and as the clouds scud over Merlin's Cove it's easy to imagine the magician transforming Uther Pendragon's features to those of the Duke of Cornwall to let the king bed Ygraine and father Arthur, the once and future king.

Below: Teignmouth, Devon
Not the prettiest town in Devon, Teignmouth—as its name suggests—sits at one side of mouth of the River Teign (Shaldon is on the other). Its an old resort blessed with a sandy beach and a natural harbour—from which in the 1830s granite quarried on Dartmoor left to build London Bridge. The estuary allows all types of watersports and makes it a popular summer tourist location.

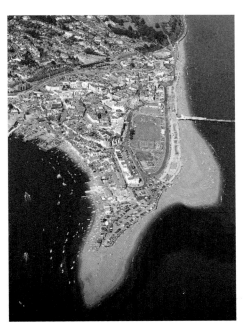

menai bridge

needles

newcastle

newport

norfolk broads

norwich

osborne

oxford

pembroke

pendeen

penzance

peterborough

petworth

plymouth

port isaac

portland

portmeirion

porthmadog

raglan

reading

rochester

romney marsh

rye

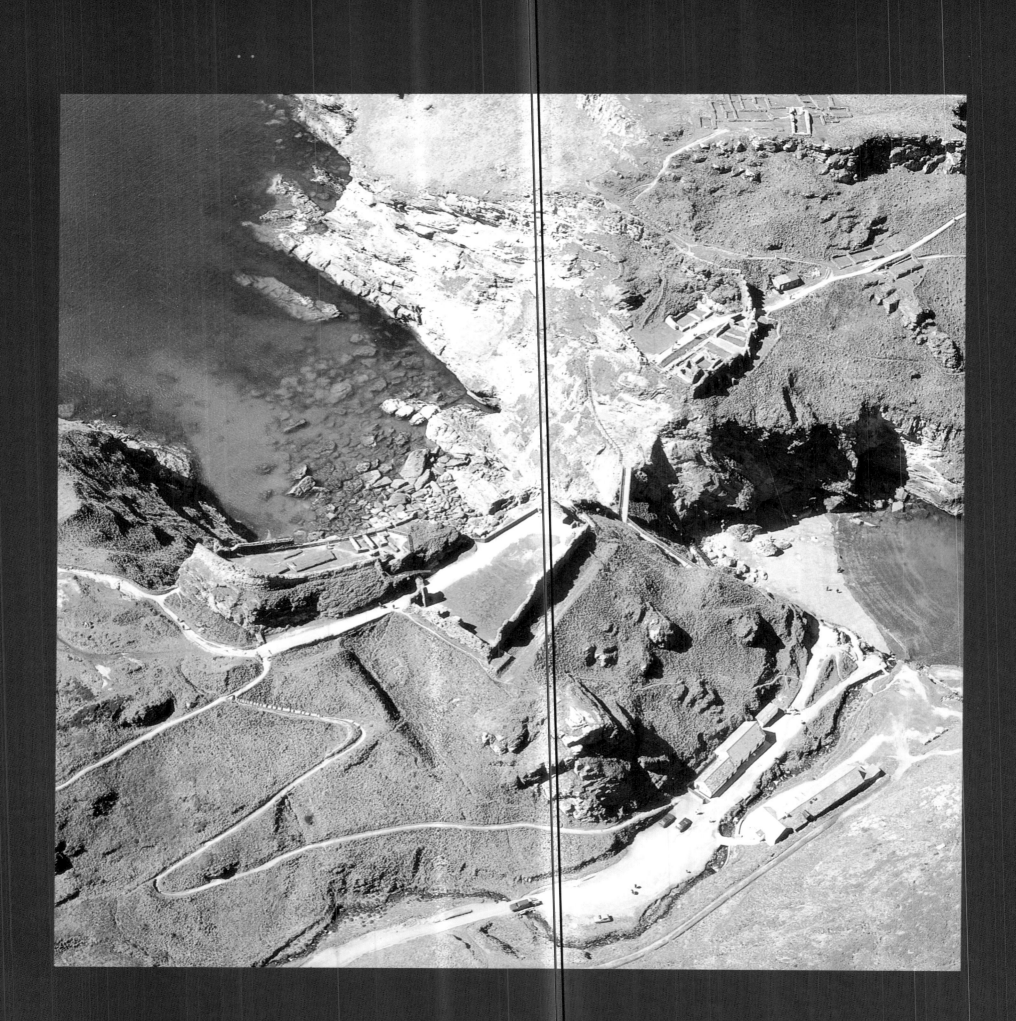

On the World Stage

· · · · · The 18th century saw Britain's influence in the world expand. Although the North American colonies in New England were lost as a result of the American Revolution, this was countered by increased dominance in India, in the Pacific and in Africa. The far-flung colonies were linked to the mother country by trade, and the trade routes were guaranteed by the power of the Royal Navy. Without doubt it was Britain's control of the seas—evinced by such popular songs as 'Rule Britannia'—that enabled the country to achieve its dominance. From dockyards such as **Chatham**, which underwent major modification and expansion from the late 17th century, and Portsmouth, ships bearing the White Ensign sailed the oceans. The power and domination of the Royal Navy was such that even when major European wars threatened, as between 1793 and 1815, there was no real likelihood of invasion. The great wooden warships of the 18th and early 19th century that formed this impenetrable barrier have largely disappeared, but in **HMS *Victory***—preserved at Portsmouth—it is still possible to imagine life in the navy of Nelson's day. The importance of the navy can be seen in the number of clichés—such as 'firing a broadside' or 'a loose cannon'—which owe their origins to this period.

The 19th century dawned with Britain as the first world superpower; its economic and industrial power was such that its position would rarely be challenged during the period up to the outbreak of World War 1 in 1914.

Following the death of George IV in 1830, the throne was held William IV. It was during his reign that the Reform Act of 1832 was passed a piece of legislation that was crucial to Britain's emergence as a true parliamentary democracy, although universal male suffrage did not arrive until later in the century and votes for women did not materialise until after World War 1. In 1837, on the death of William IV, the crown passed to Victoria. Her long reign of 64 years was to mark the period when British power in the world was at its peak, a power that was reflected when Queen Victoria became Empress of India; such was the scope of British overseas territories that it was portrayed as the Empire 'on which the Sun never sets'.

The Victorian Age was one of profound self-confidence for Britain; its place in the world order seemed assured and its dominance in commerce, industry and science was undoubted. This self-confidence was reflected in the exuberance of many of the buildings that were constructed during the 19th century. These included Barry's rebuilt **Houses of Parliament**, as the Palace of Westminster is better known, constructed after a disastrous fire in 1840, **Tower Bridge** and, further north, **Manchester Town Hall**. Many of these great buildings were built in a highly decorated Gothic Revival style; High Victorian Gothic epitomised the confidence of the age in a highly visible form.

Just as the buildings of the era demonstrated a self-confidence in the power of man, so too did many of his other creations. The 19th century was marked by an increasing belief that man could tame the forces of nature, that science could provide all the answers. It was no coincidence that revolutionary ideas such as Charles Darwin's theory of evolution arose at the time. Engineers, also, took the knowledge of the time and pushed this to its extremes. Figures like Isambard Kingdom Brunel achieved a fame that persists to this day. Amongst Brunel's greatest triumphs are the Great Western Railway—recently declared a World Heritage Site—running from London to Bristol, and the **SS *Great Britain***, the first iron ship constructed to be powered by a propeller driven by steam. Built in 1843 and eventually rescued from the Falkland Islands, the *Great Britain* is now preserved and under restoration in Bristol. Brunel was also the designer of the **Clifton Suspension Bridge** in Bristol along with various dock schemes and a unique atmospheric railway that once ran along the coast in Devon. Other great triumphs of Victorian engineering include the **Forth Railway Bridge**, north of Edinburgh, where the structure is so immense that a team of painters is kept constantly employed repainting the vast cantilevered structure. At a more mundane level, the increasing urbanisation of the country required vastly improved provision of water supplies; in the greater London area a network of pumping stations, such as those at **Sunbury** and Kew, were built with massive steam pumping engines to draw water up from below ground level.

By Victoria's death in 1901, Britain's predominance in the world was under threat; the newly unified Germany under Kaiser Wilhelm II was entering the colonial race with a vengeance, and creating a navy that was a significant threat to the Royal Navy. And across the Atlantic lay a sleeping giant, the United States of America whose size, manpower and vast natural resources made it the superpower of the future. In the event, however, it was to be a crisis in the Balkans—the assassination of Archduke Franz Ferdinand in Sarajevo in 1914—that was to plunge Europe into war and, with hindsight, sound the death knell for Britain's empire and world position. World War 1 lasted until 1918; although its direct effects on the British landscape were relatively light, the country lost huge numbers of men in the trenches of France and had expended great resources on the war effort.

The interwar years were an age of struggle for Britain. Many of the traditional industries, such as textiles, coal and shipbuilding, struggled to compete and the years were marked both by an immediate postwar recession and by the great slump after the Wall Street Crash of 1929. There was some optimism; **Wembley Stadium** was built in the early 1920s, its familiar twin towers a symbol for football fans worldwide, and in 1925 the area surrounding the ground was utilised for the great Empire Exhibition. However, by this date, the Empire was already under threat; in Ireland, Home Rule in the area outside the six counties of the future province of Northern Ireland had been granted, whilst there were stirrings for freedom in other parts, most notably in India. Despite the increasing weakness of Britain, particularly in the face of fascism in Spain, Italy and Germany, the Silver Jubilee of George V in 1935 saw a great popular revival.

Within five years, however, Britain and its Empire was again at war, facing on its own the threat from Nazi Germany following the defeat of France and the conquest of most of Western Europe by Hitler's forces. That Britain survived owes much to the Prime Minister of the day, appointed to succeed Neville Chamberlain. Winston Churchill's bulldog spirit did much to fire the belief that Britain could stand alone. The Churchillian speeches of the era—'The Battle of France is over, the Battle of Britain is about to begin', 'We will fight them on the beaches...', 'Never in the field of human conflict has so much been owed by so many to so few', etc—remain a powerful statement to the doggedness of the British during the war.

World War 2 represented the arrival of total war on the British Isles; whilst there had been limited damage resulting from Zeppelin raids during World War 1, this was as nothing compared to the damage wrought by the Luftwaffe during the Blitz and by the German flying bombs later on. The Germans bombed both military targets and civilian centres of population. **Coventry** was particularly hard hit and the modern cathedral, built to a design of Sir Basil Spence postwar, is adjacent to the ruins of the mediaeval church destroyed during the Blitz. A naval town like **Plymouth** was an obvious target and the modern townscape illustrated in this book was a result of the wholesale destruction caused by the war. Even tourist centres like Canterbury, **Bath** (where the Royal Crescent received a direct hit), **Norwich**, **York** and **Exeter** were all attacked. It was, however, London that bore the brunt of the German onslaught. Even **Buckingham Palace** and the Palace of Westminster were damaged; Queen Elizabeth—today's Queen Mother—commented on the former that the Royal Family was now able to look the long-suffering East Enders in the eye, having experienced such an attack.

World War 2 was to cost Britain dear. As with World War 1, the country had been forced virtually to bankrupt itself in order to fund the war and this was reflected in the age of austerity and rationing that persisted well after the conflict in Europe had ceased. Moreover, after World War 2, there was an increasing awareness of self-determination in the European-controlled empires, with the result that Britain's influence gradually diminished as most of the great parts of the Empire—such the Indian sub-continent—achieved independence; Empire was replaced by Commonwealth, but the constitutional ties were weaker.

In 1951, the Festival of Britain was staged. Consciously organised to mark the centenary of the Great Exhibition of 1851, the Festival was designed to show that, despite austerity and rationing, the country was still confident to look to the future. Today, much of the Festival site has disappeared, although buildings like the Royal Festival Hall still survive from that era, but a new century is being marked by an equally ambitious display in the **Millennium Dome** at Greenwich.

In the 50 years since the Festival of Britain, much has changed in Britain and these changes are reflected in many of the illustrations in this book. Great industries—such as ship building, textiles and coal mining—have disappeared, but there is a greater awareness of the heritage that many of these industries have bequeathed to the nation. In **Liverpool**, for example, the former docks on the Mersey are now home to a world-famous maritime museum and northern outpost of the Tate Gallery. In London, the former **Bankside Power Station** is gradually being converted into another branch of the Tate. Not all is positive, however, as further along the Thames, the impressive site of **Battersea Power Station** lies derelict, as various schemes for its reuse have fallen by the wayside. These buildings, the cathedrals of industry, merit as much attention in the future as the great medieval structures of places like York. Many cities, such as Birmingham with its famous **Bull Ring**, have undergone radical transformation over the past half century and the pace of change shows no slowing down.

The French emperor Napoleon Buonaparte characterised the British as a nation of shopkeepers; at the time, the comment was meant as derogatory. In the past two centuries, however, as Britain's industrial might has declined, so Buonaparte's description becomes all the more appropriate. Sunday and evening shopping have revolutionised the lives of many—not necessarily for the better—and huge shopping complexes, such as the **Metro Centre** near Gateshead or Blue Water near Swanscombe, cater for the ever-growing consumer society. There are undoubted concerns about these huge out-of-town complexes—particularly over traffic congestion and the likelihood of decline in the local high streets—but these sites seem destined to play an ever more important role in society in the future.

As the working week has shortened and as the overall level of wealth has increased, so there is more leisure time. The 19th century saw many of the most familiar sports in the country—such as rugby (both codes), football and cricket—properly codified and regularised. Britain is home to many of the most famous sporting venues in the world—such as **Aintree** racecourse (home of the Grand National), **Epsom** racecourse (home of the Derby), the **Oval** (one of the great cricket test match venues) and **Wembley** stadium.

As Britain enters the third millennium, so its isolation from Europe has declined. Membership of the European Union has brought closer political, economic and social ties, whilst the physical barrier of the Channel, so long a source of strength, has itself been broken with opening of the **Channel Tunnel** from Folkestone to Calais. With the world's two busiest international airports at **Heathrow** and **Gatwick**, Britain has long been one of the greatest international crossroads; new and improving transport links into the new century will only enhance Britain's position and reinforce the importance of the City of London—illustrated here by the **Lloyds' Building** (designed by Sir Norman Foster) and the **Bank of England** (the 'Old Lady of Threadneedle Street')—in the world's economy.

This can only be a brief outline of Britain's history providing a taste of the history and events that have shaped the isles. The country's composition, both landscape (from mountainous such as **Snowdon** in North Wales, through moorland, such as **Exmoor**, to the landscape created or manipulated by man, such as the **Norfolk Broads** and the Fens, such as the **Great Ouse Drain**) and social, is varied and this perhaps is one of the factors that helps to make the British Isles unique.

One common strand, howver, runs throughout Briain's history from the dawn of time—its location. The country has one the longest coastlines of any European country; the sea has provided it with defence, for example during the Napoleonic period and during World War 2, whilst at the same time allowing for regular waves of pillagers and invaders—from the earliest tribes through the Romans, Vikings and Normans through to the 'Glorious Revolution' of 1688. The coastline is constantly evolving with the pressure of erosion in certain areas matched by a retreat of the sea elsewhere. The sea, however, remains a constant—and growing—threat, as shown by the need to construct the **Thames Barrier**. Britain's location made the country ideally suited to a dominant role in world trade and in the dissemination of European ideas worldwide. It is, perhaps, no accident that English is increasingly the dominant language worldwide and that British patterns of government and law hold sway in much of the globe.

The illustrations in this book have been selected carefully to reflect the great variety of building, townscape and landscape that represent the giant jigsaw represented by the United Kingdom.

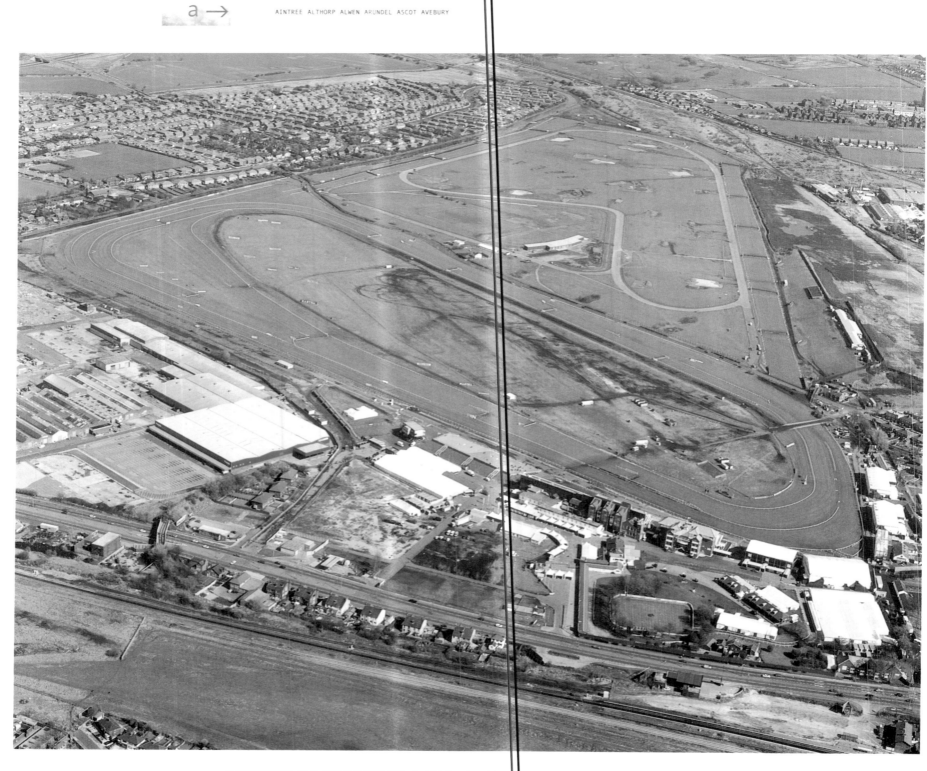

AINTREE RACECOURSE LANCASHIRE North of
Liverpool, Aintree has hosted the famous Grand National steeplechase since 1839. The
race is held every year in March or April over a testing 4 miles and 855 yards over
severe fences including Becher's Brook, Valentines and the Chair. There are also two
other courses: the Mildmay and a hurdle course.

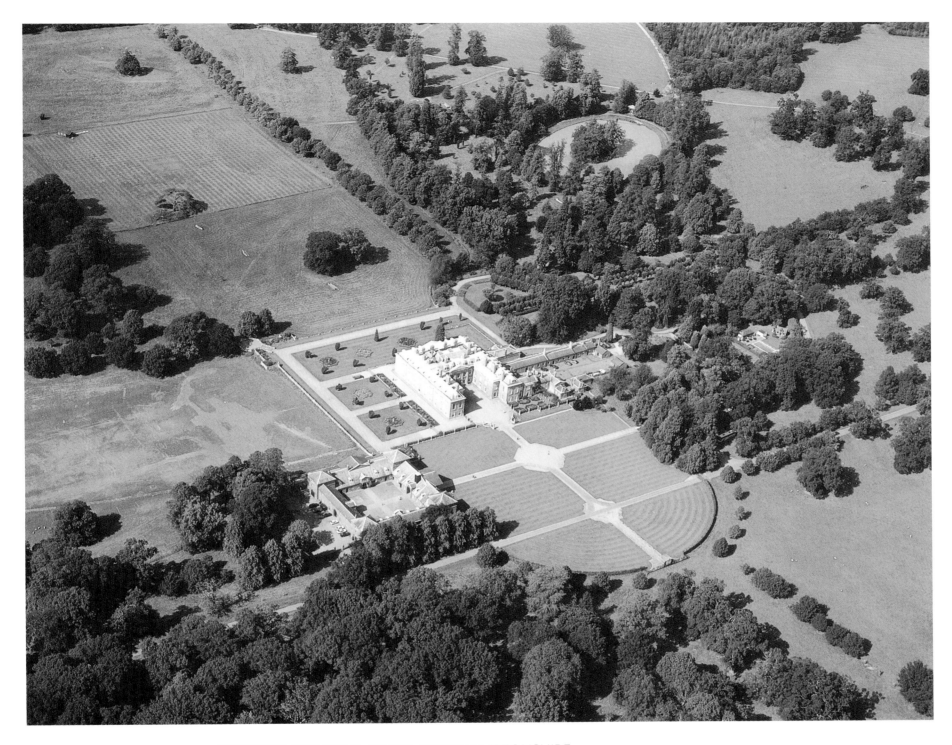

ALTHORP HOUSE & PARK NORTHAMPTONSHIRE

The 16th-century Althorp House has been the home of the Spencer family since 1508.
Diana, the Princess of Wales, was buried in the park on the island in the ornamental
lake known as the Round Oval, which is the site of the family mausoleum. An elegant
stone stable-block lies to the side of the house.

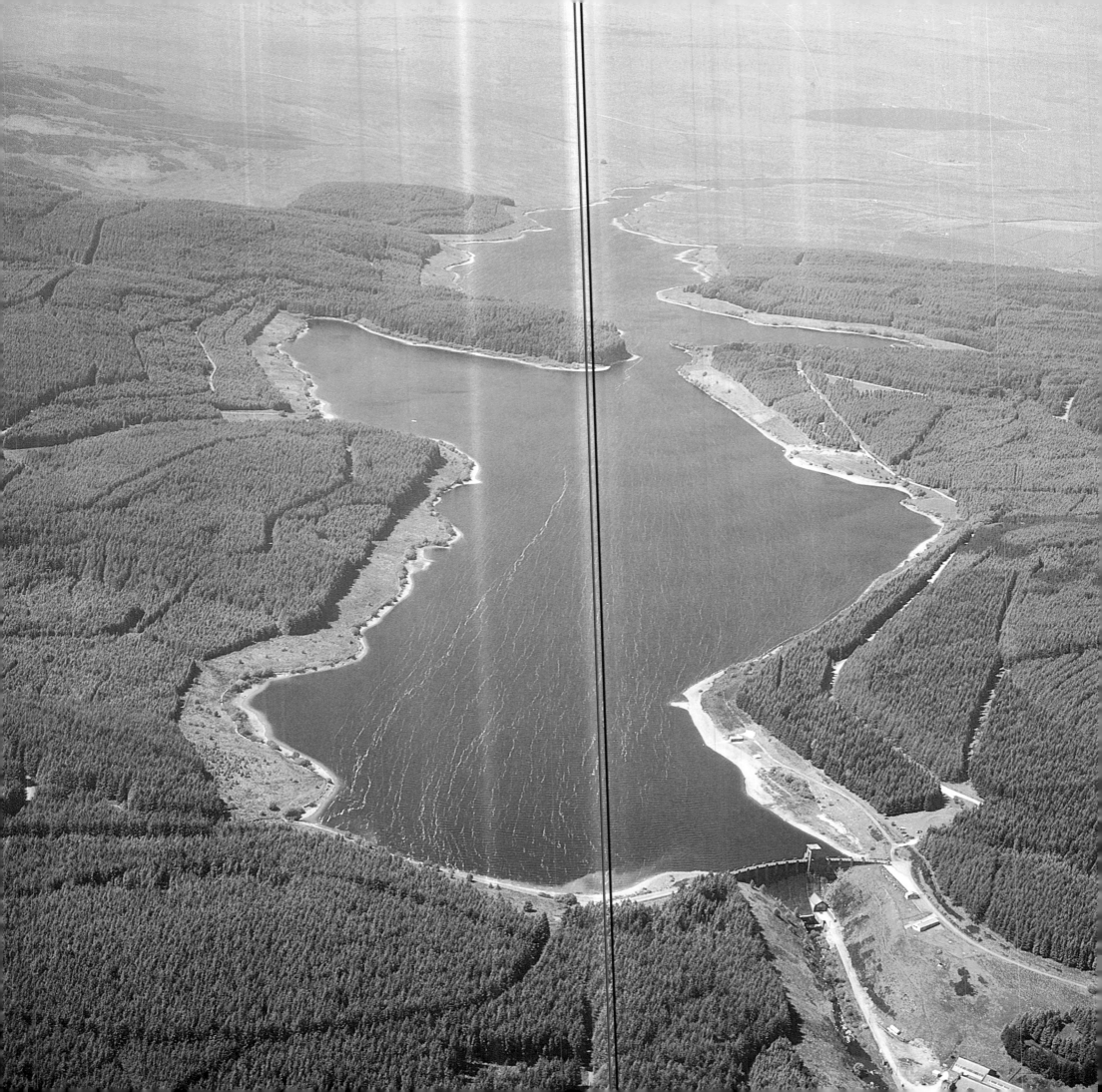

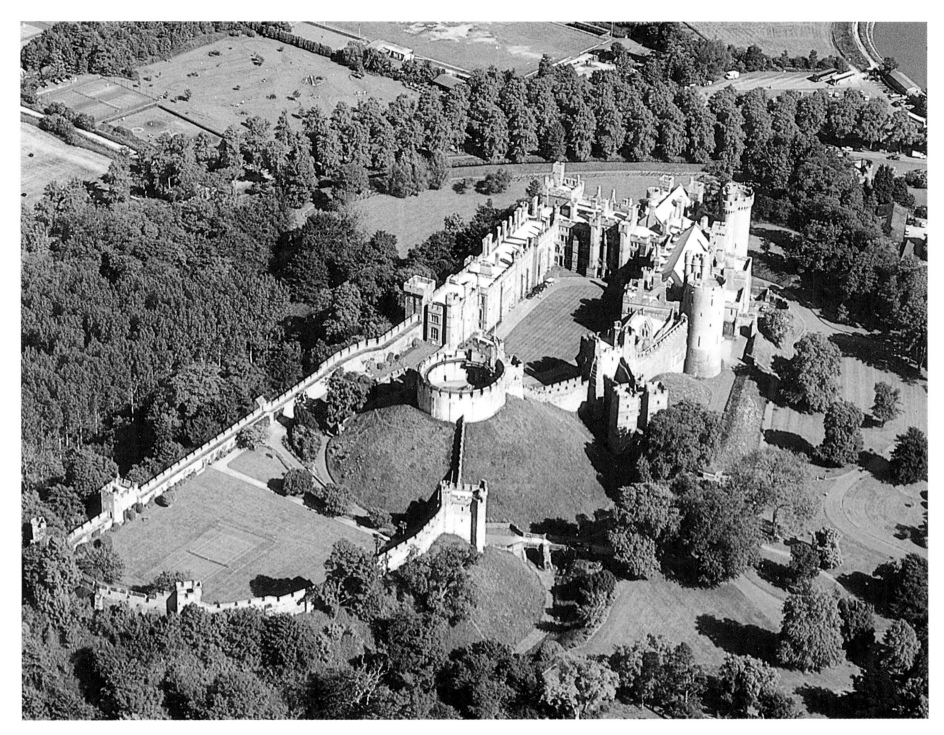

ALWEN RESERVOIR CONWY WALES Three miles
long, the Alwen Reservoir (left) lies just outside the eastern boundary of the
Snowdonia National Park in north Wales among heather-clad hills at the northern end
of the Cambrian Mountains. The reservoir was constructed a century ago to provide
water for the Merseyside town of Birkenhead.

ARUNDEL CASTLE WEST SUSSEX Perched above
the River Arun as it cuts through the South Downs, Arundel is dominated by its huge
castle, home of the Dukes of Norfolk. The castle dates from the Norman conquest,
although it was restored in the 18th and 19th centuries. Equally imposing is the 19th
century Roman Catholic cathedral.

a

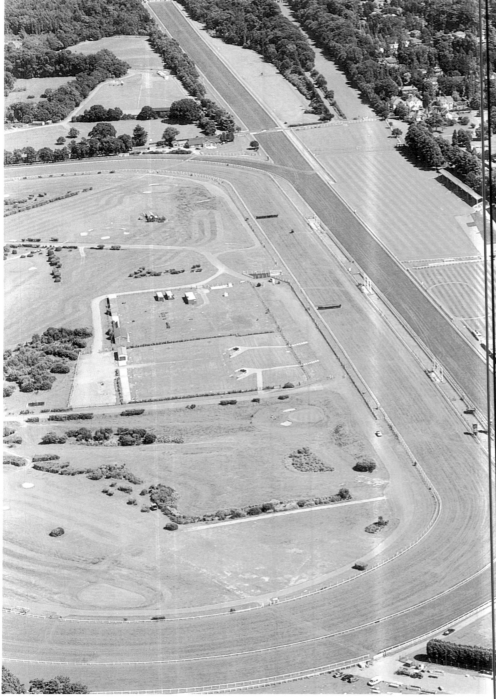

ASCOT RACECOURSE BERKSHIRE The smartest flat race meeting in the English social calendar, Royal Ascot takes place over four days in the third week of June. The premier race is the Gold Cup, held on the Thursday which is also Ladies' Day—an occasion when the most eye-catching fashions are worn!

AVEBURY RING WILTSHIRE In the ancient heart of
Wessex, the Avebury stone circles have fascinated visitors for centuries. The stones have
stood for over 4,000 years, forming three concentric circles within a giant circular
earthwork surrounded by a deep ditch. The outer larger stones weigh up to 60 tonnes.
An avenue of smaller stones leads out of the circle to the Sanctuary.

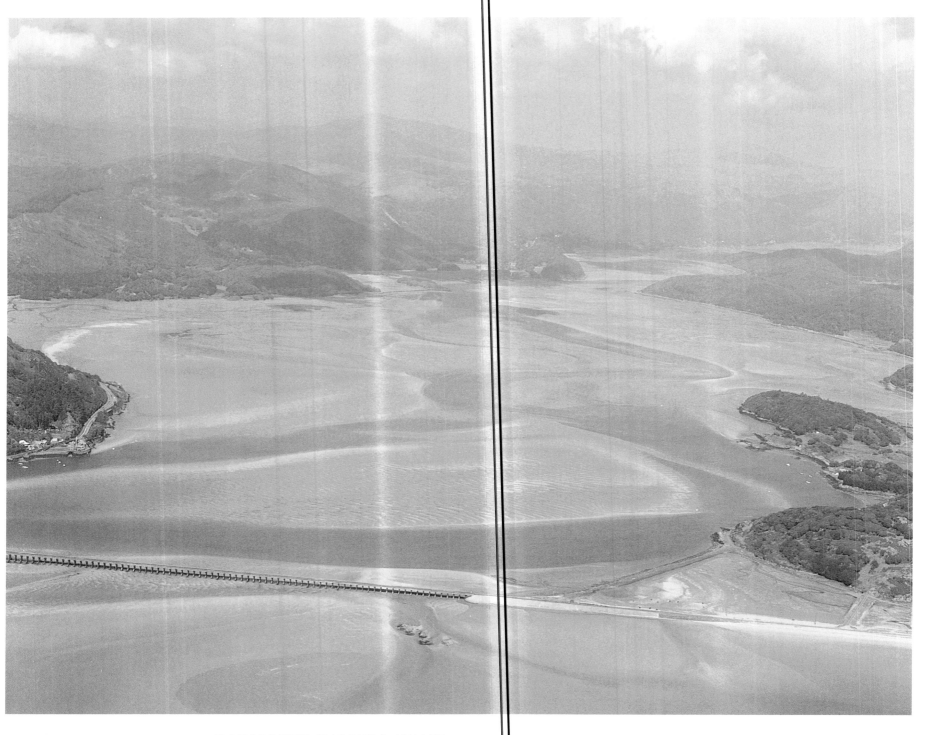

BARMOUTH GWYNEDD WALES Crossing the
Mawddach estuary the 800yd-long railway bridge links the seaside resort town of
Barmouth with the southern shoreline of Barmouth Bay. In the background looms the
massive ridge of Cader Idris—the chair of Idris, the giant after whom this 2,927ft-high
mountain is said to be named.

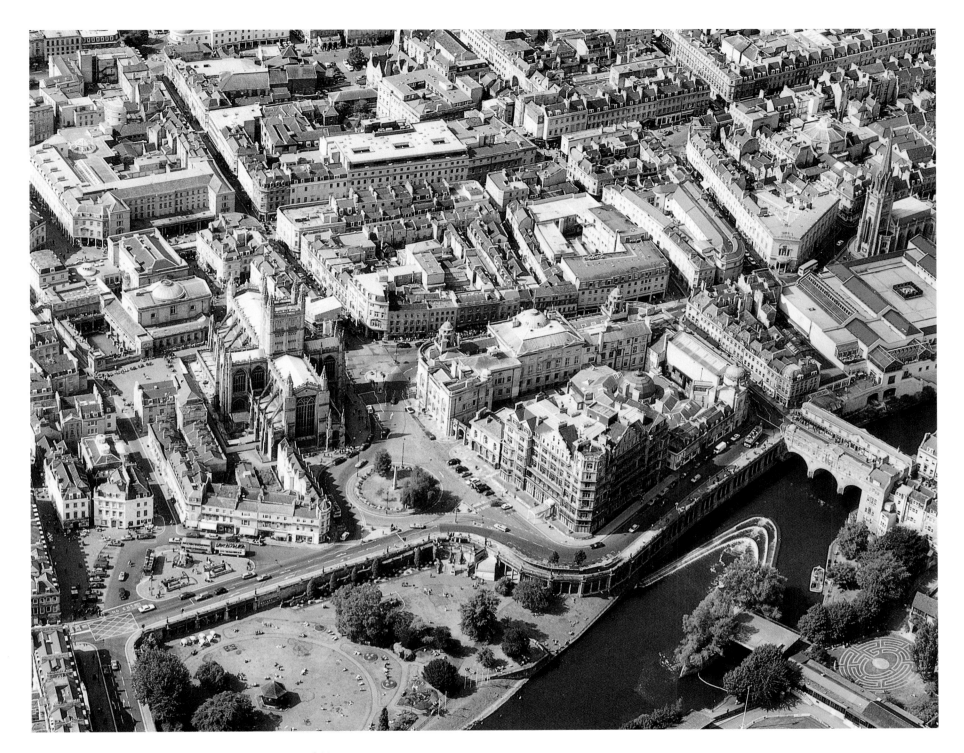

BATH AVON One of the most beautiful cities in England, Bath
was known by the Romans as Aquae Sulis after its hot springs, which can still be seen in
the preserved Roman baths. The city became the centre of fashionable society in the
18th century when many of its buildings were constructed, including the charming
shop-lined Pulteney Bridge across the River Avon at the right of the photo.

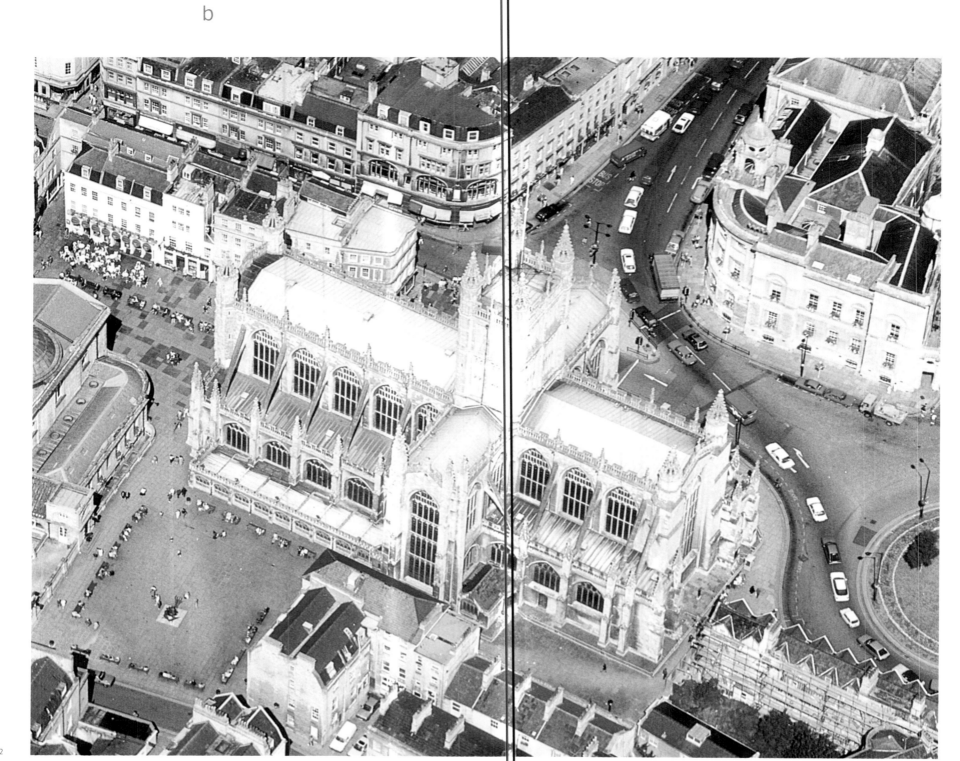

BATH ABBEY AVON Although a church has stood on this site since Saxon times, the present late Gothic building was started in 1499; it is in the Perpendicular style with striking flying buttresses. The Pump Room and the Roman baths are in the buildings across the square known as the Abbey Churchyard.

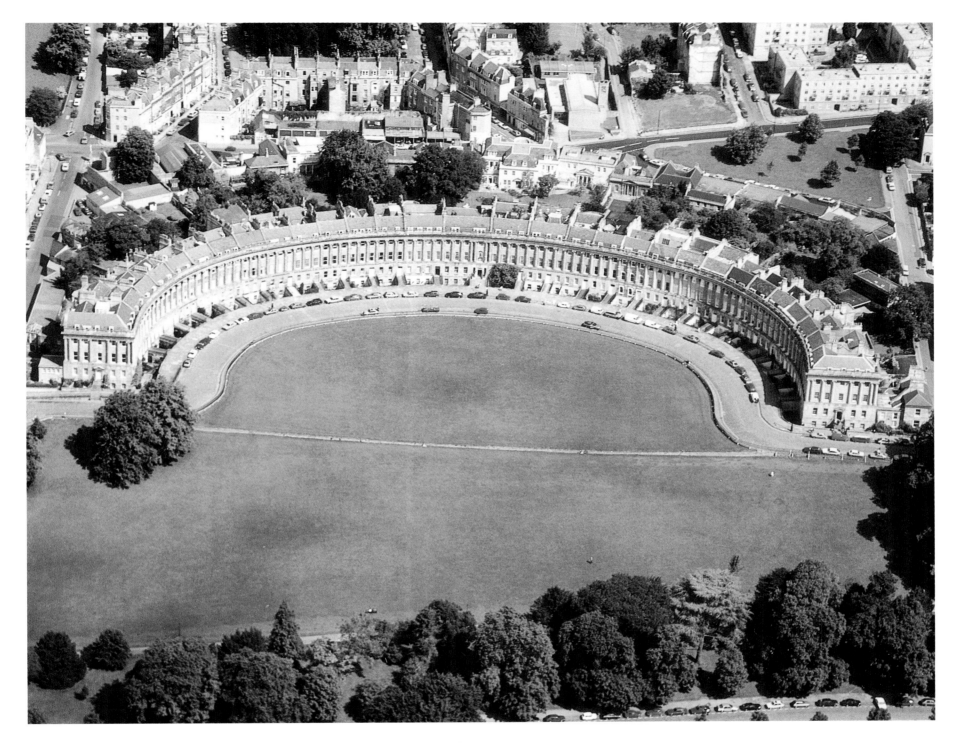

BATH ROYAL CRESCENT AVON Bath is most famous
for its elegant Georgian buildings. The honey-coloured streets, squares and terraces rise
up the hillsides above the River Avon. One of the finest terraces is the Royal Crescent,
built by John Wood (the Younger) between 1767 and 1774.

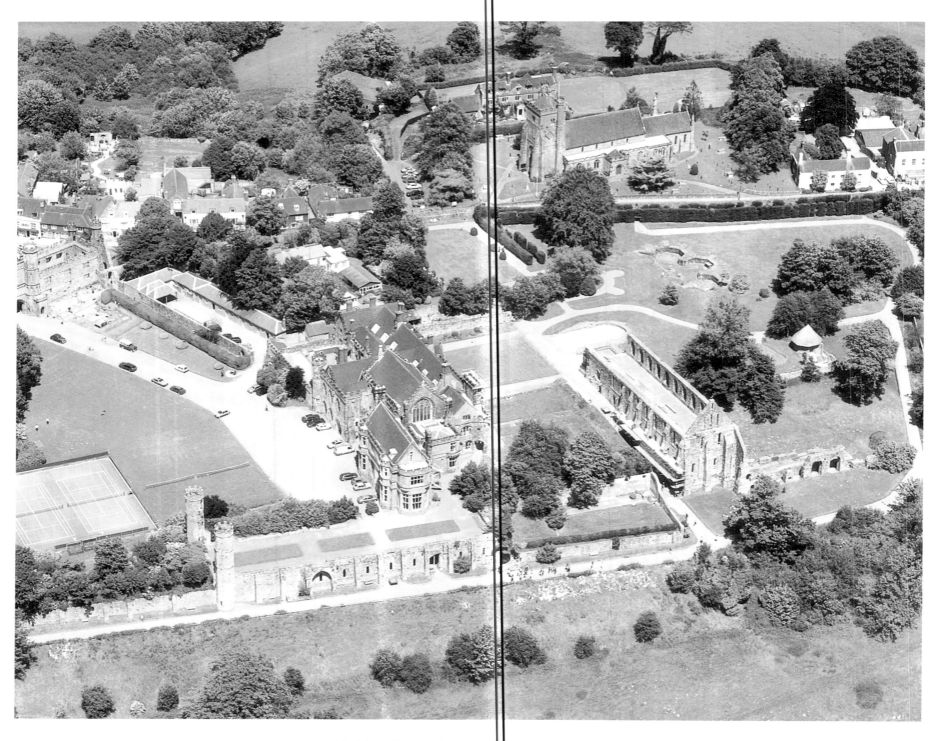

BATTLE ABBEY EAST SUSSEX Built by William the
Conquerer on the site of the Battle of Hastings, the high altar of the abbey church is
said to mark the spot where King Harold died. The abbey fell prey to the depredations
of the Reformation and a school was founded in its grounds. The gateway still domi-
nates the pretty Sussex market town of Battle.

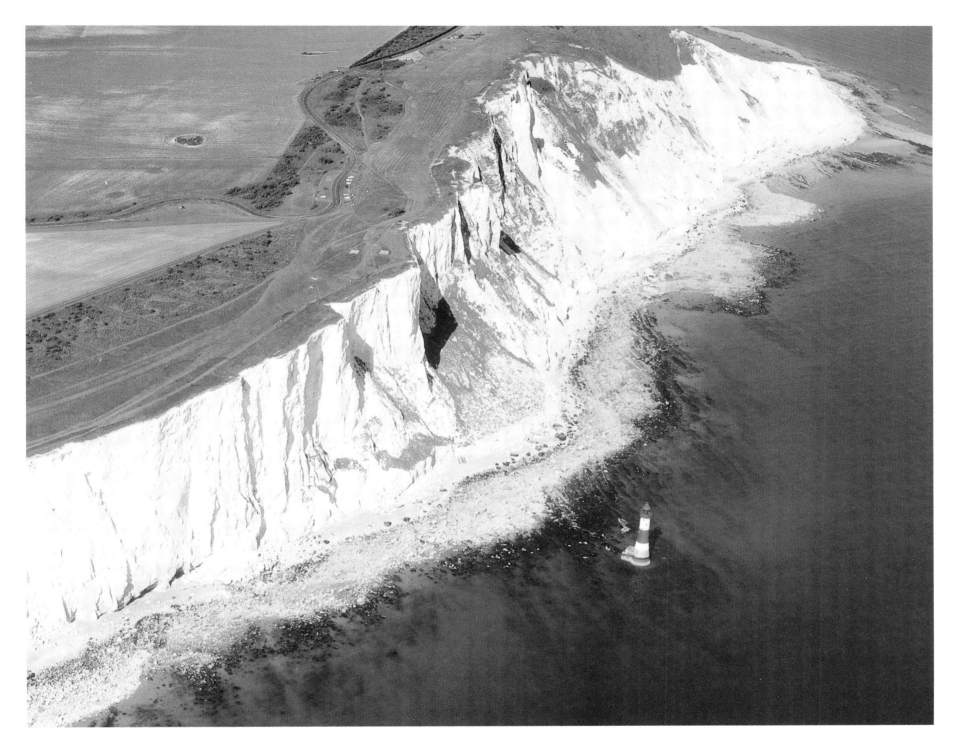

BEACHY HEAD EAST SUSSEX The 575ft-high cliff of
Beachy Head stands where the South Downs abruptly meet the sea on the south coast
of England near Eastbourne. A few miles west, the Seven Sisters cliffs are formed from
the same chalk ridge that eventually continues inland as far as Winchester.

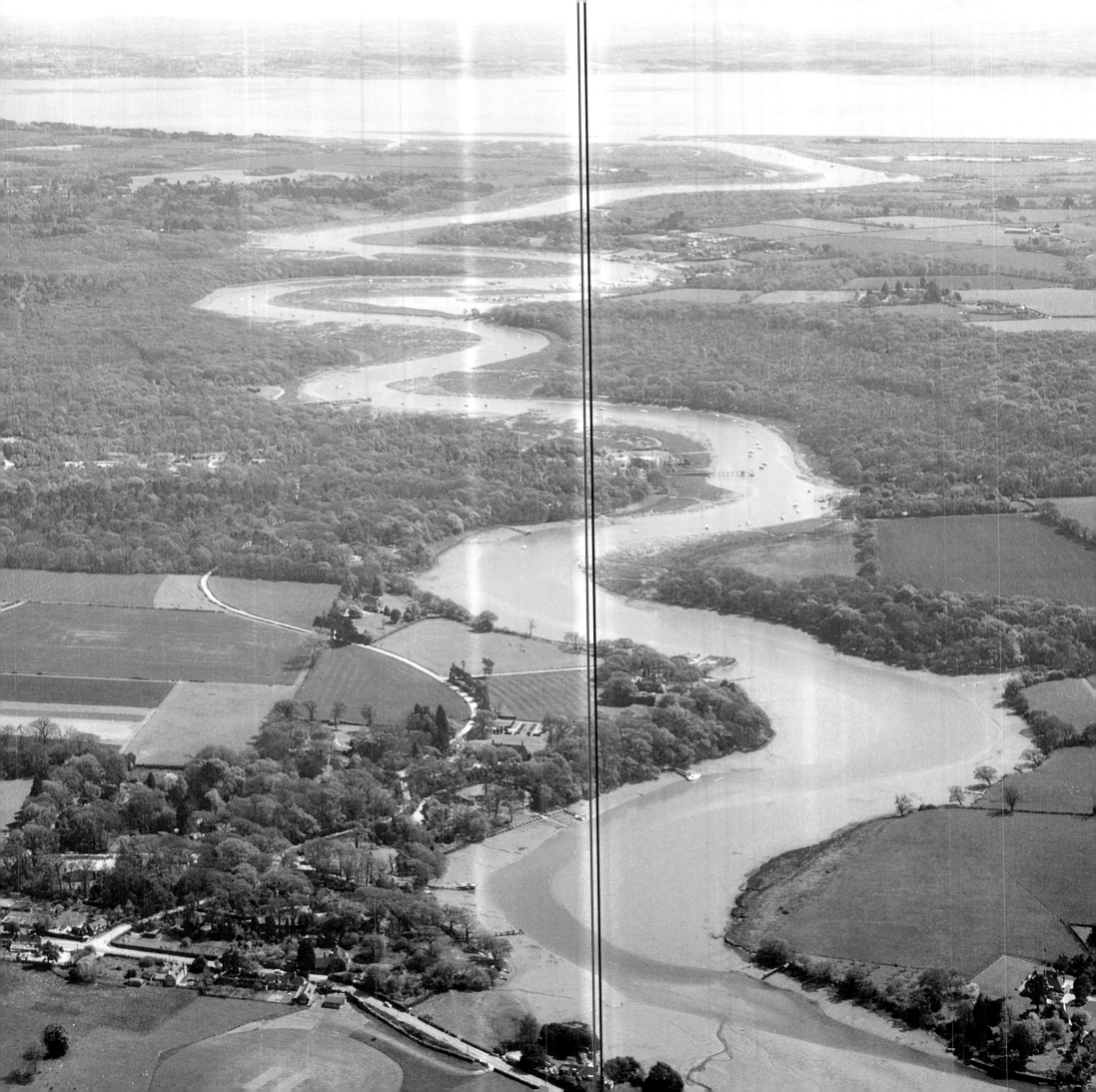

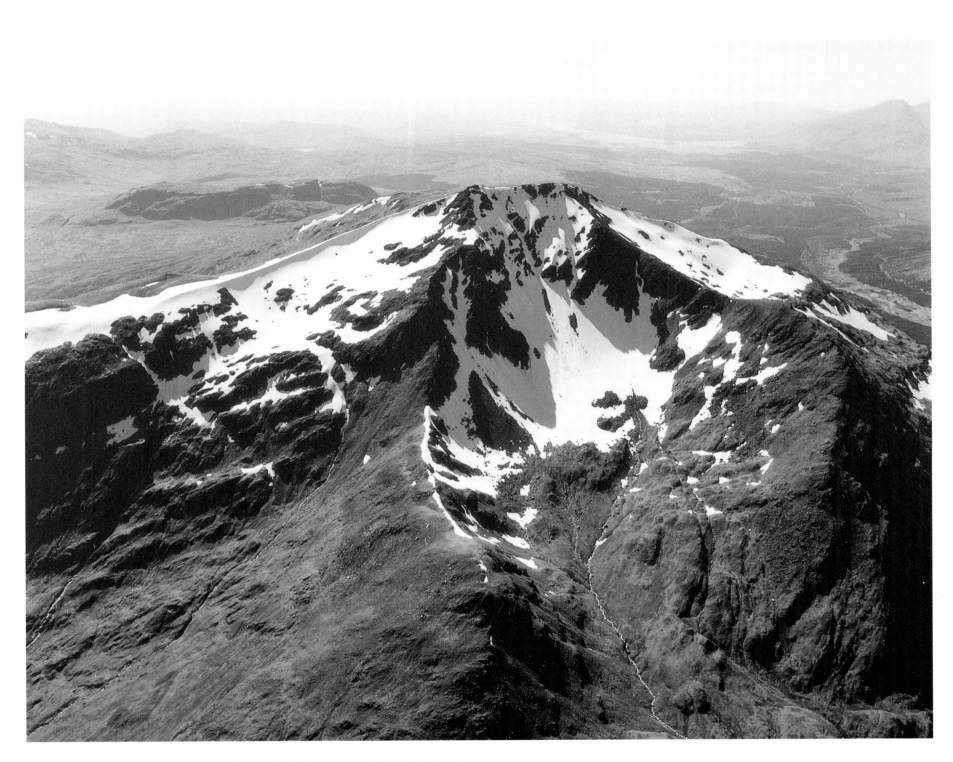

BEAULIEU RIVER HAMPSHIRE The Beaulieu river (left) winds through the New Forest down to the Solent. In the distance lies the Isle of Wight. In the past, oak from the forest was used to build many famous ships at yards along the river including the picturesque hamlet of Buckler's Hard near the coast.

BEN NEVIS HIGHLANDS SCOTLAND Snow-capped throughout the winter, the 4,406ft summit of Ben Nevis is the highest point in the British Isles. On a clear day one can see the coast of Ireland from this peak in the Highlands. The town of Fort William lies at the foot of the mountain.

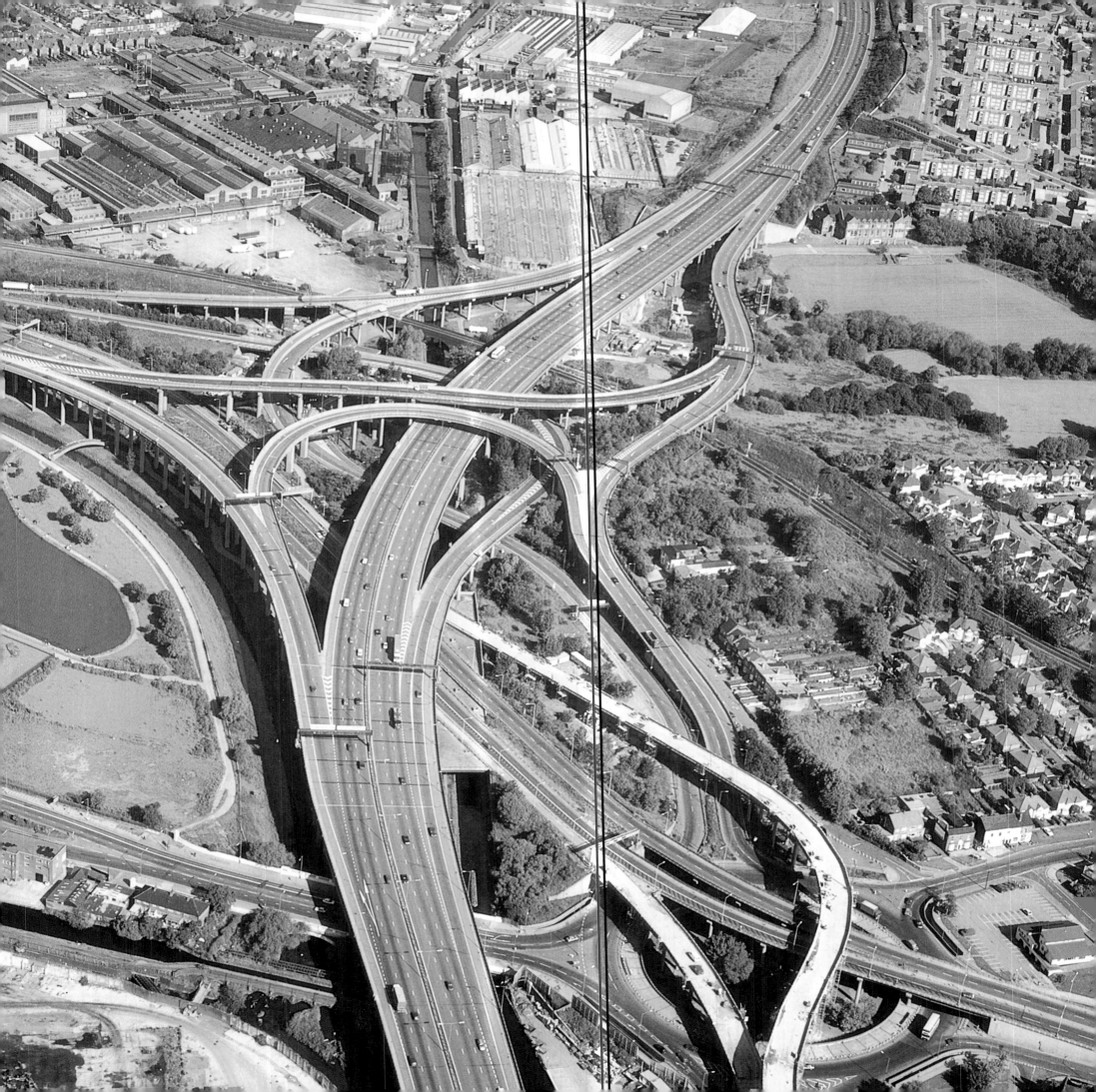

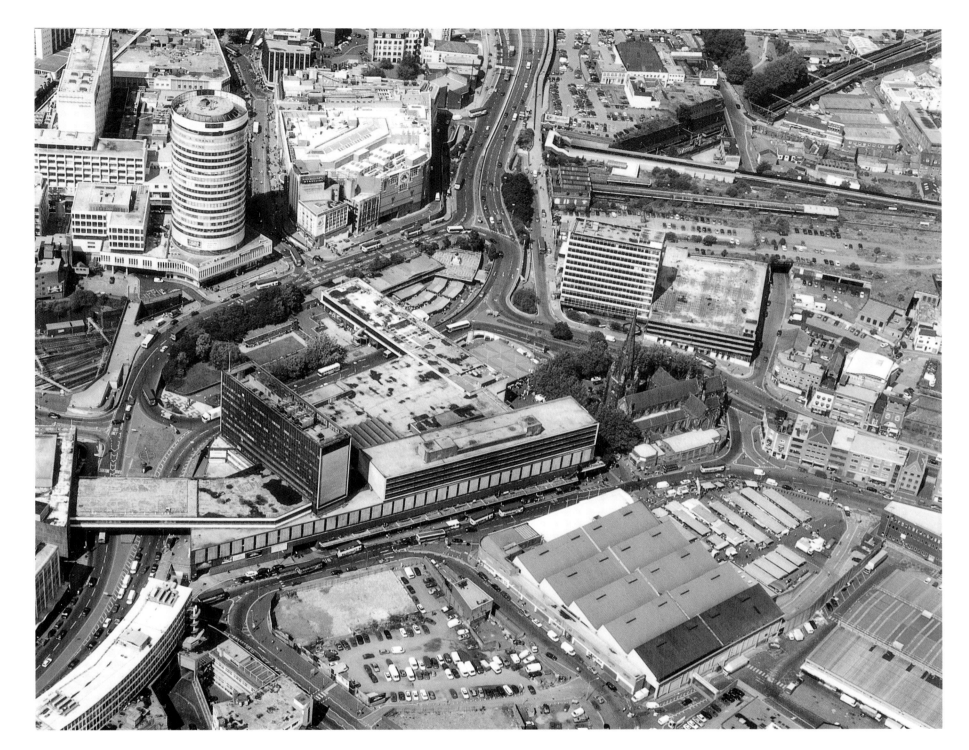

BIRMINGHAM BULLRING WEST MIDLANDS The centre of
Birmingham has changed greatly over recent years. The rebuilding of the 1960s centred
on the Bull Ring shopping centre, New Street railway station and the Rotunda. The
shopping centre has now being demolished and is again being redeveloped.

BIRMINGHAM SPAGHETTI JUNCTION WEST MIDLANDS
The complex curves of the junction (left) bear witness to Birmingham's central position
in England's transport network. Motorways and other major roads, railway lines and
canals all pass through this point, serving the city that grew to be the second largest in
the country during the Industrial Revolution.

b

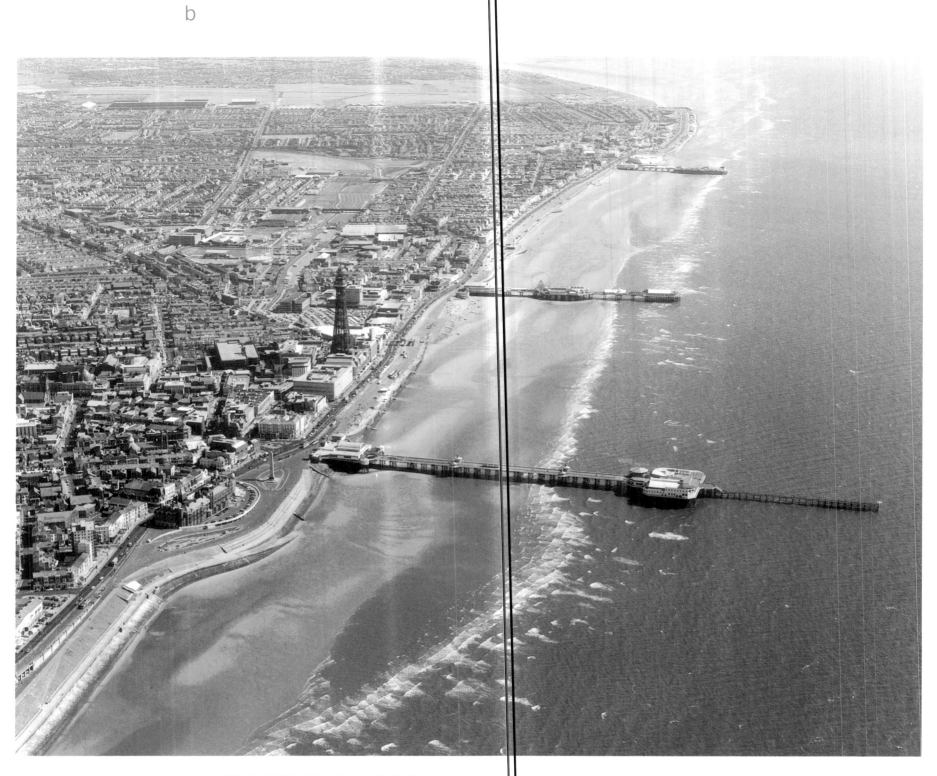

BLACKPOOL LANCASHIRE One of England's most popu-
lar tourist resorts, Blackpool boasts miles of sandy beach, three piers, the Tower, which
was built as a half-size version of France's Eiffel Tower, and numerous other attractions.
The famous illuminations also attract visitors every autumn.

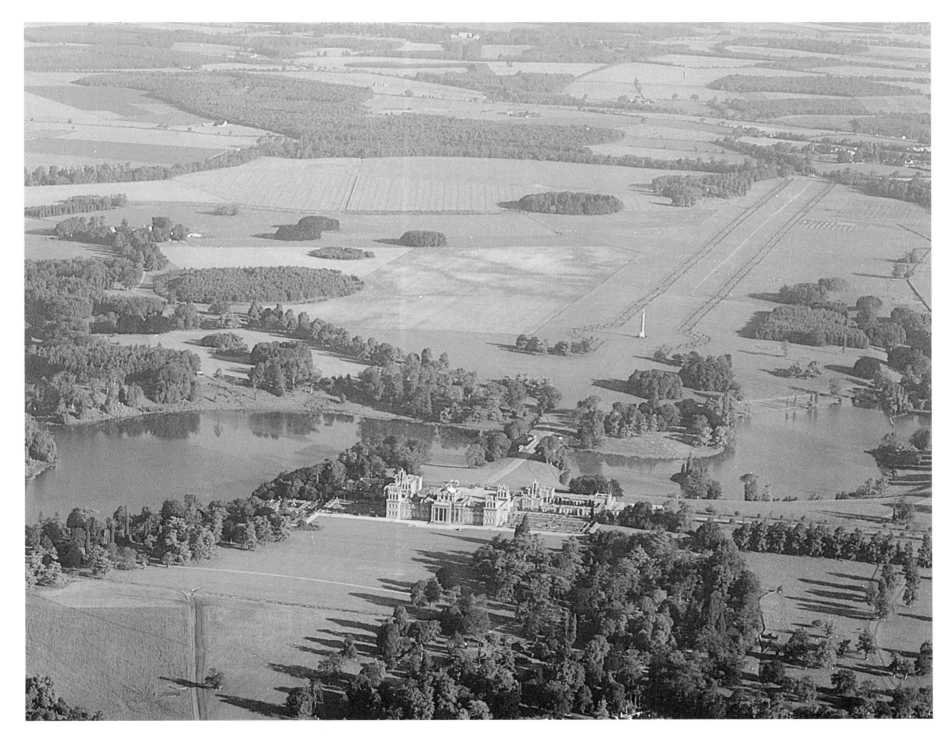

BLENHEIM PALACE OXFORDSHIRE A gift from
Queen Anne to the Duke of Marlborough for his victory over the French at the Battle
of Blenheim, this magnificent baroque palace in its extensive grounds was built by John
Vanbrugh at the beginning of the 18th century. Winston Churchill, a descendant of the
Duke, was born in the palace.

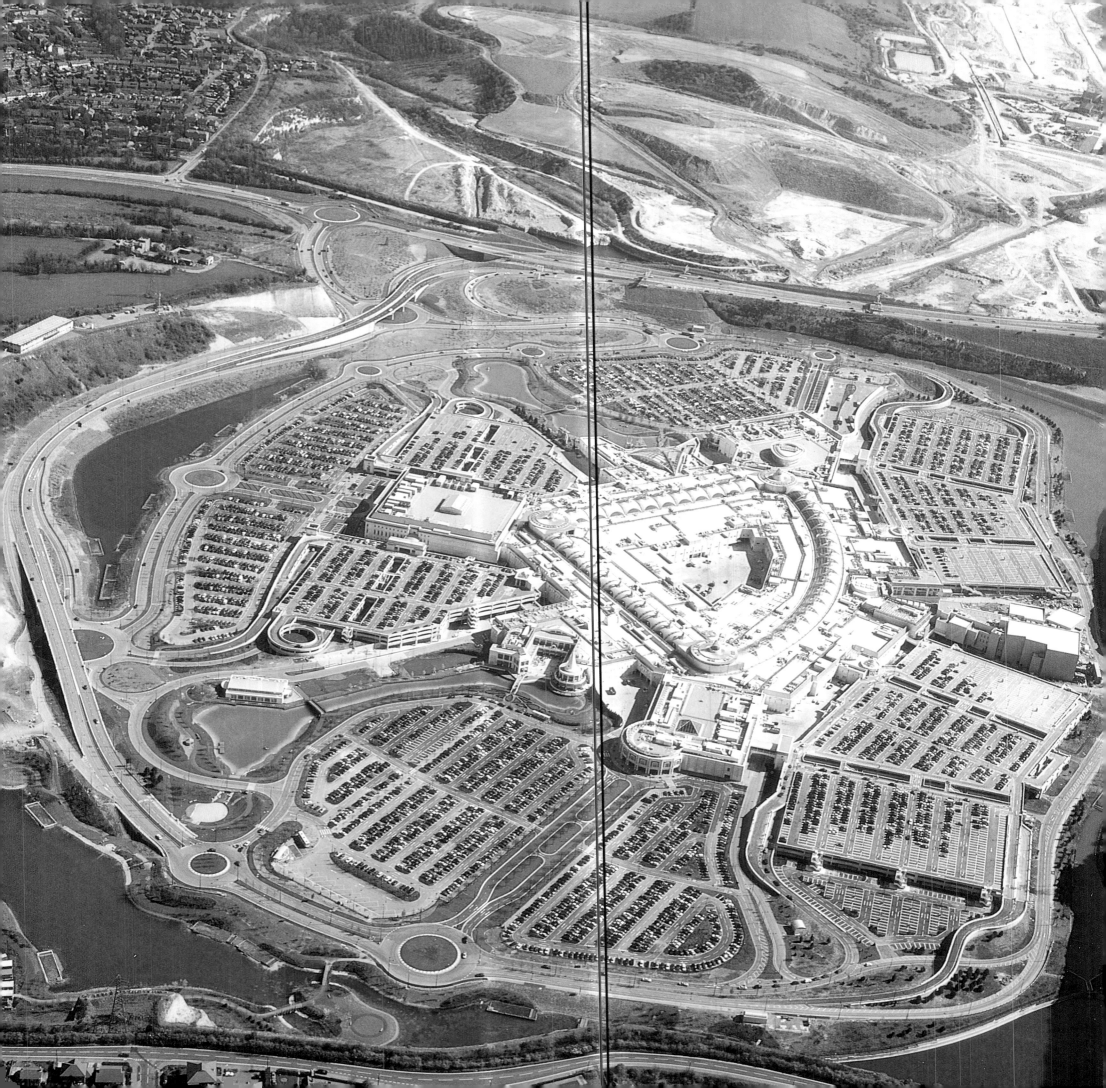

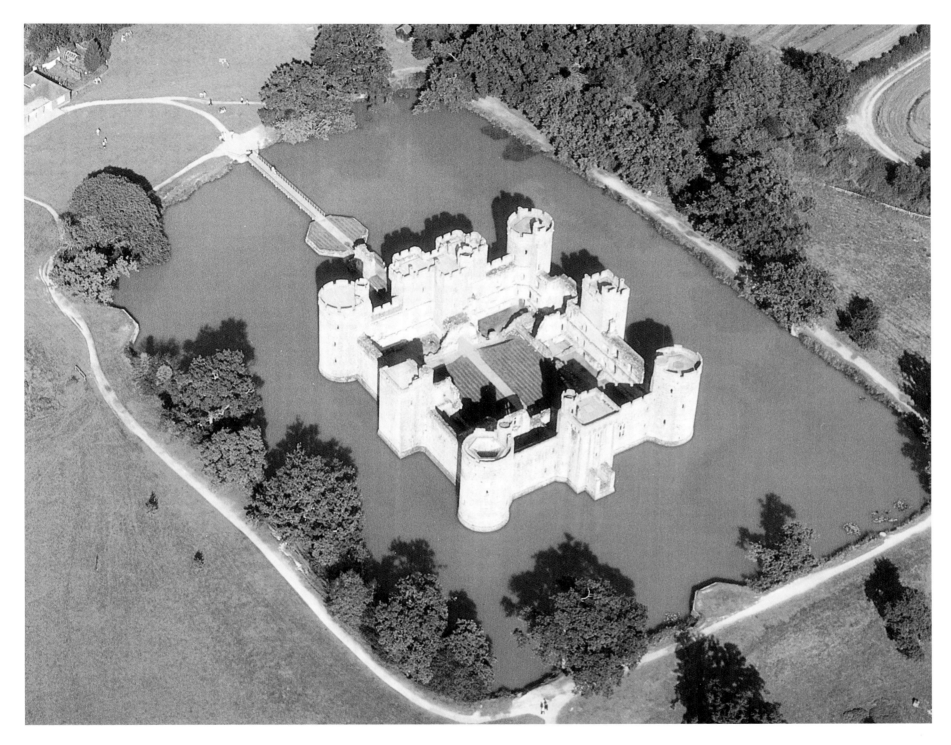

BLUE WATER SWANSCOMBE KENT One of
Britain's newest shopping centres, Blue Water (left) is conveniently situated for the
motorist, downstream of the Dartford Bridge across the Thames. The complex is built
around seven lakes and contains shops, restaurants and a cinema. It was opened on
16 March 1999.

BODIAM CASTLE EAST SUSSEX Surrounded by its
wide moat, Bodiam Castle appears to be a perfectly preserved medieval fortress. In fact,
the castle, built in 1385, was dismantled during the Civil War and only the outer walls
survive.

b

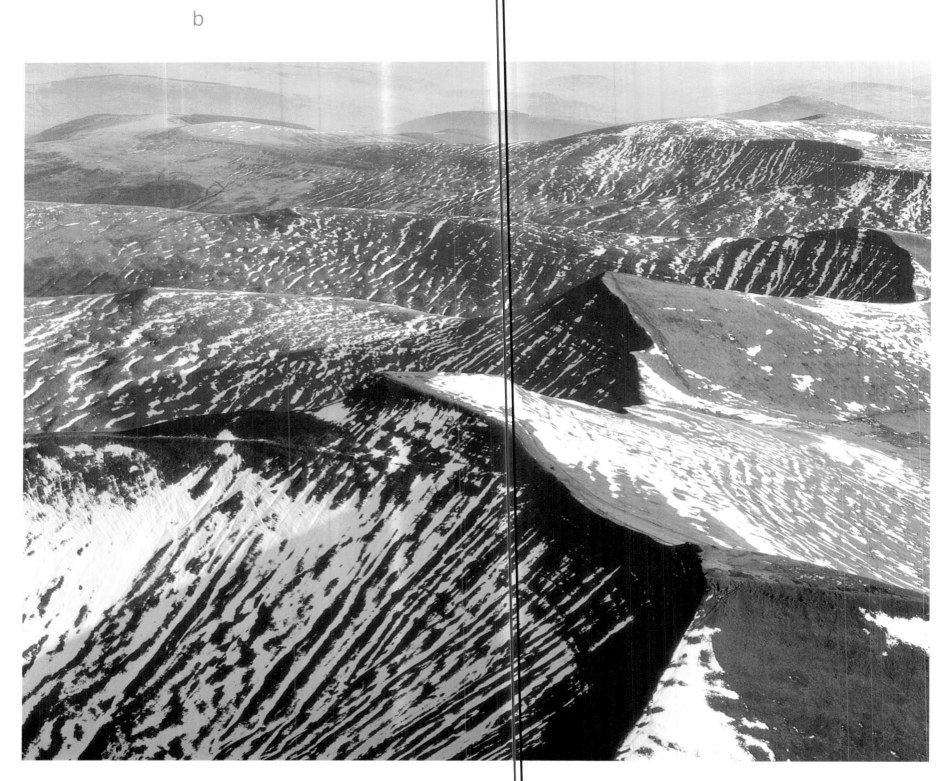

BRECON BEACONS POWYS WALES The Brecon
Beacons are a mountain range in south Wales which form part of the National Park of
the same name. The highest point of these sandstone peaks is Pen y Fan, 2,907ft above
sea level. The park also contains dramatic moors, lakes and forests as well as the Black
Mountains.

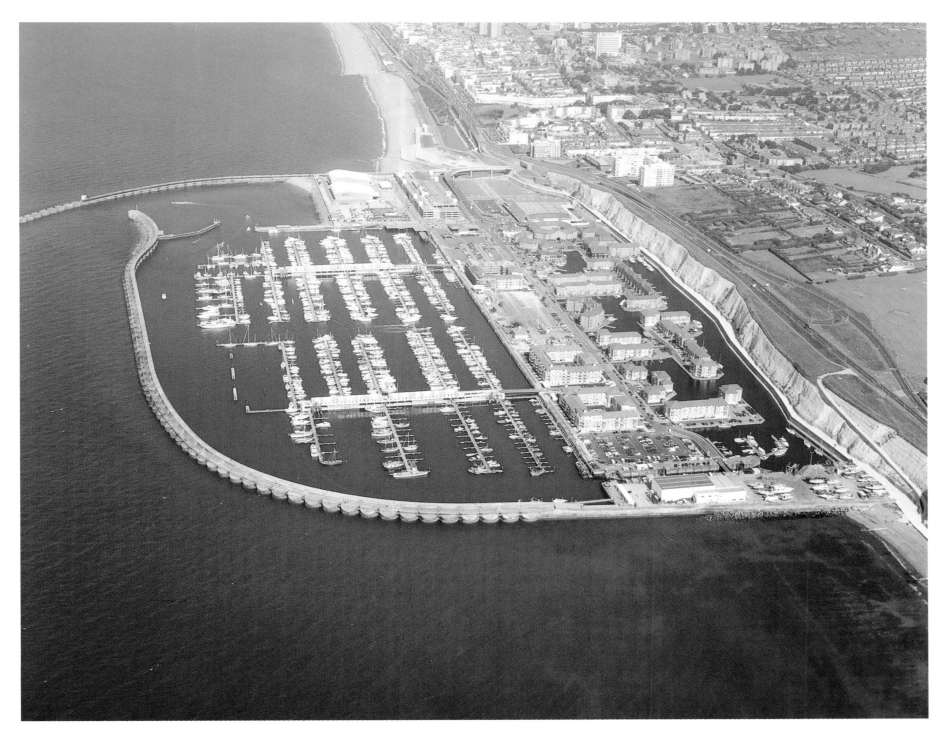

BRIGHTON MARINA EAST SUSSEX A mile along
the beach out of the lively resort of Brighton, just past the designated nudist bathing
beach, lies the Marina at the foot of the cliffs. Completed in the 1990s it provides a
safe haven for boats from the rough waters of the English Channel.

b

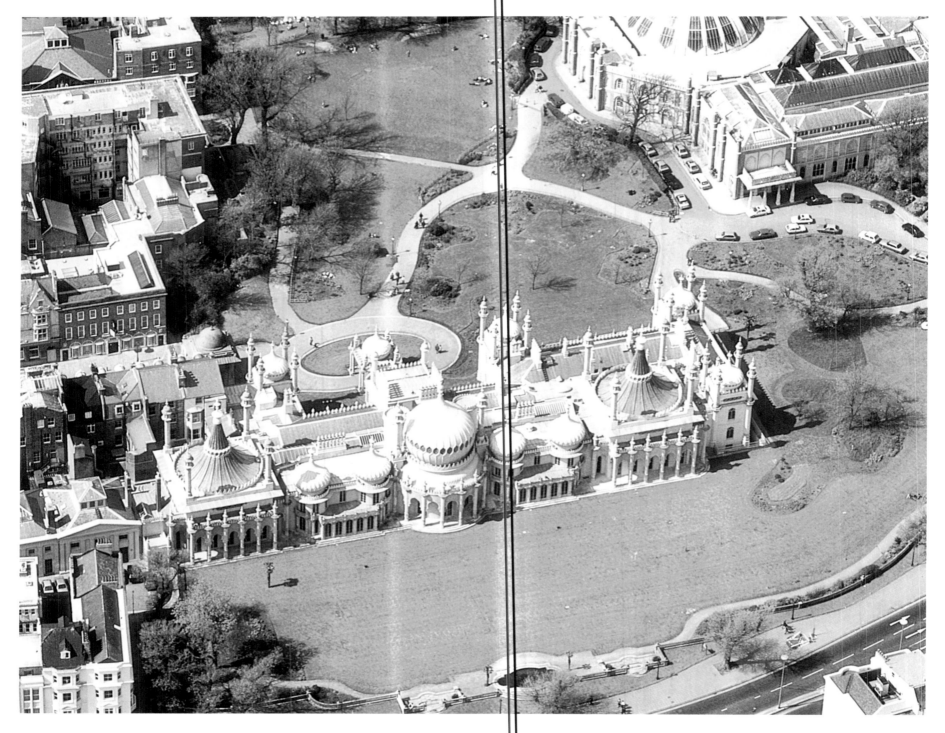

BRIGHTON PAVILION EAST SUSSEX Before fashionable society discovered Brighton in the mid-18th century, this busy town was just a small fishing village. The Prince Regent, later George IV, was fond of the town in which many Regency buildings stand today, none more spectacular than his Royal Pavilion which was built as his summer residence.

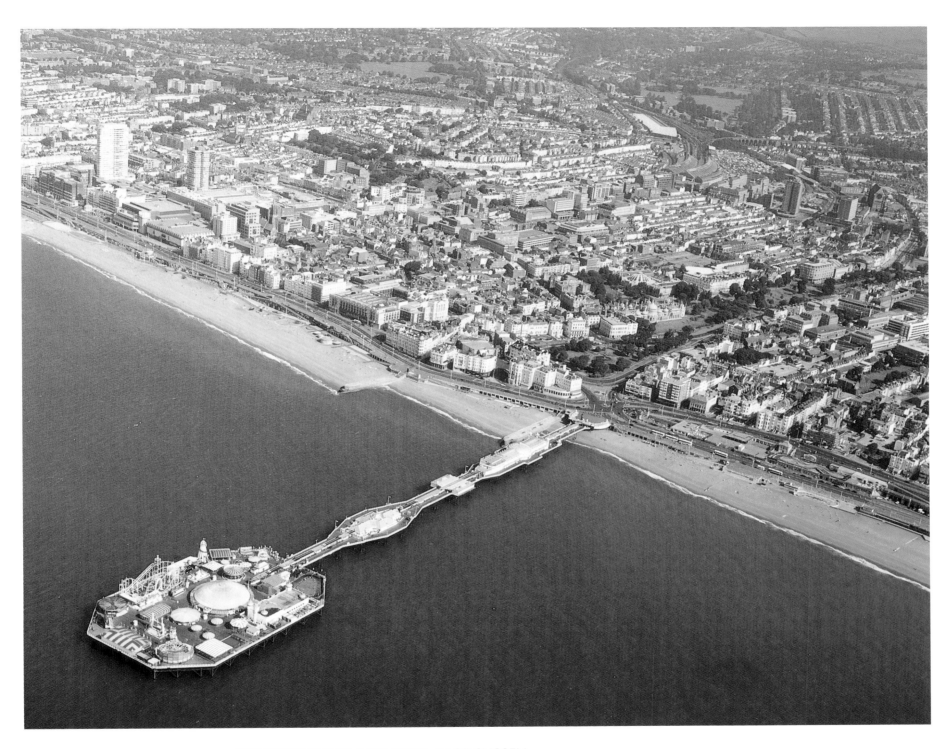

BRIGHTON PALACE PIER EAST SUSSEX Brighton
has two piers: the derelict West Pier and the 1,700ft-long Palace Pier built in the 1890s,
shown here. The Palace Pier today offers the visitor many attractions, including a mini-
funfair, although at one time the pier also served as a terminus for cross-Channel
steamers.

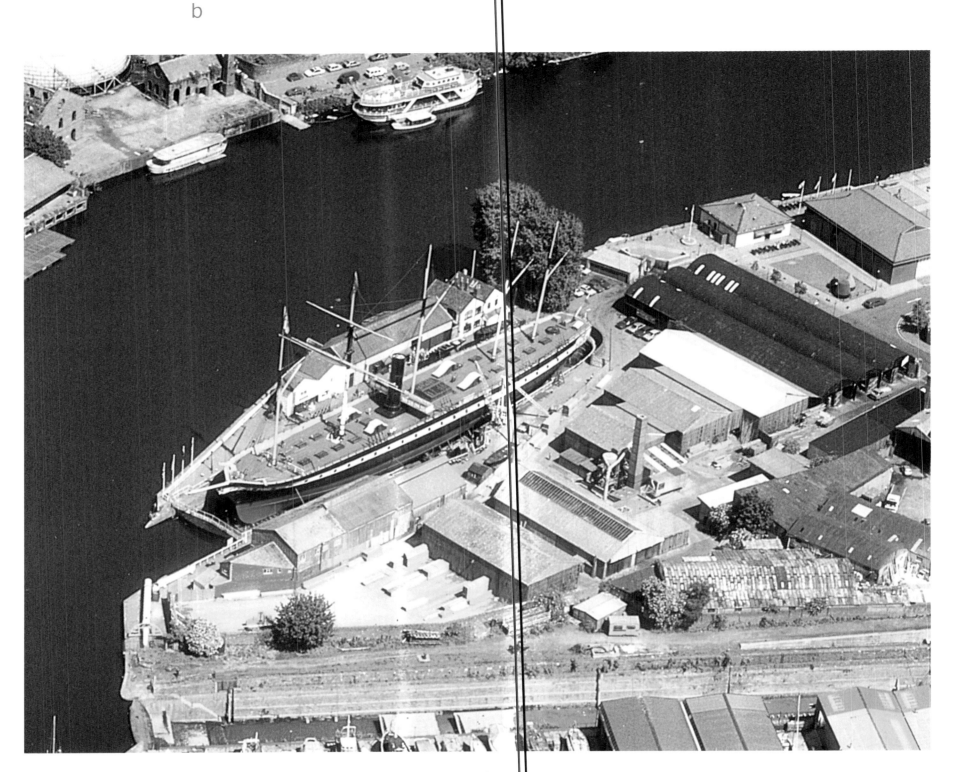

b

BRISTOL SS *GREAT BRITAIN* AVON Brunel's iron-
hulled steamship SS *Great Britain* lies in Bristol's Great Western Dock, where she was
built. The first ocean-going ship to use screw propulsion when she crossed the Atlantic
on her maiden voyage in 1845, she later lay wrecked in the Falkland Islands until being
towed back to Bristol in 1970 and restored.

BRISTOL FLOATING HARBOUR AVON The
wealth of Bristol historically derived from its position as a port. Most of the shipping
has now moved further down river but the wharves and warehouses of the old port
area, known as the Floating Harbour (right), have been substantially redeveloped.

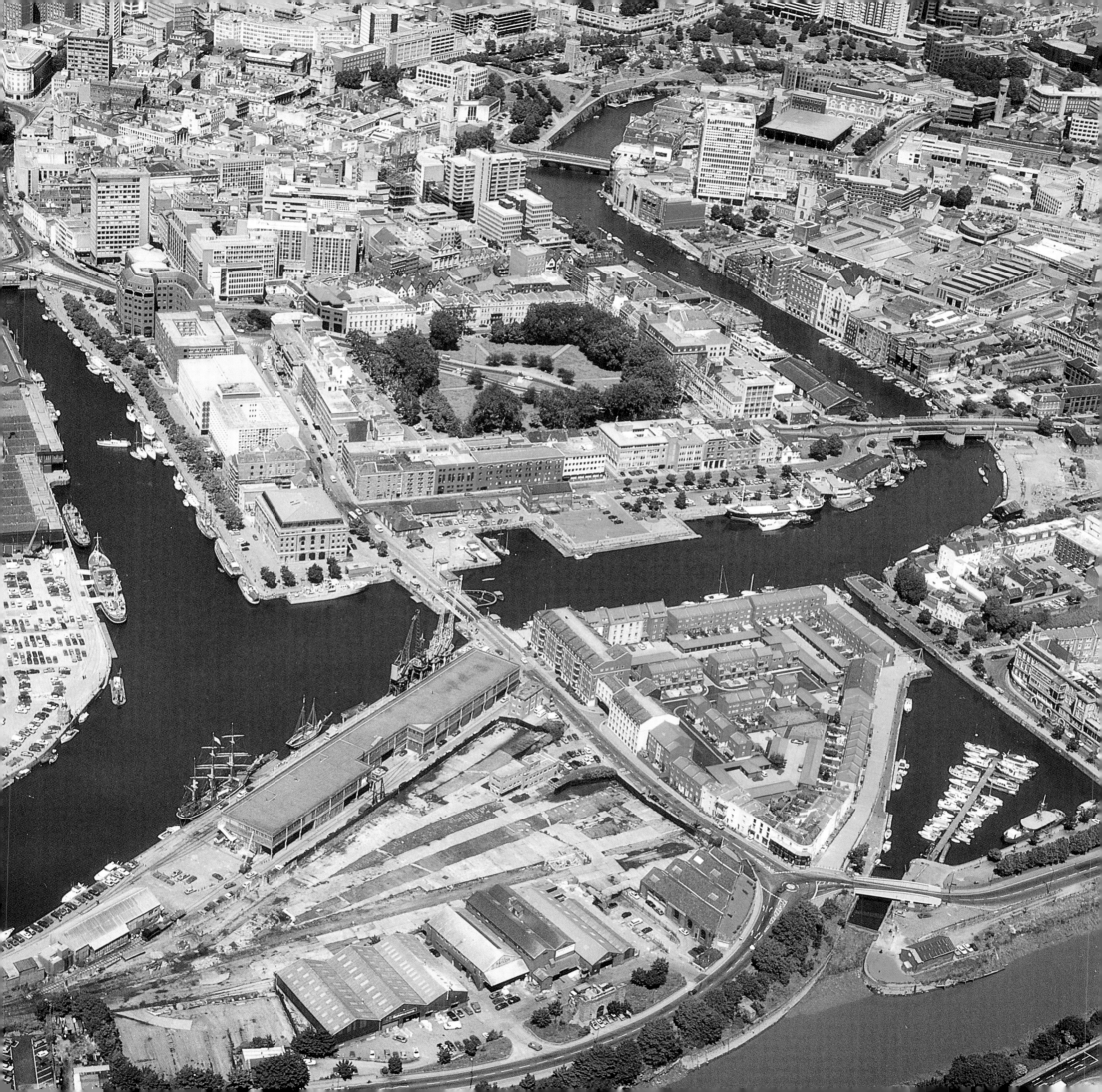

b

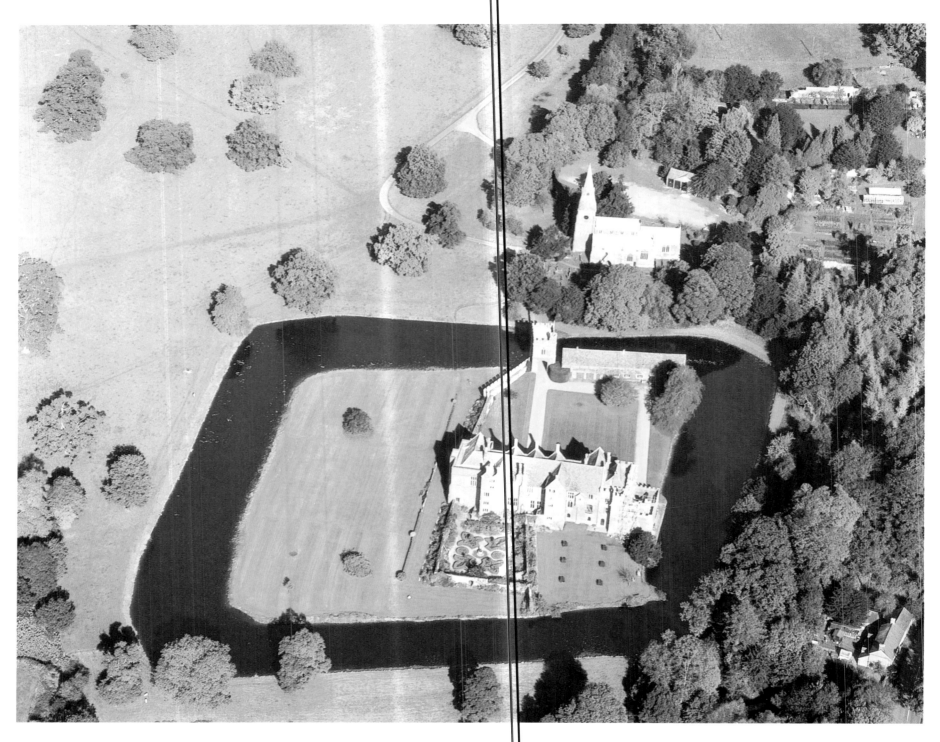

BROUGHTON CASTLE OXFORDSHIRE Standing on
its island in a large square moat, Broughton Castle is the home of the descendents of
the First Lord Saye and Sele. Much of the original 14th-century manor house survives,
including the gatehouse, although the house was remodelled during the 16th century.
Many of the family are buried in the nearby St Mary's Church.

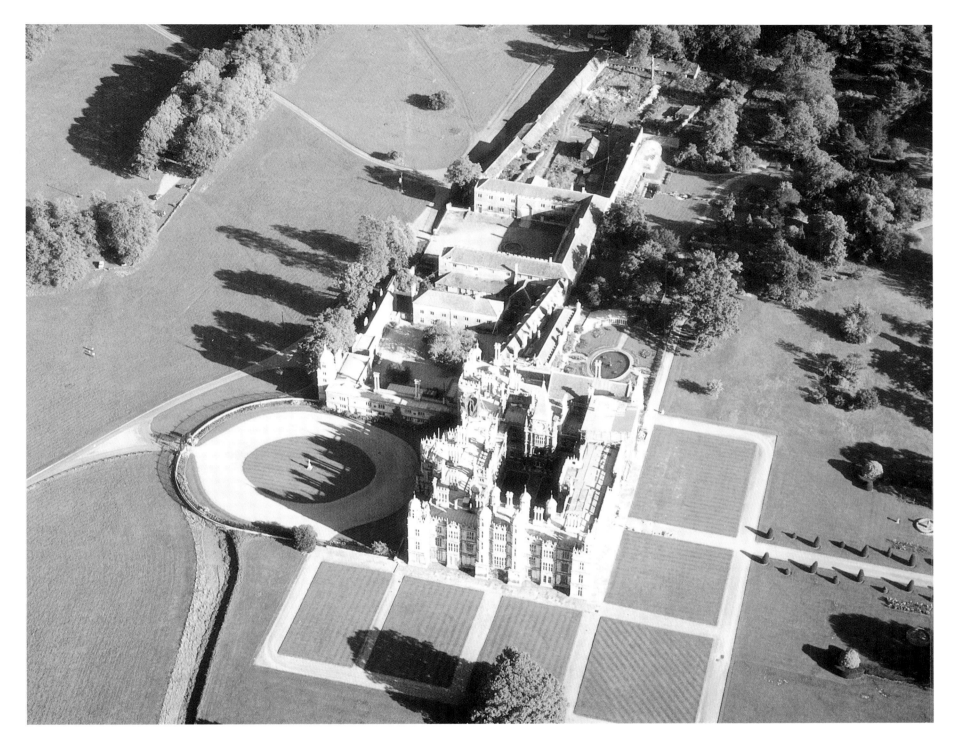

BURGHLEY HOUSE CAMBRIDGESHIRE Burghley
House was built by Queen Elizabeth I's Lord Treasurer Sir William Cecil and remains in
the possession of the family today. Completed in 1587, this superb example of
Elizabethan architecture, lying in its extensive deer park landscaped by 'Capability'
Brown in the 18th century, also contains a large collection of art treasures.

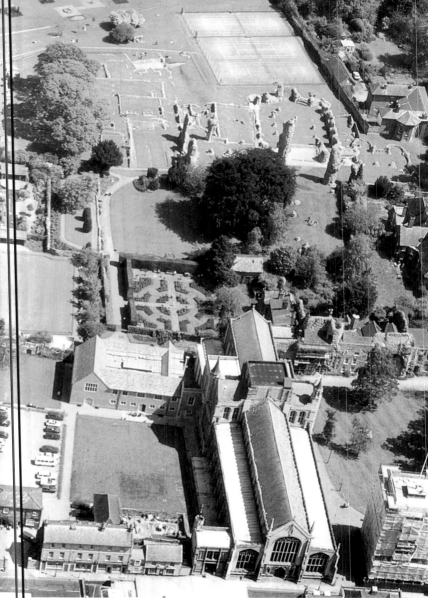

BURY ST EDMUNDS SUFFOLK Bury St Edmunds grew up around its abbey which contained the shrine to the East Anglian King Edmund, killed by the Vikings in AD869. One of the richest abbeys in England, it fell into ruin after Henry VIII dissolved the monasteries. The gatehouses still stand, as does the 15th century Cathedral of St James.

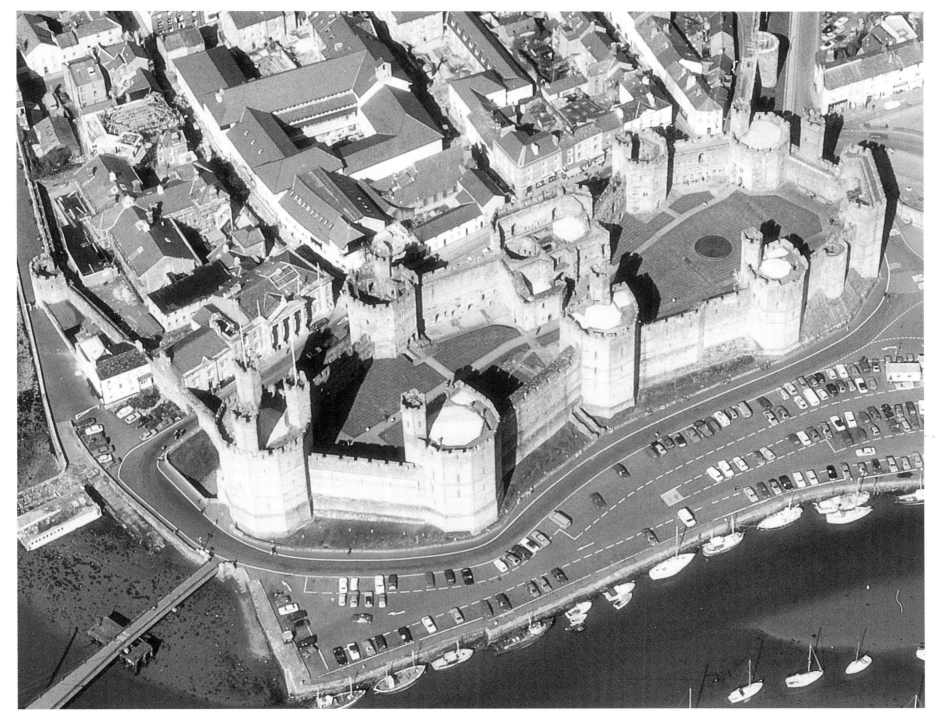

53

CAERNARFON CASTLE GWYNEDD WALES

Guarding the entrance to the River Seiont, the north Wales town of Caernarfon is
dominated by its castle, whose polygonal towers and banded masonry are unique in
Britain. Construction was started by King Edward I in 1283 and the royal connection has
continued to this century with the investiture of Prince Charles as the Prince of Wales in
1969.

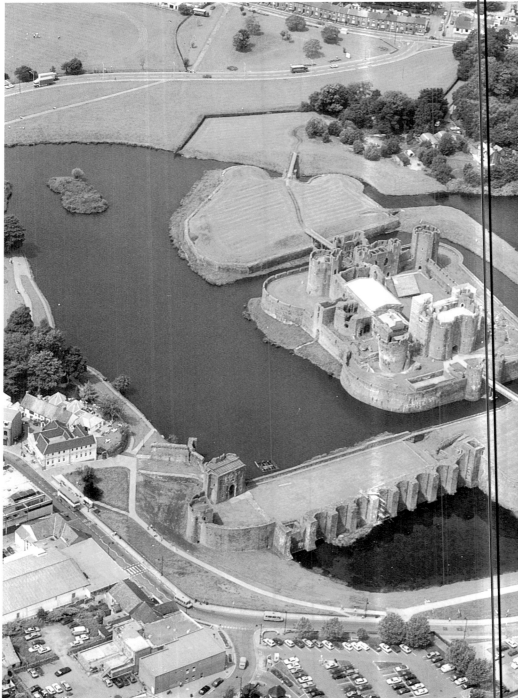
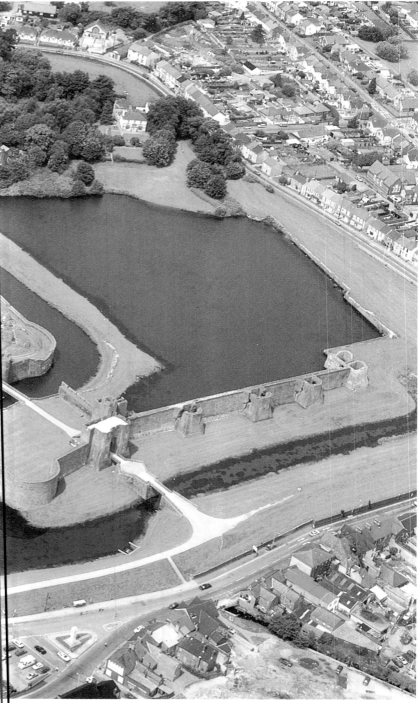

CAERPHILLY CASTLE CAERPHILLY WALES The largest
castle in Wales, this late 13th century fortification built by Gilbert de Clare sits within a
complex of lakes and elaborate defences. The castle itself, formed of two concentric
wards, is completely surrounded by the Inner Moat. This in turn is protected by the
Great Gatehouse which is reached by a drawbridge across the Outer Moat.

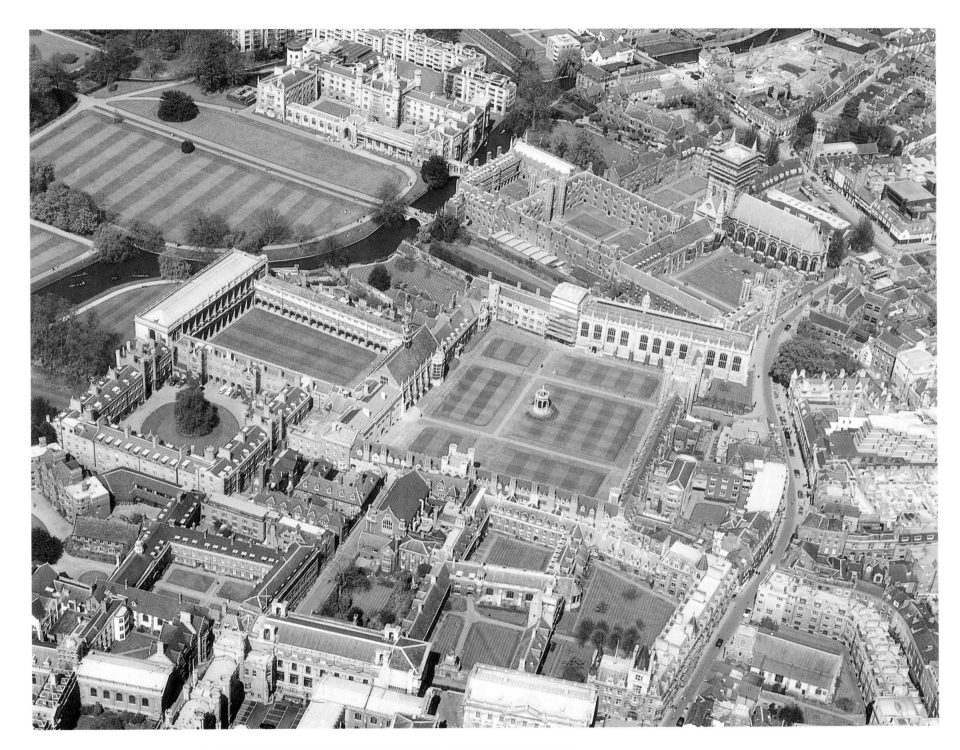

CAMBRIDGE TRINITY COLLEGE CAMBRIDGESHIRE

Cambridge is famous for its university, founded in the 13th century. The university is
comprised of a number of colleges, the largest being Trinity, established by Henry VIII in
1546. In the centre of this photograph can be seen the Great Court of Trinity College
laid out in 1600, and surrounding are other college and university buildings, including
St John's to the north.

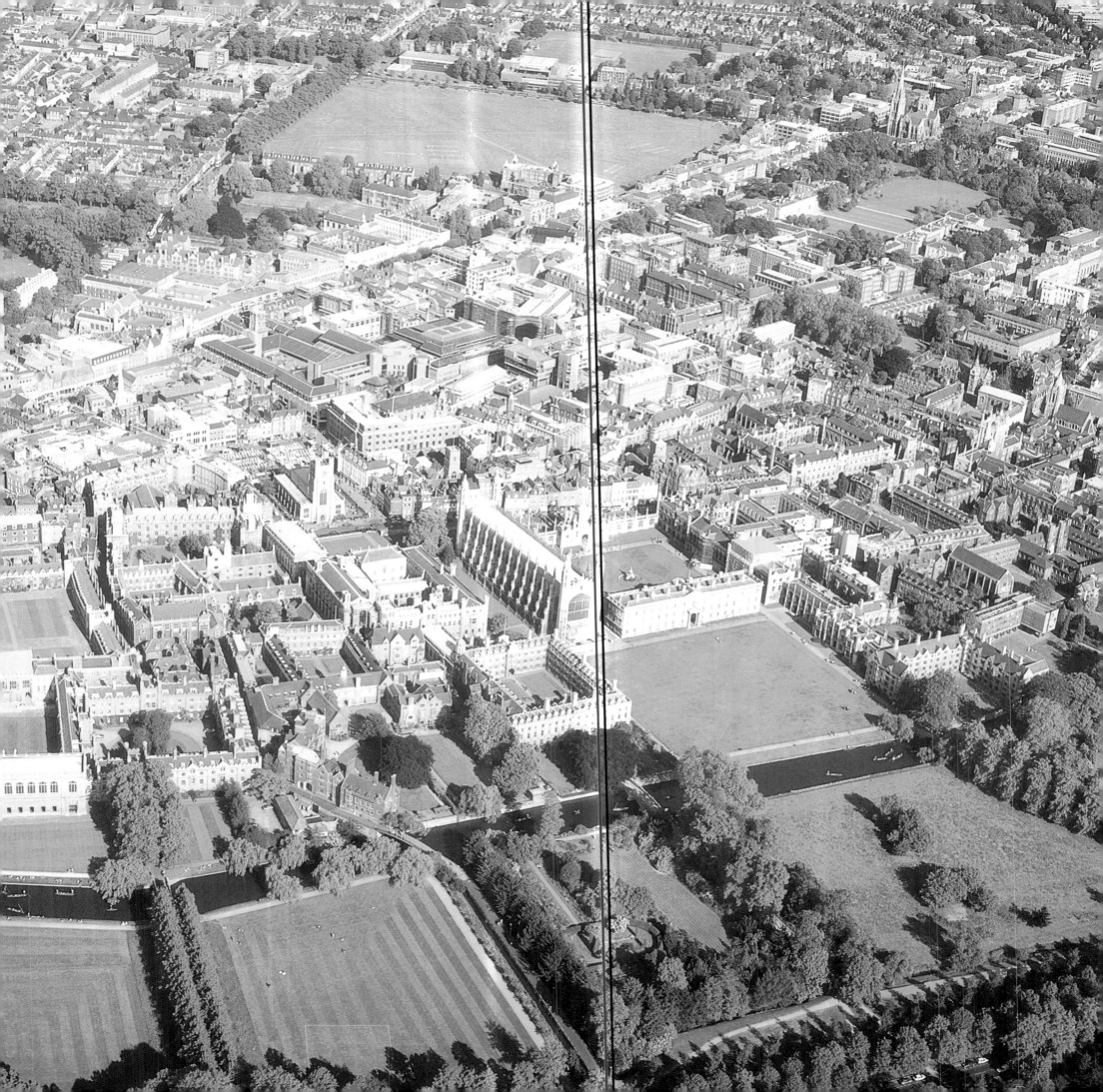

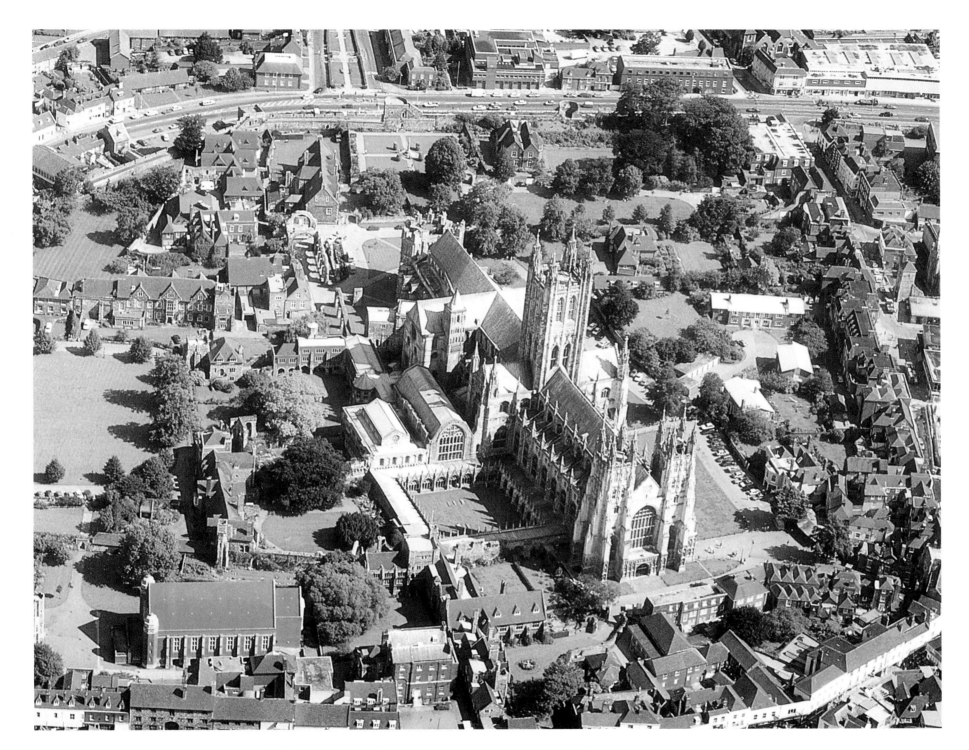

CAMBRIDGE **KING'S COLLEGE** CAMBRIDGESHIRE

The River Cam winds along behind many of the older Cambridge colleges, an area known as the Backs, including (from right to left in this photograph) Queens, King's, Clare, Trinity Hall, Trinity and St John's. The soaring Perpendicular chapel of King's College stands out, a beautiful example of late Gothic architecture.

CANTERBURY **CATHEDRAL** KENT The seat of the

Archbishop of Canterbury, the earliest parts of the cathedral (left) date from the 11th century. Until the Reformation, many pilgrims made the journey to the shrine of Thomas Becket, the Archbishop killed in the cathedral on the orders of Henry II.

C

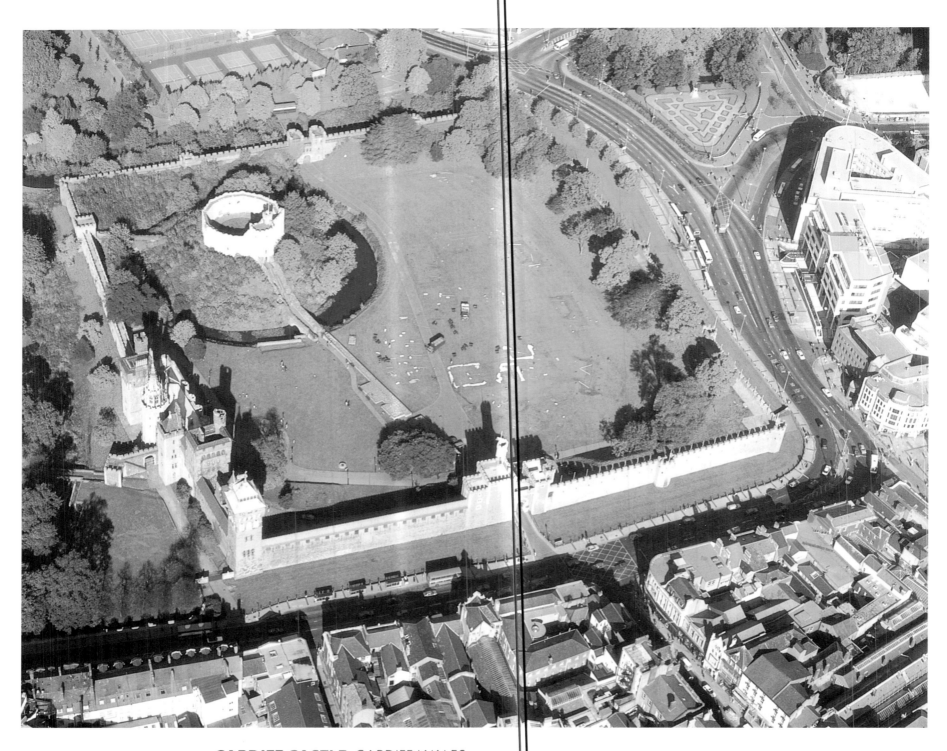

CARDIFF CASTLE CARDIFF WALES The capital of Wales,
Cardiff is founded on a Roman fort on which a Norman castle was subsequently built.
The castle has been added to over the years, culminating in redevelopment, including
redesigning the interior in fantastic style, by the Victorian architect, William Burges, for
the 3rd Marquess of Bute.

CARISBROOKE CASTLE ISLE OF WIGHT Situated
on a hill in the heart of the Isle of Wight, Carisbrooke Castle was originally a Roman
fort. The round Norman keep still stands on its motte but the rest of the castle dates
mostly from the 13th century. King Charles I was imprisoned here before his trial and
execution in London.

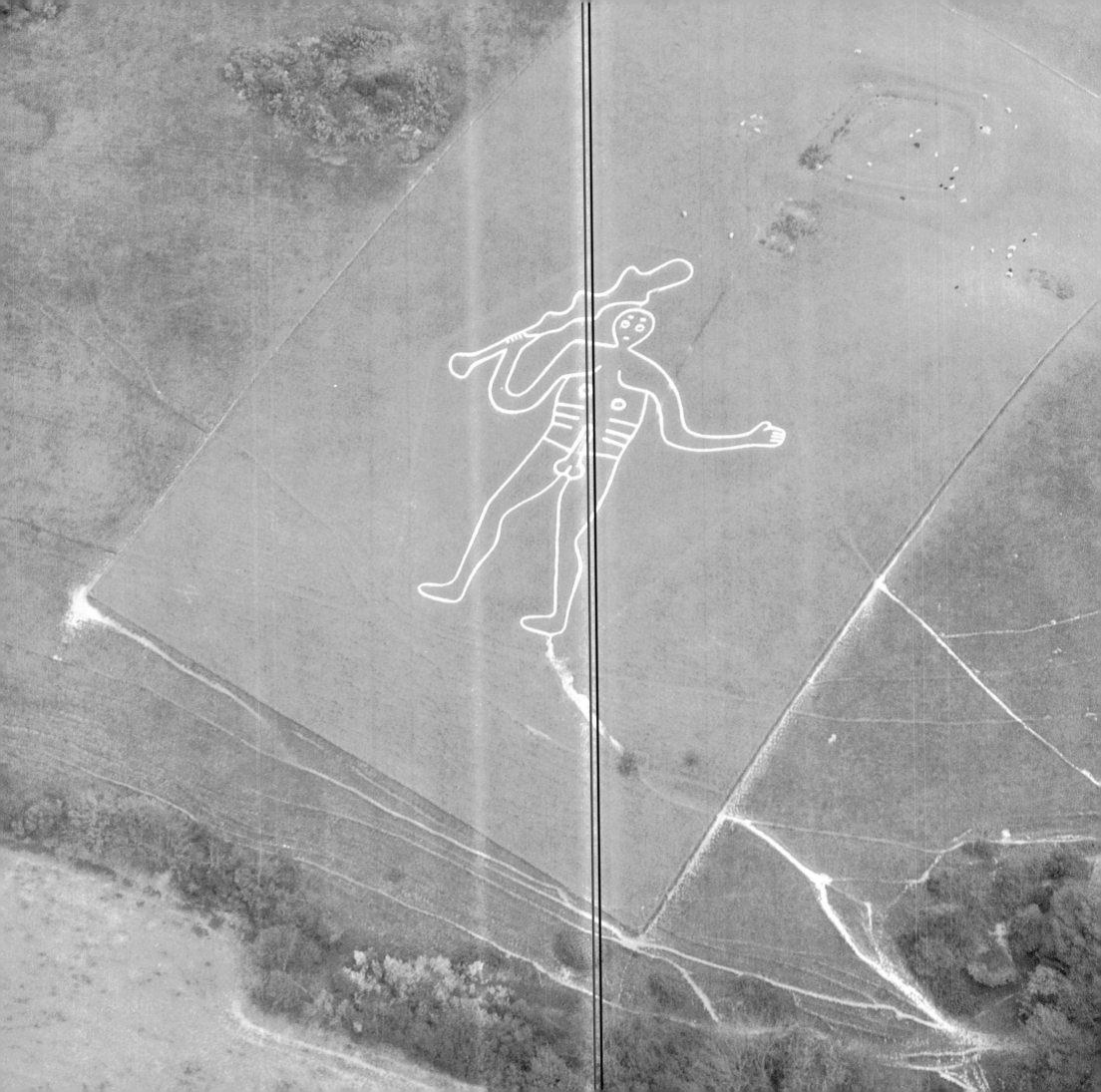

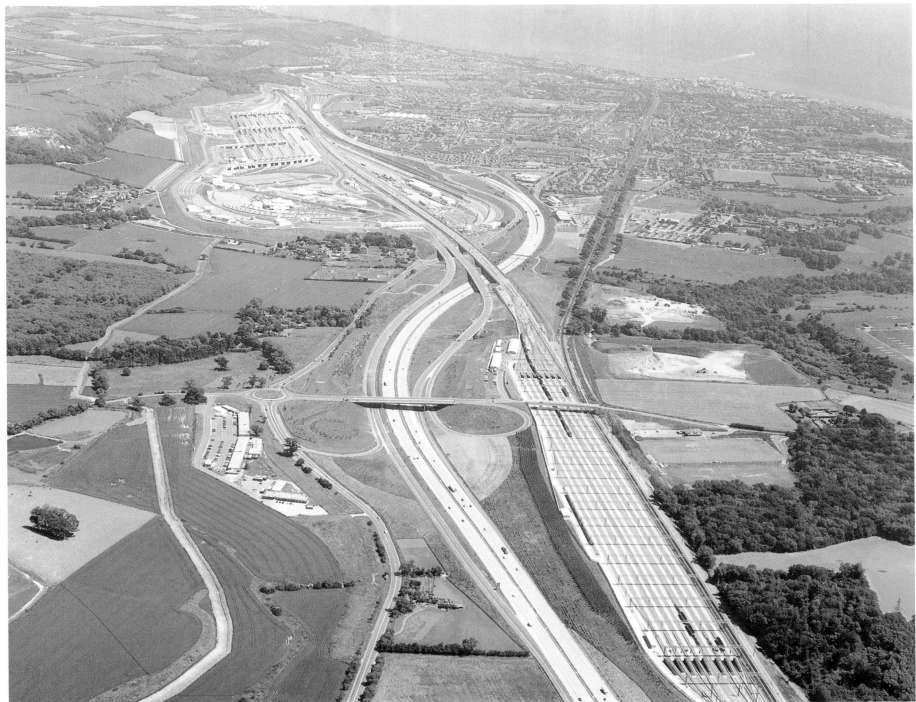

CERNE ABBAS GIANT DORSET Dating back to the
3rd century AD, it is surprising that such an obviously pagan image should withstand
the Christian period intact. The giant (left) is 182ft long and not quite the tallest man
in England (that at Wilmington is taller but not as rude!).

CHANNEL TUNNEL FOLKSTONE KENT After more
than 200 years of plans Britain was finally connected to mainland Europe when the
Channel Tunnel was completed in 1994. This rail-only link tunnels under the English
Channel for 31 miles and emerges in France at Coquelles near Calais.

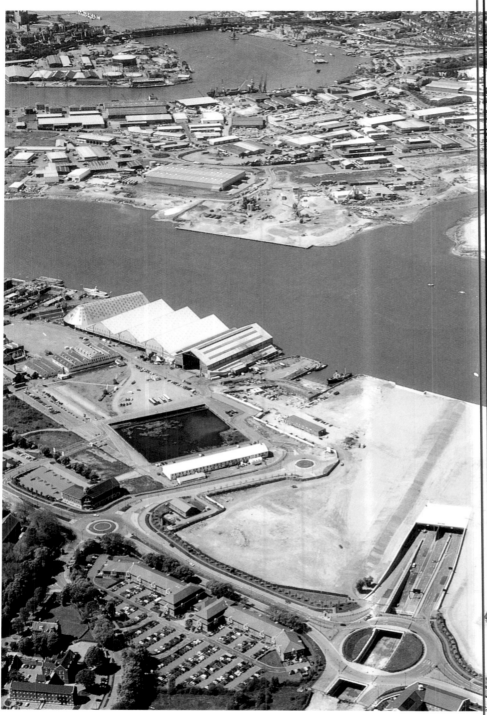

CHATHAM DOCKS KENT Lying on the mouth of the
River Medway in Kent, Chatham has been associated with the navy since Henry VIII. The
historic Royal Naval Dockyard, which built, among other ships, Nelson's flagship at the
Battle of Trafalgar, HMS *Victory*, is now empty after the Royal Navy left the site in 1984.

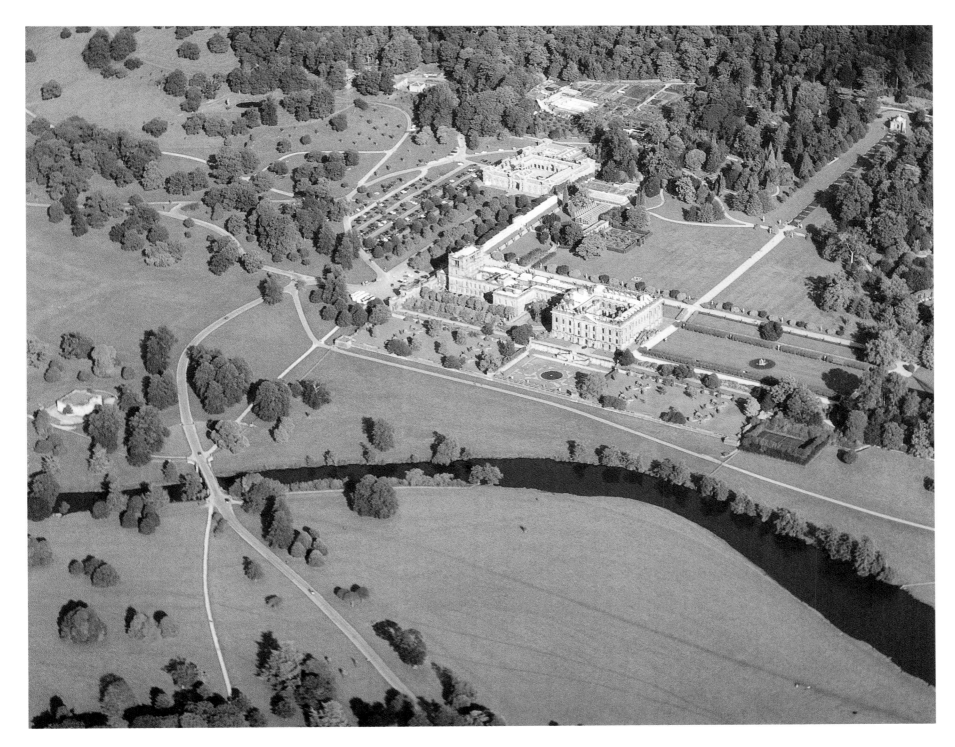

CHATSWORTH HOUSE DERBYSHIRE Chatsworth

House is the home of the Dukes of Devonshire. Built in the classical style in the late
17th and early 18th centuries, the house is set in formal gardens which include a canal,
a cascade and fountains. Surrounding these is parkland, landscaped by 'Capability'
Brown, through which the River Derwent runs.

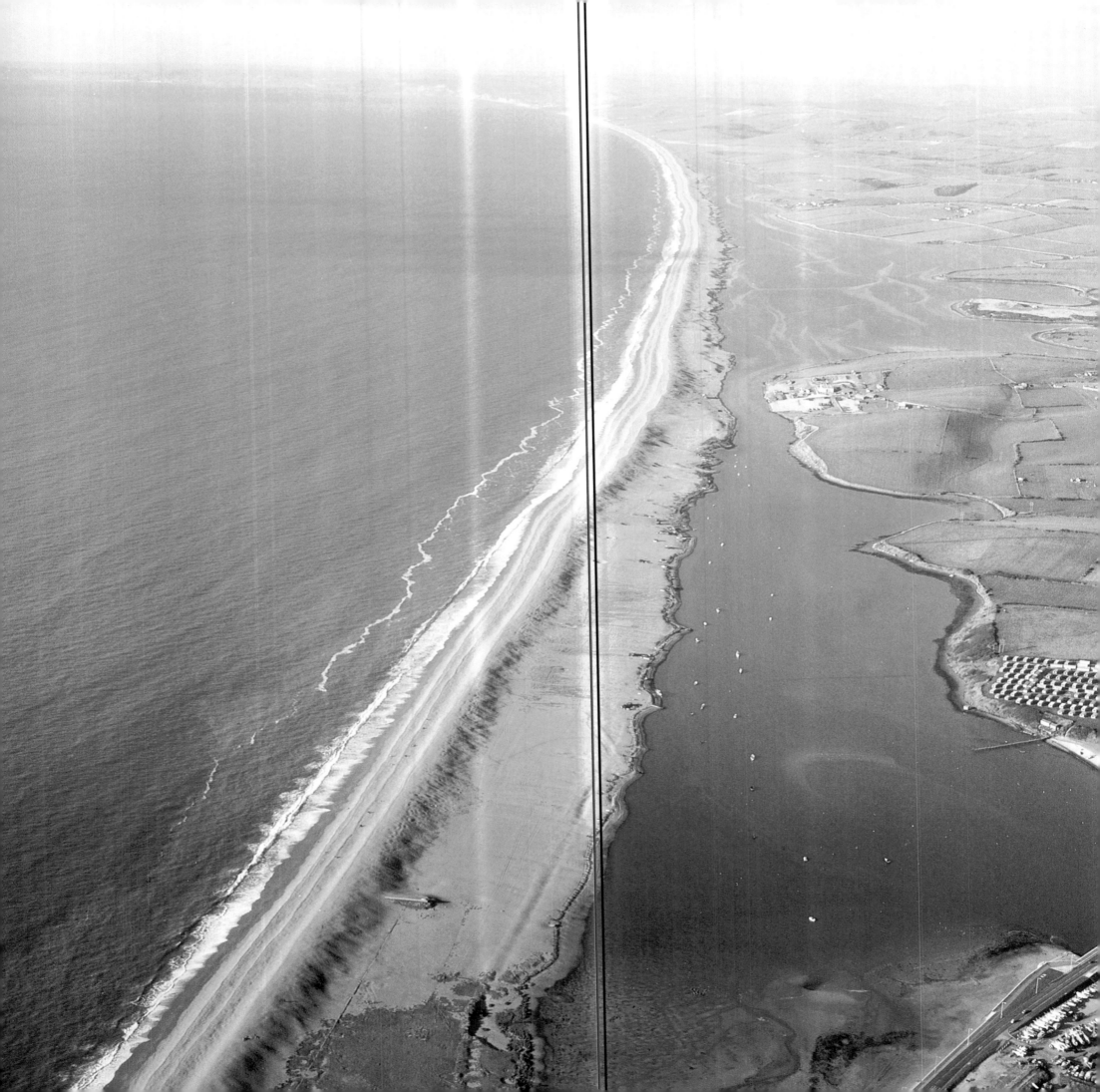

65

CHESIL BEACH DORSET For 10 miles along the coast the natural barrier of Chesil Beach (left) separates the sea from the lagoon known as the Fleet. The pebbles on this shingle bank gradually increase in size from the western end at Abbotsbury to the eastern point connecting Portland Bill with the mainland.

CHISELBURY CAMP WILTSHIRE On the ridge of the Wessex Downs above the village of Fovant stands the Iron Age hill fort of Chiselbury Camp, dating from c800BC. On the slope below can be seen a series of giant regimental badges, carved out of the chalk during World War I by troops stationed in the area.

C

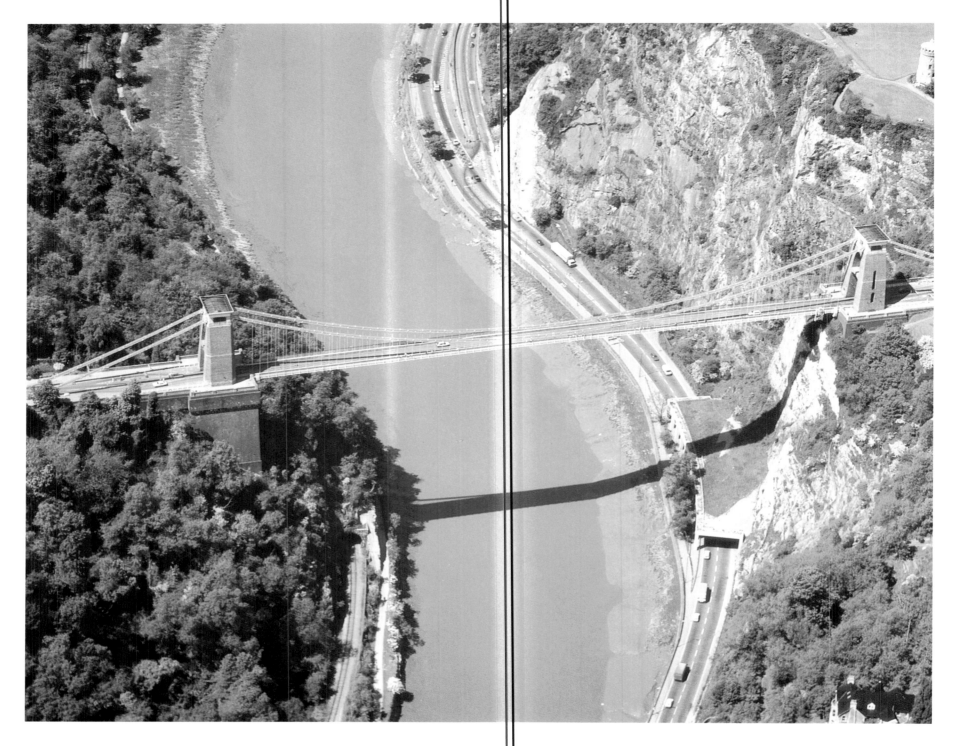

CLIFTON SUSPENSION BRIDGE AVON The
Bristol suburb of Clifton was bounded by the Avon Gorge until Isambard Kingdom
Brunel's plans to cross the gorge were accepted in 1831. Clifton Suspension Bridge,
completed only in 1864, after Brunel's death, spans 702ft between its piers and stands
245ft above the river at high tide.

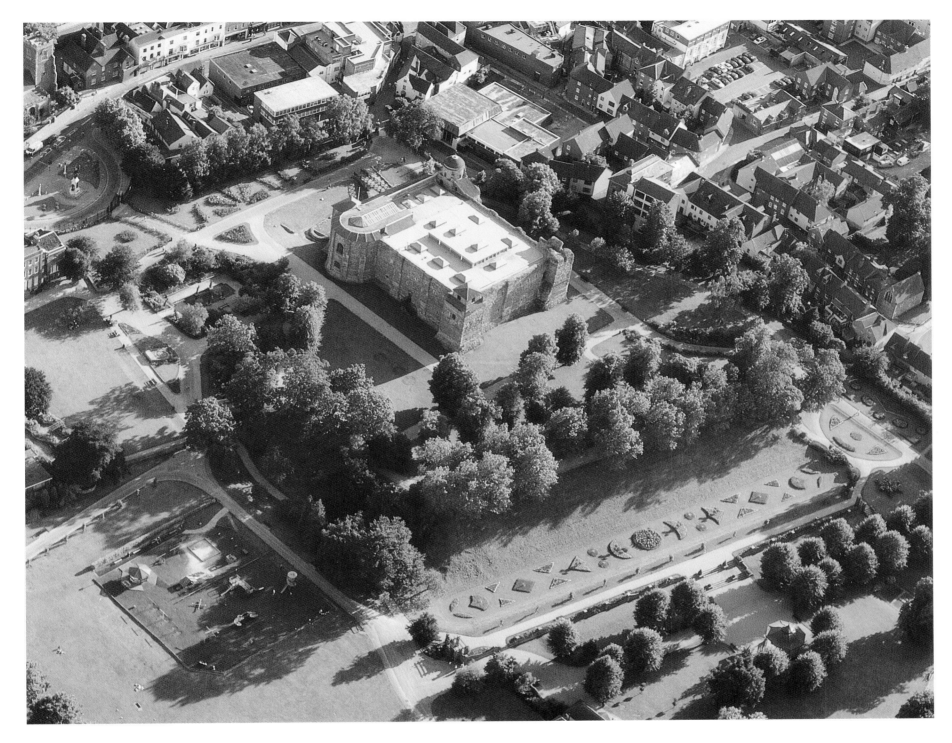

COLCHESTER CASTLE ESSEX Colchester is the oldest recorded town in England—the Roman town Camulodunum being built on an older British settlement. In the centre of the town stands the Norman castle. The massive keep was built using in part Roman bricks and the surrounding park also contains a section of preserved Roman wall.

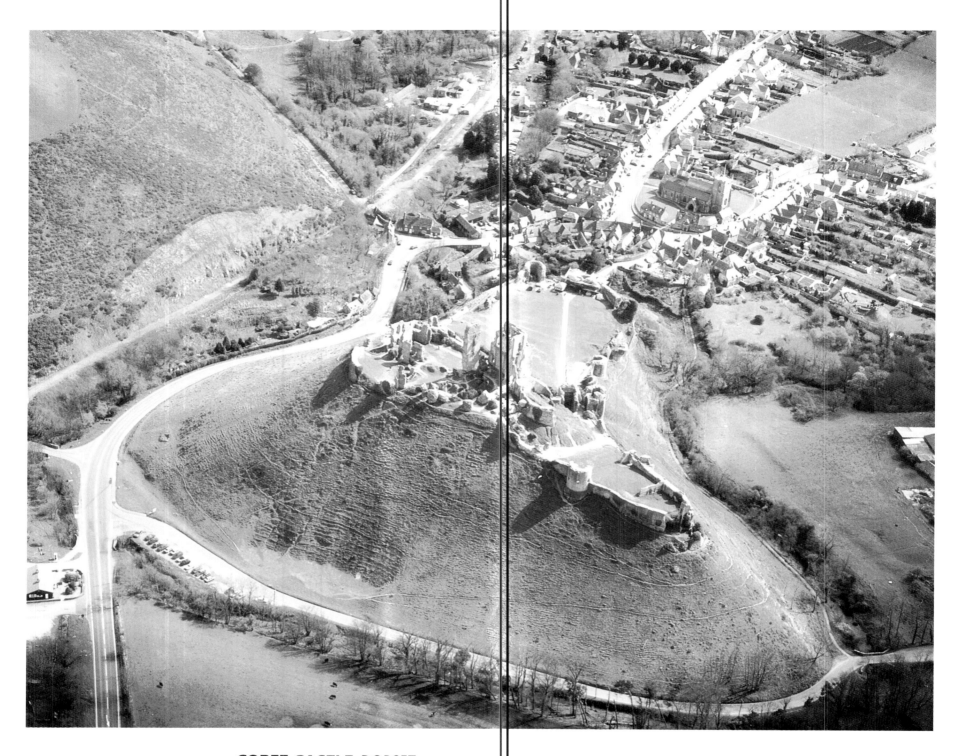

CORFE CASTLE DORSET Guarding the main route through the downs on the Isle of Purbeck peninsula, Corfe Castle stands on its hill above the village of Corfe. Although the castle resisted a siege by Parliamentary troops in 1643 during the Civil War, the castle eventually fell in 1646 through trickery and was destroyed by gunpowder.

THE COTSWOLDS GLOUCESTERSHIRE The

Cotswolds are an upland limestone plateau running from Oxfordshire across
Gloucestershire to the Severn Valley west of Gloucester. The towns and villages, with
many beautiful buildings largely built of the local stone, demonstrate the wealth of
this area which was built on the wool trade in the late Middle Ages.

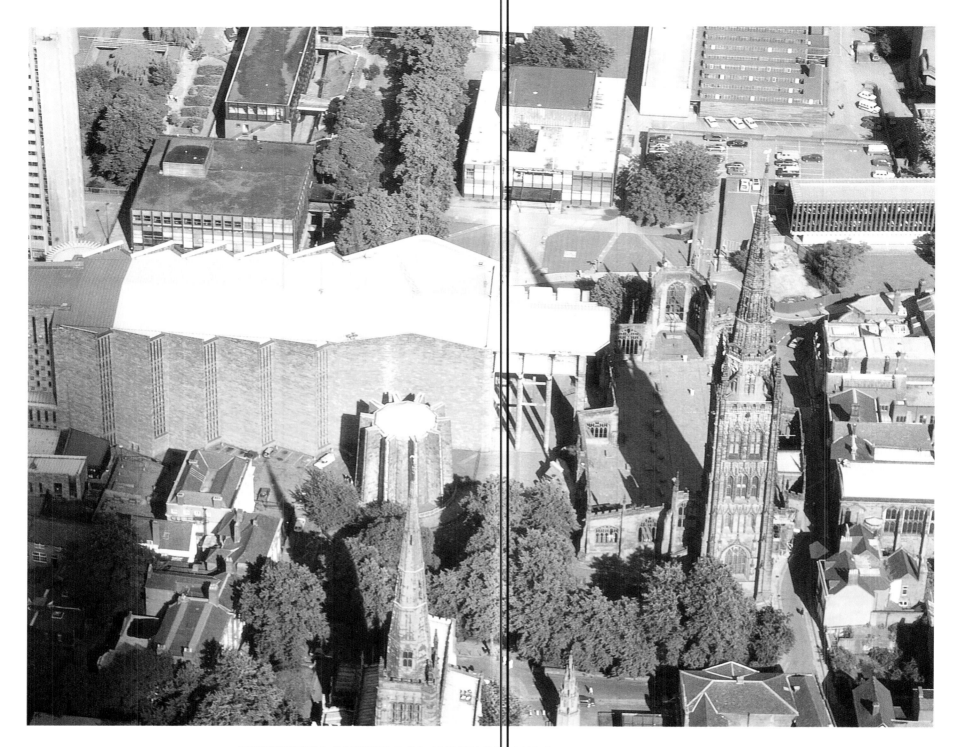

COVENTRY CATHEDRAL WEST MIDLANDS The stark ruins of Coventry's medieval cathedral bear witness to the destruction of Coventry by the German bombing raid during World War 2. Joined to it is Sir Basil Spence's new cathedral, built between 1954 and 1962. The interior contains the work of many artists, including Graham Sutherland's altar tapestry, sculpture by Jacob Epstein and stained glass by John Piper.

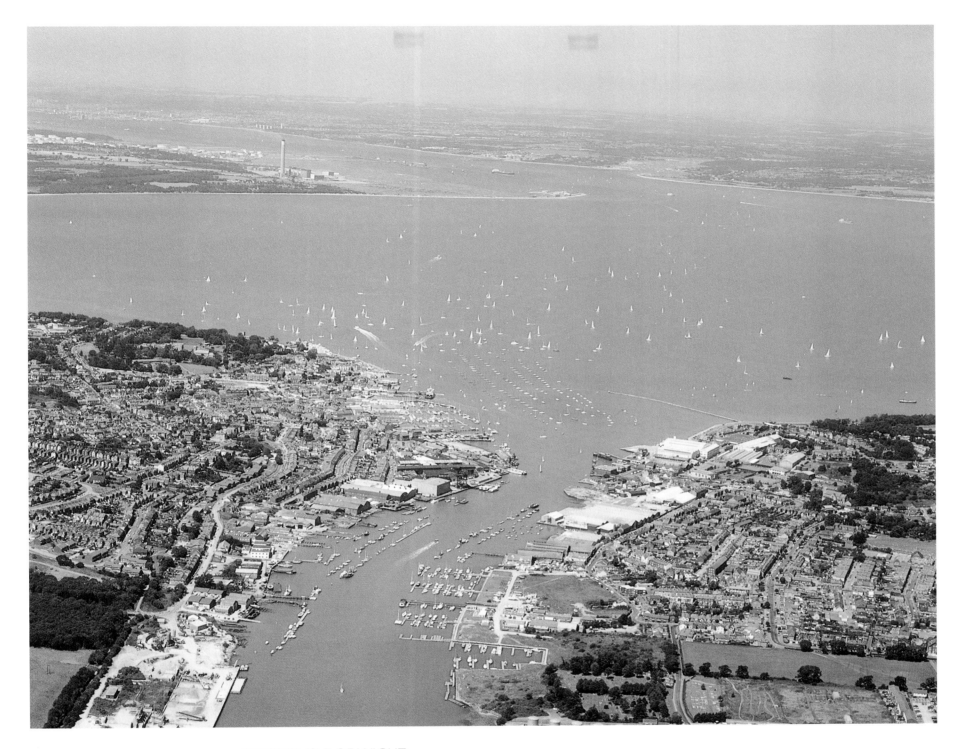

COWES ISLE OF WIGHT Famous as a yachting centre, including the exclusive Royal Yacht Squadron club founded in 1815, the Isle of Wight town of Cowes hosts the busy Cowes Week regatta at the beginning of August every year. Separated from the mainland by the Solent, the town lies on the mouth of the River Medina.

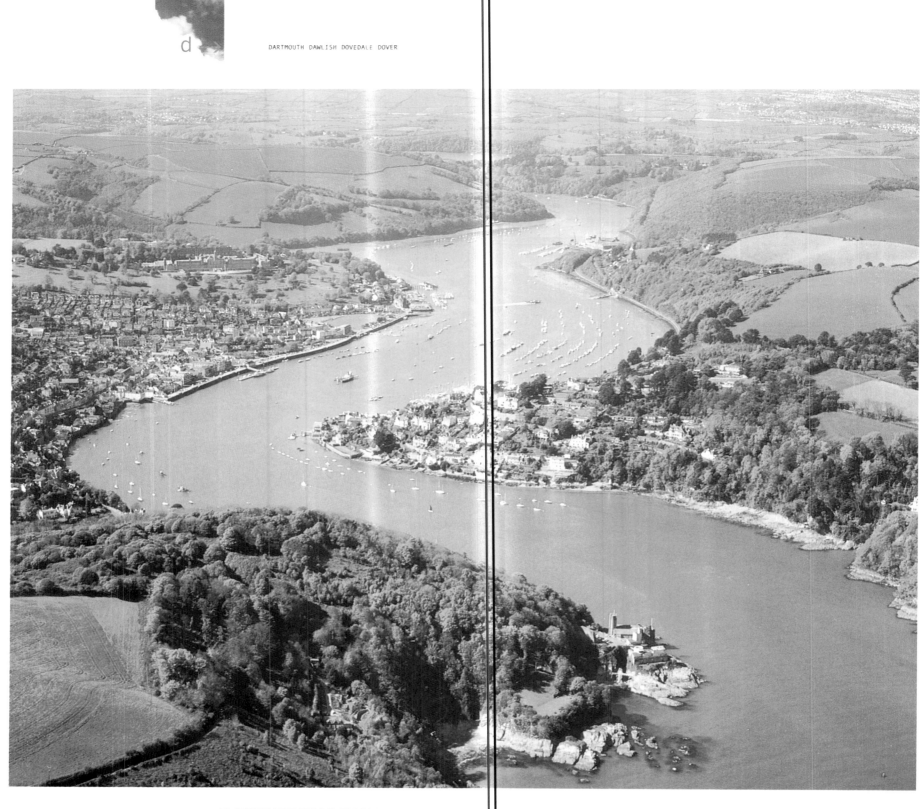

DARTMOUTH DEVON The small town of Dartmouth has long been connected with England's naval history and the Royal Naval College buildings still stand high above the town. Further down the River Dart stands St Petroc's Church and Dartmouth Castle. The town is connected to Kingswear on the other bank of the river by a ferry.

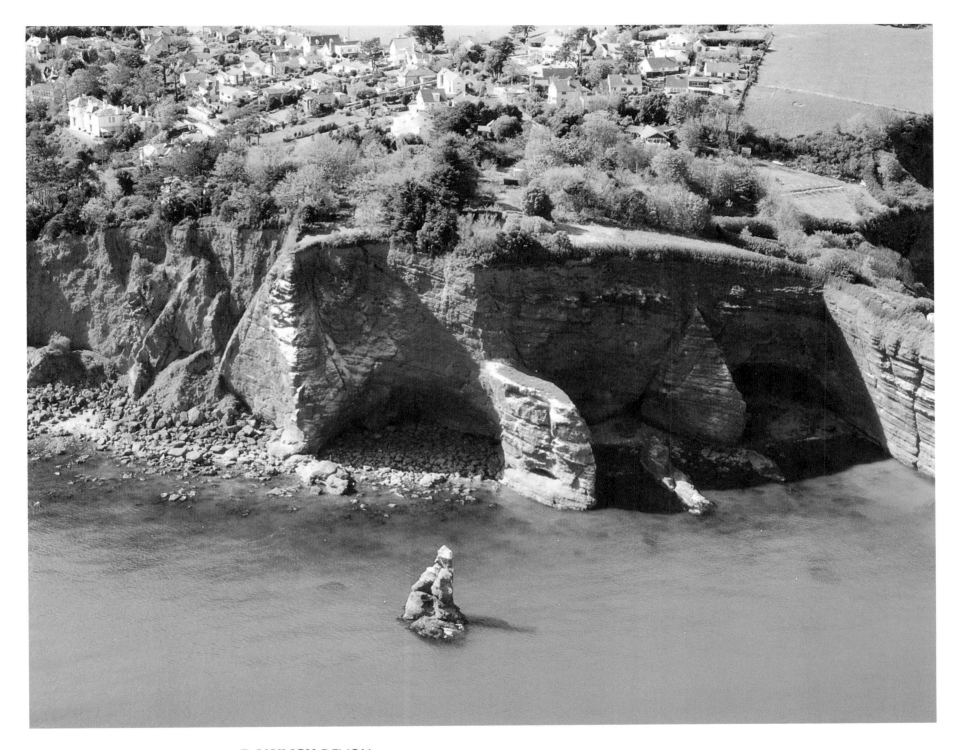

DAWLISH DEVON Dawlish is one of several seaside towns
that grew up in the early 19th century along the south Devon coast, and the railway
that came later in the century here was built along the coastline to serve these resorts.
The characteristic red cliffs of this section of the coast are formed of sandstone.

d

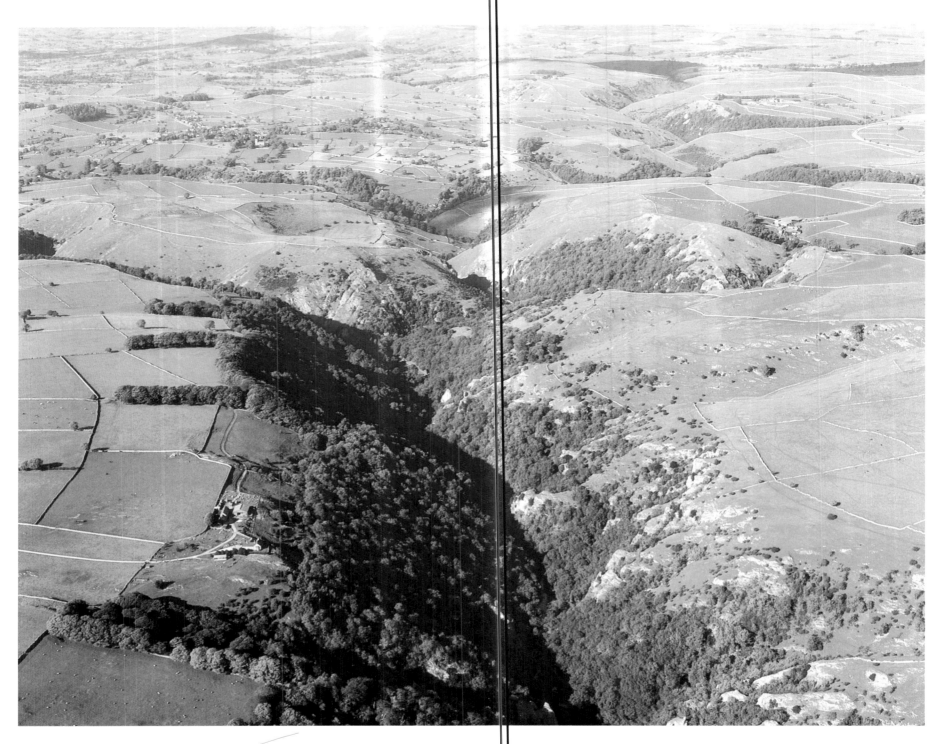

DOVEDALE DERBYSHIRE A famous beauty spot in the
Peak District, Dovedale is formed where the River Dove cuts a deep gorge through the
surrounding limestone hills. Visitors can follow the footpath by the river, starting in the
villages of Thorpe and Ilam at the south, which passes through the ravine below
strangely shaped limestone crags.

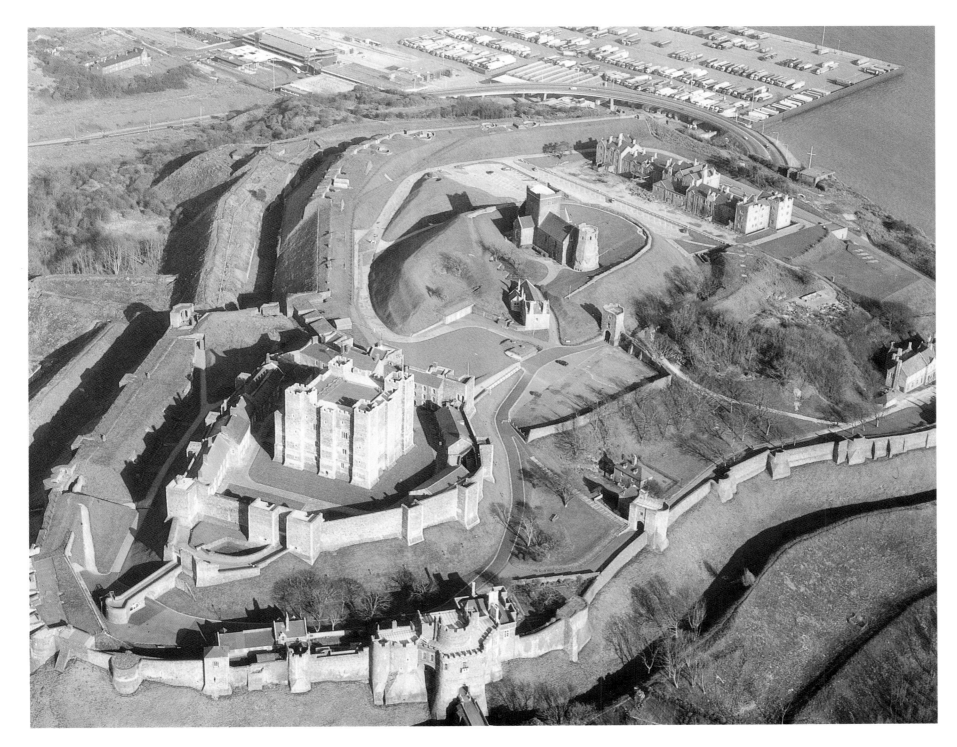

DOVER CASTLE & HARBOUR KENT The nearest
point in England to Continental Europe, Dover has long been a major port. The
Romans recognised Dover's strategic importance and built a fortress on the cliff above
the harbour of which the Pharos—lighthouse—still stands. These remains are now
contained within the walls of Dover Castle, with the Norman keep on the crest of the
hill.

d

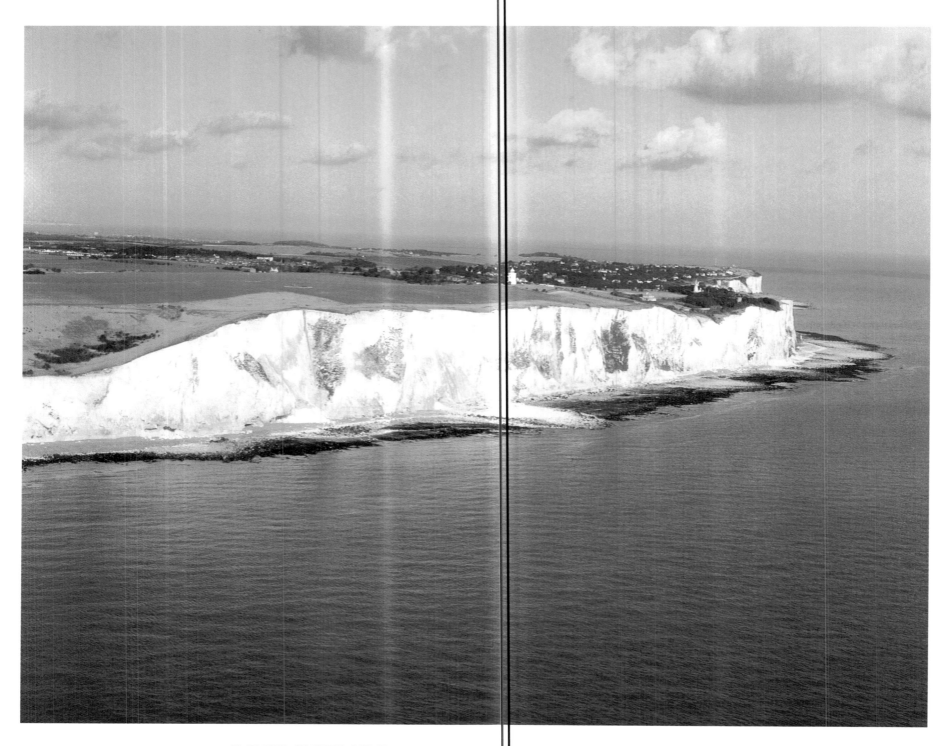

DOVER CLIFFS KENT The white chalk cliffs over the Port of Dover are the first sight that many travellers have of England, being visible on a clear day from France. The most imposing cliff is named Shakespeare Cliff after a passage in the playwright's tragedy *King Lear* describing the 350ft-high 'dread summit of this chalky bourn'.

EDINBURGH CASTLE LOTHIAN SCOTLAND

Edinburgh Castle stands at the top end of the Royal Mile looking across to the New Town. Fronting the New Town is Princes Street—the mile-long main shopping street in Edinburgh. Linking the two thoroughfares is the Mound, on which stand two neo-classical buildings housing the Royal Scottish Academy and the National Gallery of Scotland.

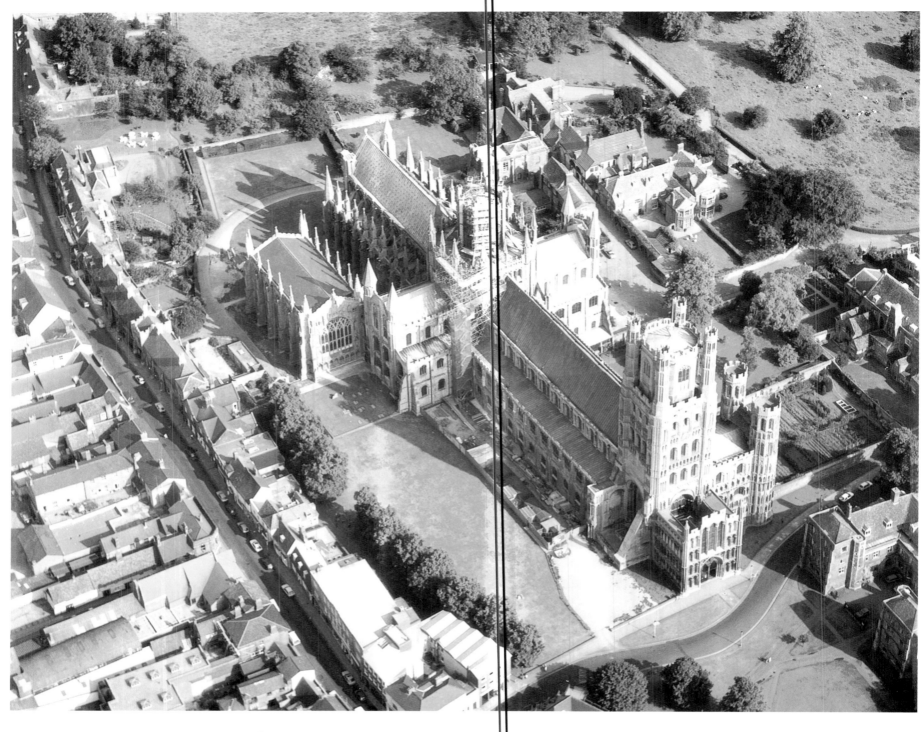

ELY CATHEDRAL CAMBRIDGESHIRE Rising from the Fens on a low hill, the small city of Ely is built around its cathedral. This magnificent building has an unusual castellated Norman tower and a unique 14th century octagon topped by its lantern tower spanning the junction of the nave and transepts, built to replace the original Norman tower which had collapsed.

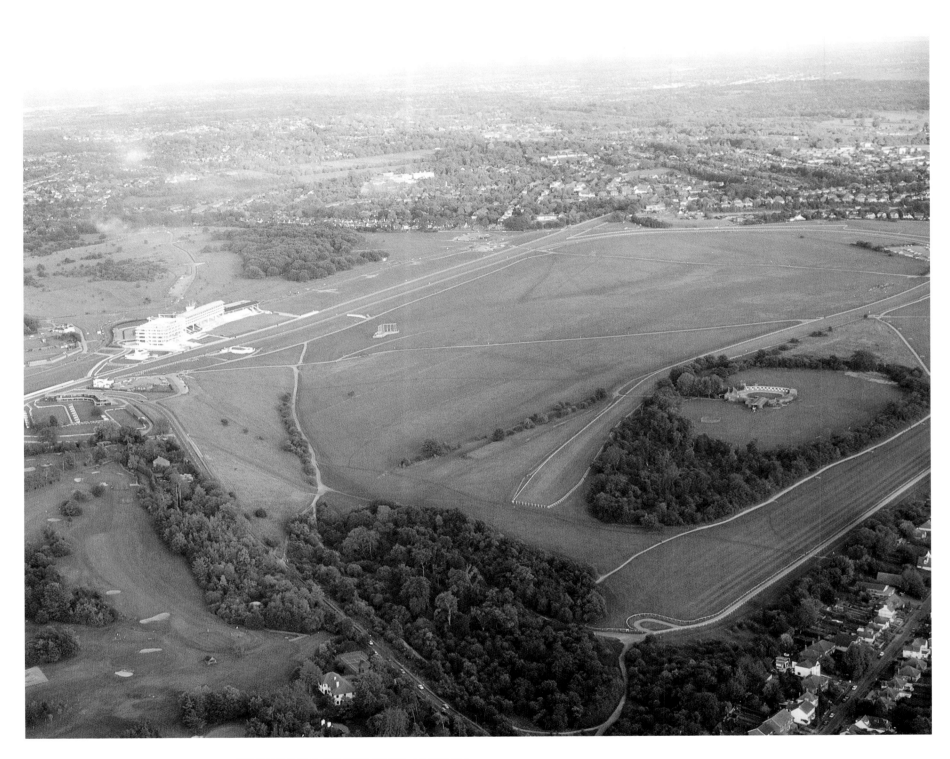

EPSOM RACECOURSE SURREY High on the North
Downs, Epsom is the home of the Derby, one of the most famous horse races in the
world. This undulating course is regarded as a true test of a thoroughbred's speed,
strength and stamina. The town of Epsom became fashionable as a spa town in the
17th century.

e

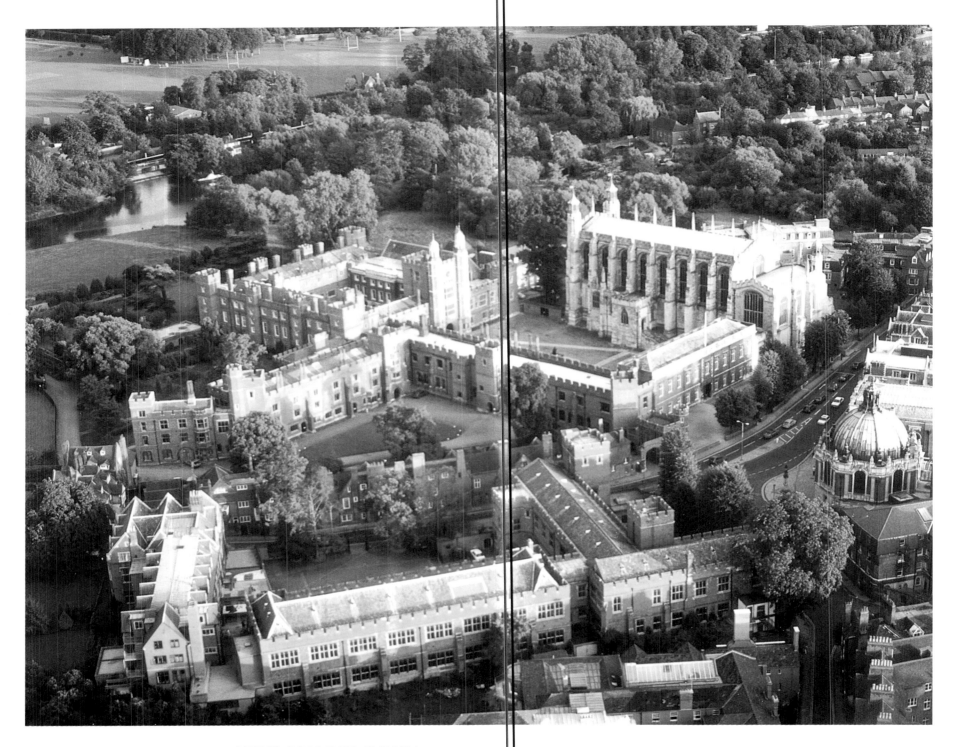

80

ETON COLLEGE SURREY Founded by Henry VI in 1440, this famous English public school lies just across the River Thames from Windsor. Built around courts or quadrangles, reminiscent of the colleges of Oxford and Cambridge universities, many of the buildings date from the school's foundation, including the Perpendicular chapel.

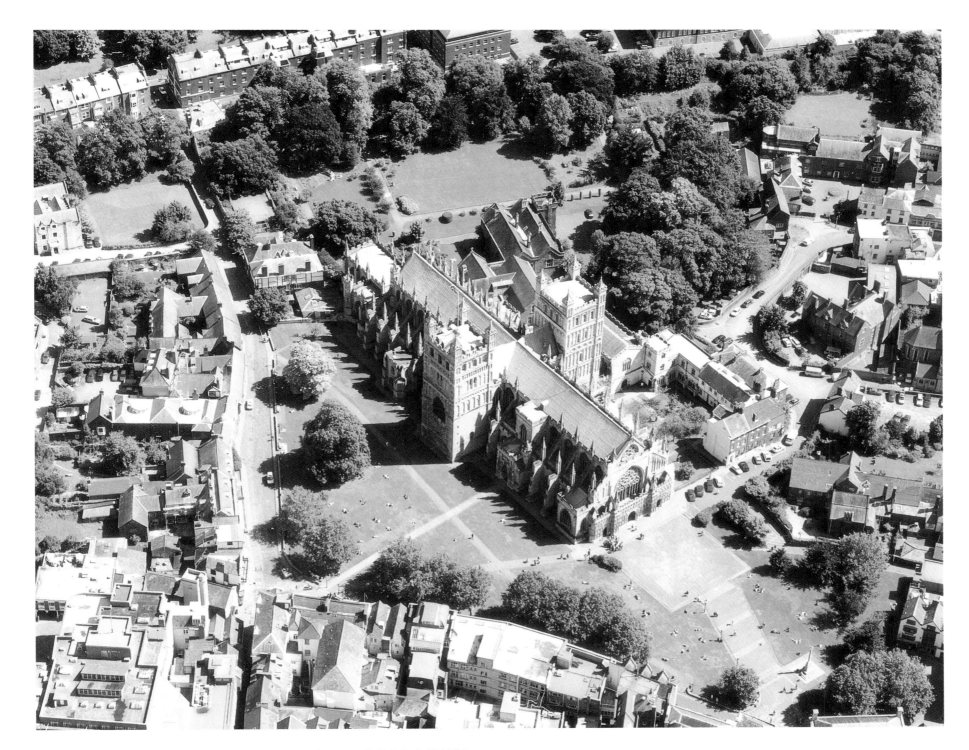

EXETER CATHEDRAL DEVON This West Country
cathedral boasts the longest unbroken Gothic vault in the world, the roof being over
300ft long. The west front is particularly noteworthy for its numerous carved stone
figures. Most of the cathedral was rebuilt in the Gothic style in the 13th and 14th
centuries but the two Norman transeptal towers remain from the earlier building.

e

EXMOOR SOMERSET The bare hills of Exmoor lying in
north Somerset and north Devon abruptly meet the sea at the Bristol Channel. This
sandstone plateau, now partially cultivated, contains large tracts of heather moorland
from which rivers drain off, cutting deep valleys such as the secluded 'Doone' valley in
R. D. Blackmore's romance *Lorna Doone*.

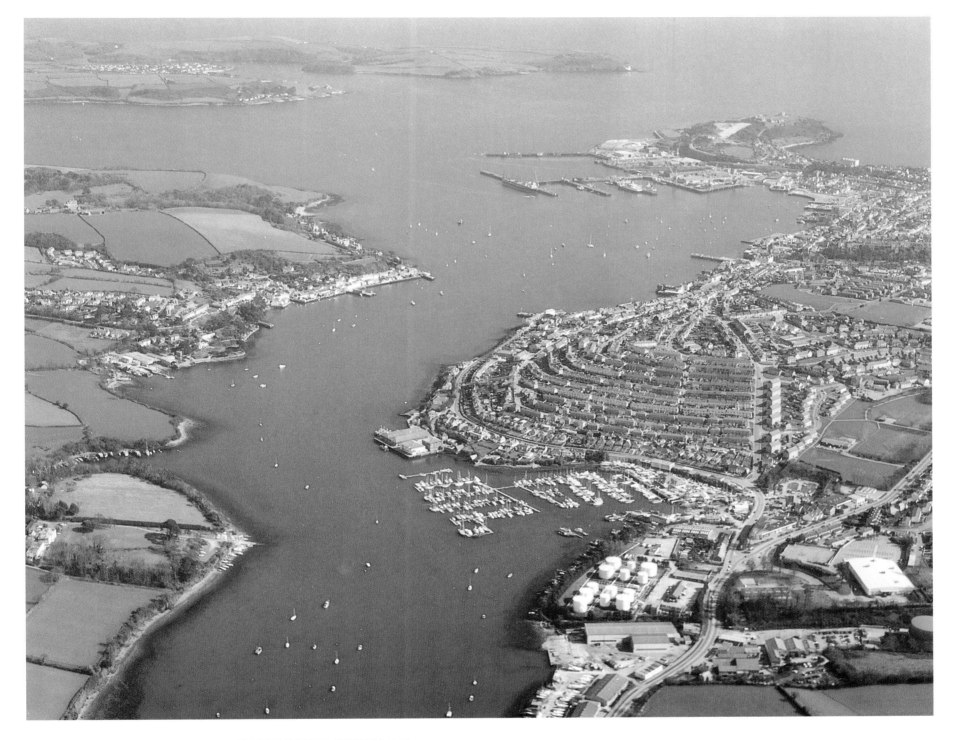

83

FALMOUTH CORNWALL Falmouth's large natural harbour, off the sheltered Falmouth Bay, has given this Cornish town a long maritime history. From the 17th to the 19th centuries it was a major embarkation point for Atlantic shipping. On the end of the peninsula, guarding the entrance to the harbour, stands Henry VIII's Pendennis Castle.

f

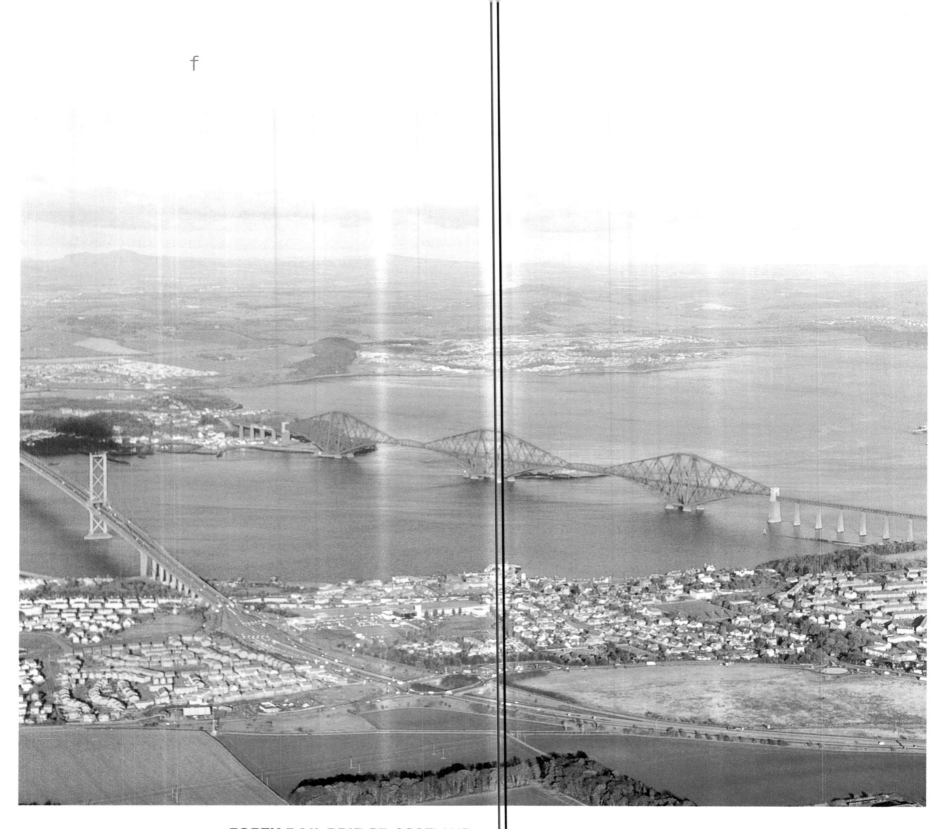

FORTH RAIL BRIDGE SCOTLAND A masterpiece of
Victorian engineering, the Forth Rail Bridge crosses the Firth of Forth at Queensferry,
west of Edinburgh, joining Lothian on the south bank and Fife on the north. Designed
by Sir John Fowler and Sir Benjamin Baker this massive tubular steel cantilever structure
was completed in 1890. The bridge is over 1.5 miles long, with the railway line running
157ft above the water.

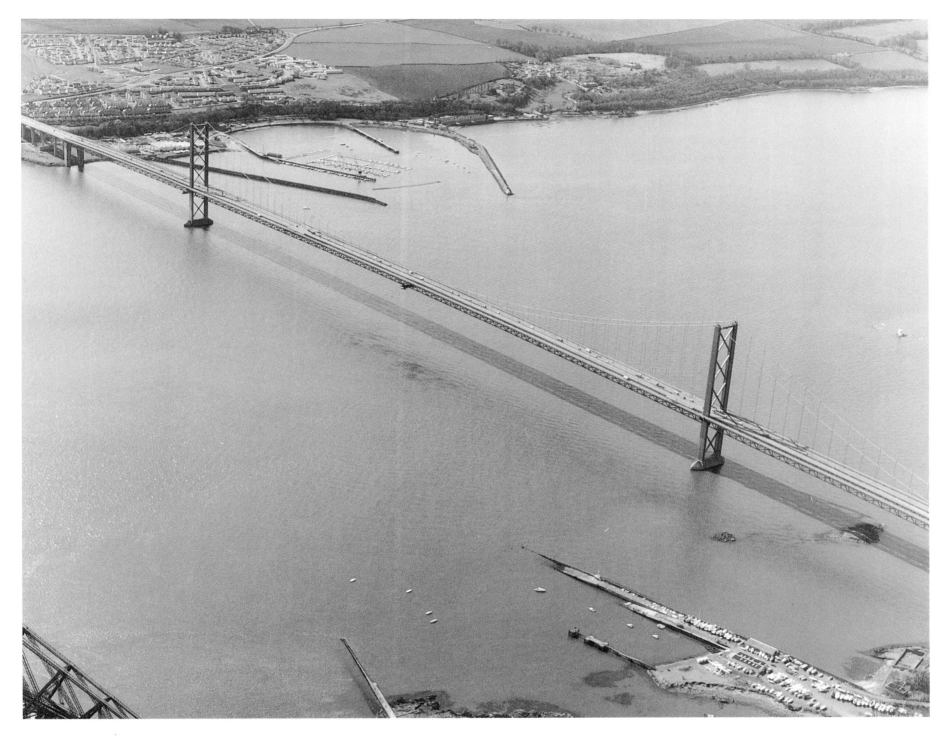

FORTH ROAD BRIDGE SCOTLAND The Forth Road
Bridge was opened in 1964 so that motorists would no longer have to cross the Firth of
Forth by ferry. Standing near the famous rail bridge, the road bridge is an equally
impressive structure, its span of 1,915yd making it one of the largest suspension bridges
in Europe.

f

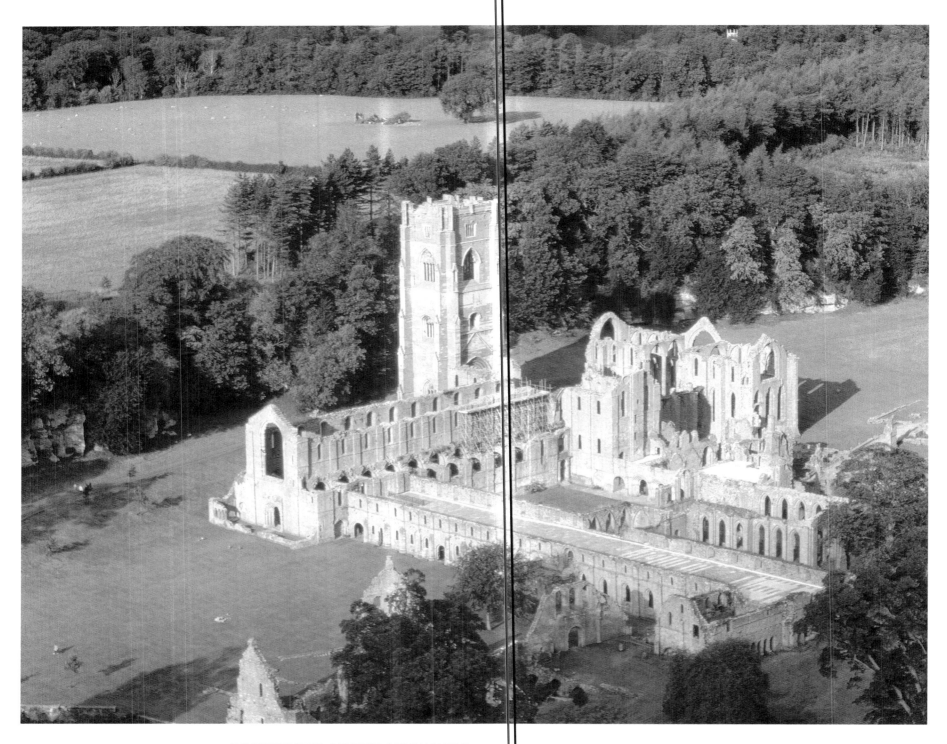

86

FOUNTAINS ABBEY YORKSHIRE Standing in the 18th century landscaped gardens of Studley Royal, the ruins of Fountains Abbey are amongst the best preserved in England. The abbey was founded in the 12th century and grew to become the richest Cistercian foundation in the country. The buildings include the monks' and lay brothers' domestic quarters as well as the abbey church.

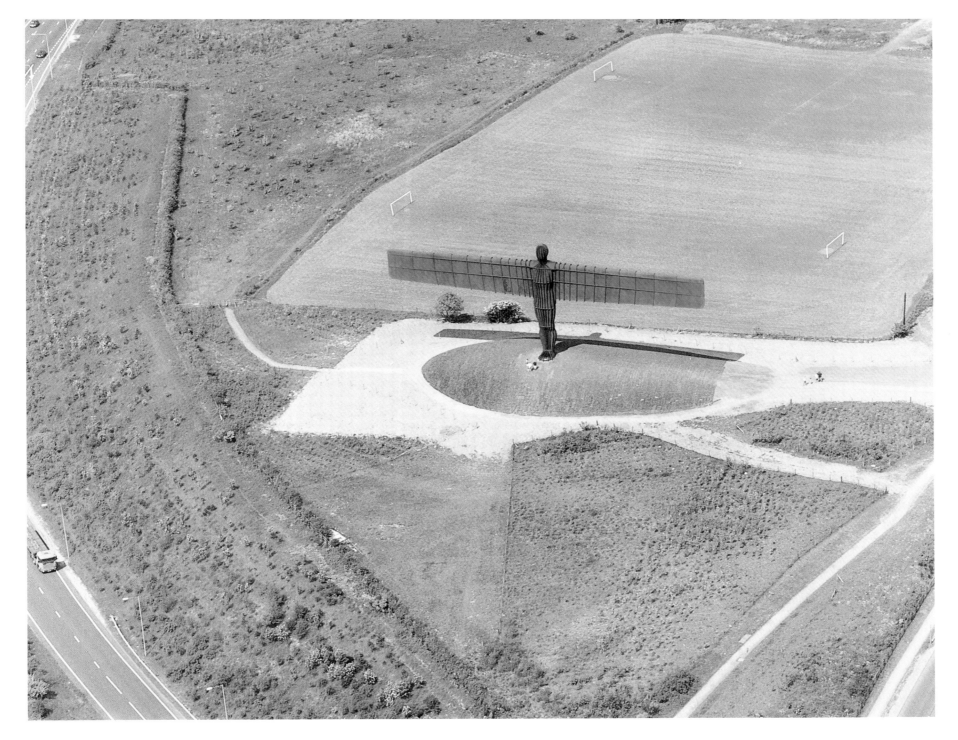

87

GATESHEAD ANGEL OF THE NORTH TYNE & WEAR

Standing on a hill beside the A1 trunk road, south of Gateshead, Antony Gormley's
massive steel sculpture, entitled the Angel of the North, greets travellers heading to
and from the northeast of England.

g

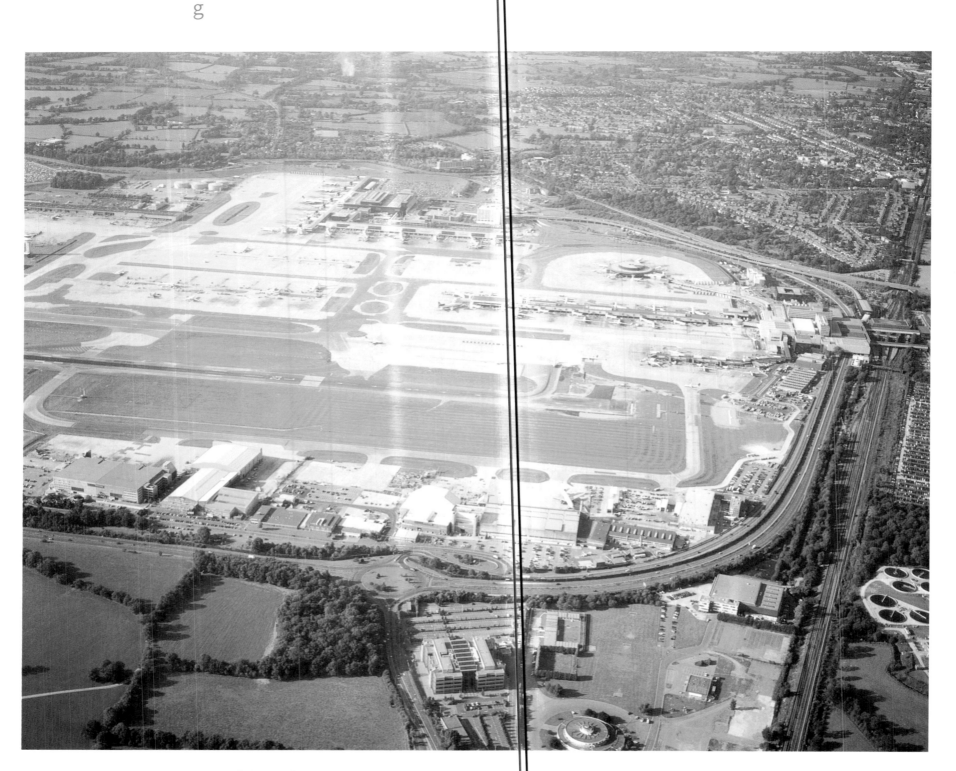

GATWICK AIRPORT WEST SUSSEX Today London's
second airport, Gatwick was originally the site of a racecourse. The early airport was
used by the Royal Air Force during World War 2 and after the war was developed for
commercial use and reopened in 1958. Despite having only one runway Gatwick has
grown considerably over the years.

GLASTONBURY TOR SOMERSET Rising from the
Somerset Levels, the summit of the tor (right), just over 500ft high, is visible for miles
around. On top stands the tower of the ruined chapel of St Michael. The isolated hill is
thought by some to be the legendary Isle of Avalon.

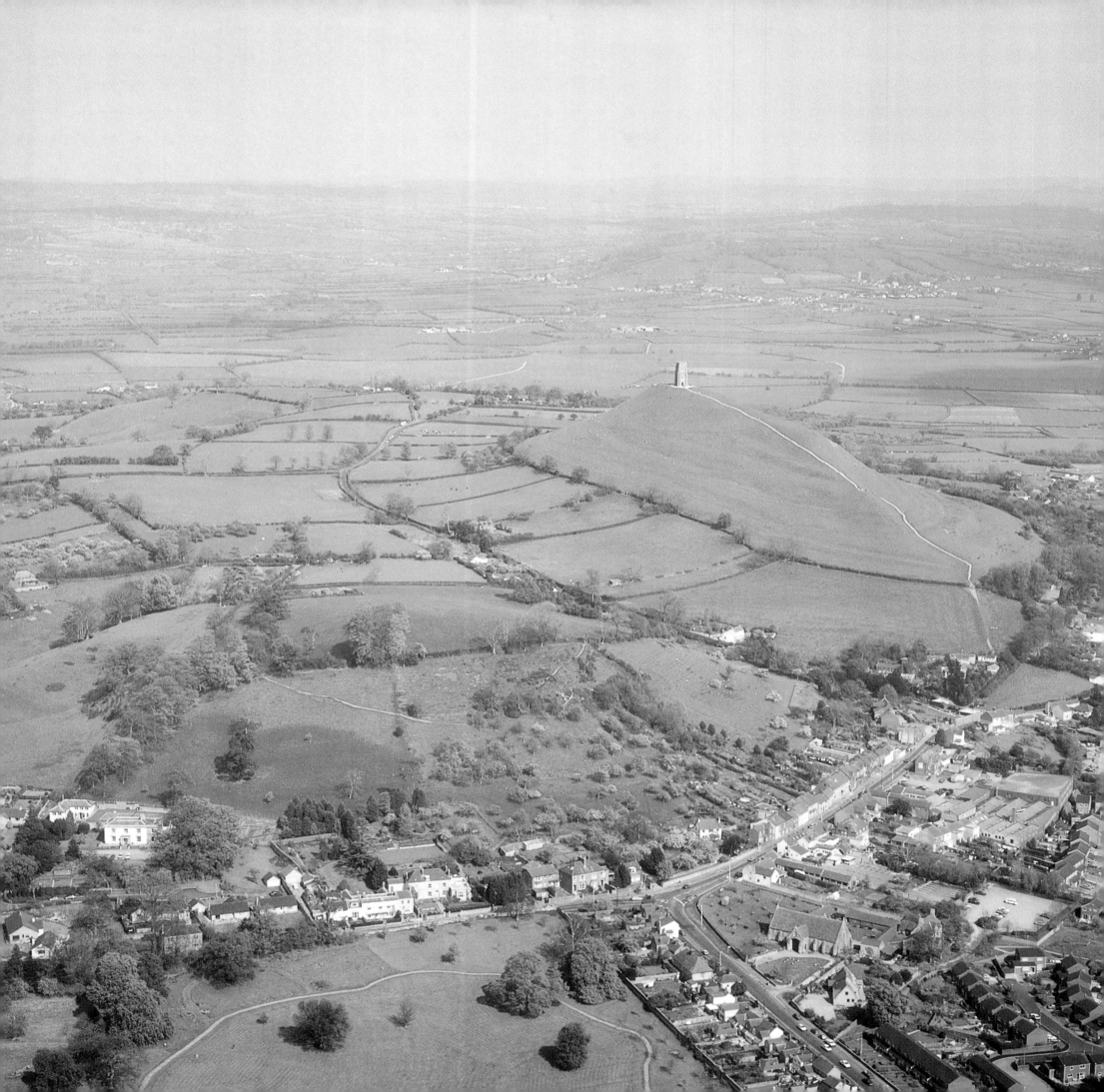

g

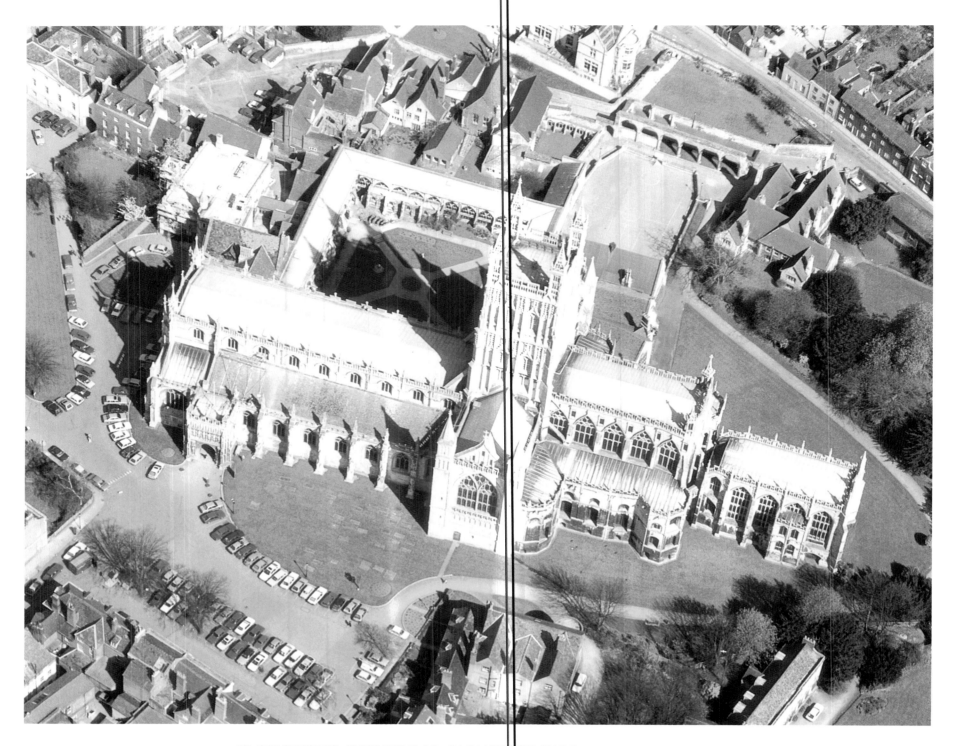

90

GLOUCESTER CATHEDRAL GLOUCESTERSHIRE

Dedicated to St Peter and the Holy Trinity, Gloucester cathedral sits on the location of a
monastery founded in AD681. The existing building was started in 1089 although
extensively rebuilt in the 14th and 15th centuries thanks to the income from pilgrims
attracted by the shrine of Edward II, buried there after his murder in Berkeley Castle.

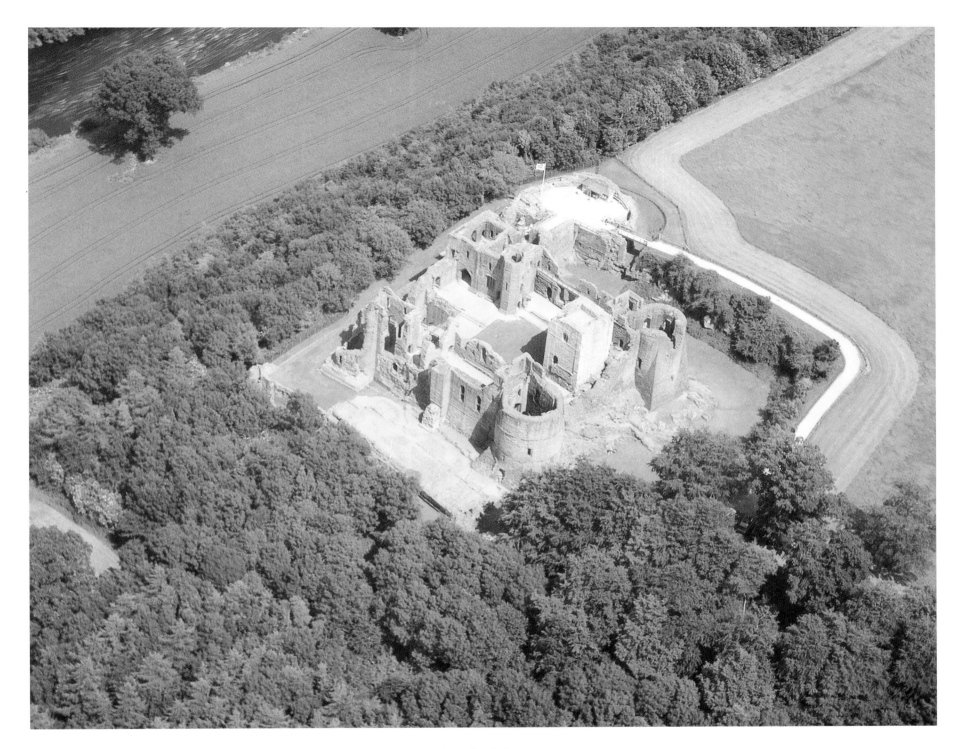

GOODRICH CASTLE HEREFORDSHIRE Goodrich
Castle, named after its early owner Godric, stands above the Wye River in the Welsh
Marches. The 12th century keep is surrounded by extensive red sandstone ruins dating
from the 13th and 14th centuries. The castle passed from the ownership of the Earls of
Pembroke to the Talbot family in the 14th century.

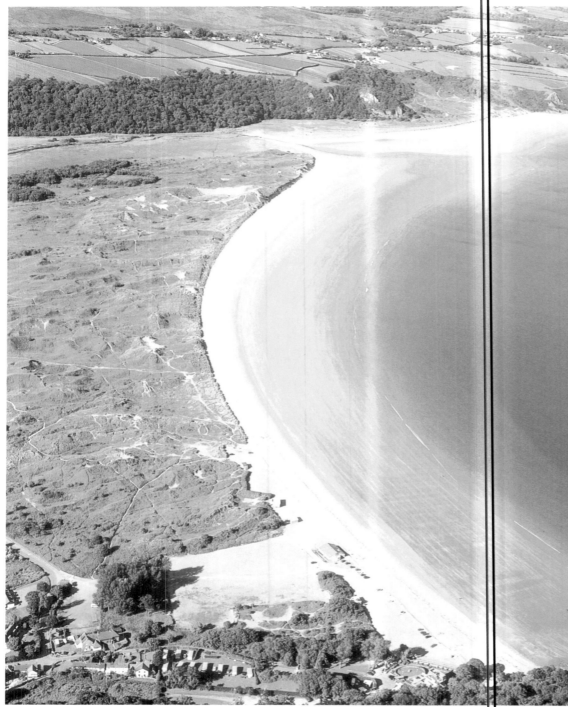

GOWER PENINSULA SWANSEA WALES Just west of
Swansea lies the unspoilt Gower Peninsula with its bays, rocky cliffs and wide sandy
beaches. Its south coast has been classified as an Area of Outstanding Natural Beauty.
Inland, the hills rise to the high point of Rhossili Down. Evidence has been found in
caves on the peninsula that humans have lived here since prehistoric times.

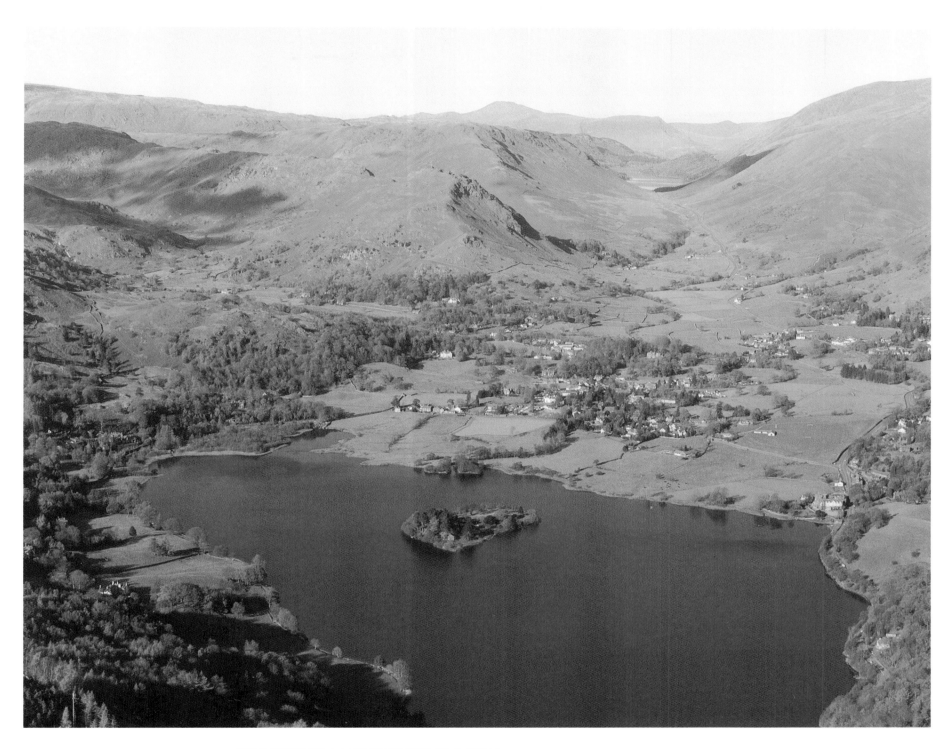

GRASMERE LAKE DISTRICT CUMBRIA The village of
Grasmere lies on the northeast shore of Lake Grasmere. This area of the Lake District is
associated with the poet William Wordsworth who lived for many years in the village in
various residences, including Dove Cottage, with his wife Mary and sister Dorothy. They
are all buried in the village churchyard.

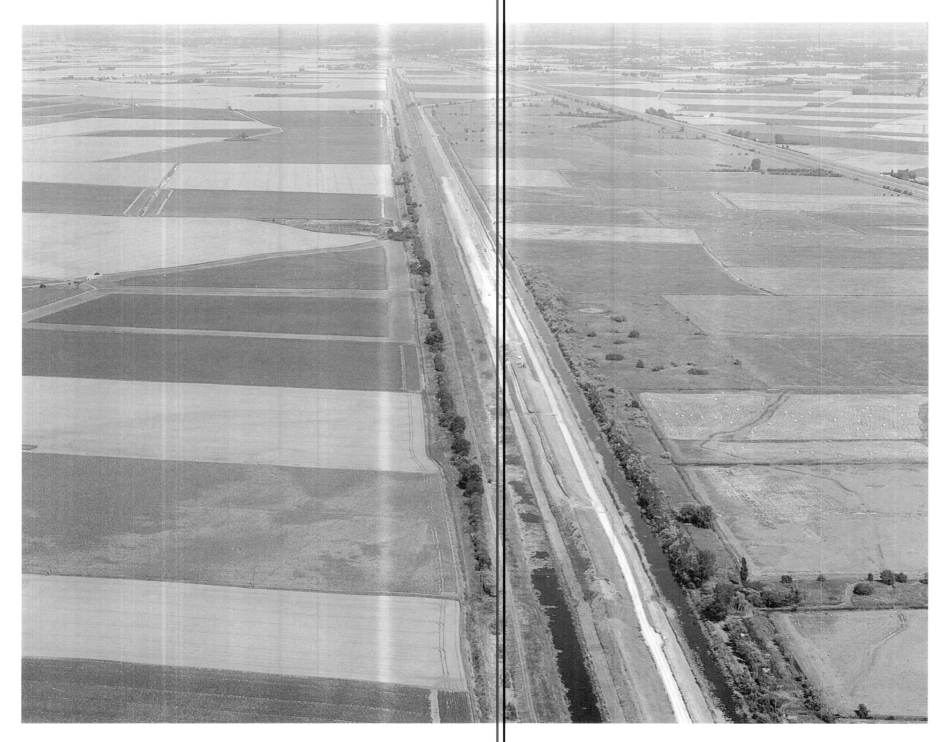

GREAT OUSE DRAIN NORFOLK The large area of
flat marshland in Eastern England known as the Fens drains into the Wash. The Romans
began the process of draining the Fens but the 17th century Dutch engineer Cornelius
Vermuyden was instrumental in reclaiming the land, including cutting the straight lines
of the Drain into the River Great Ouse.

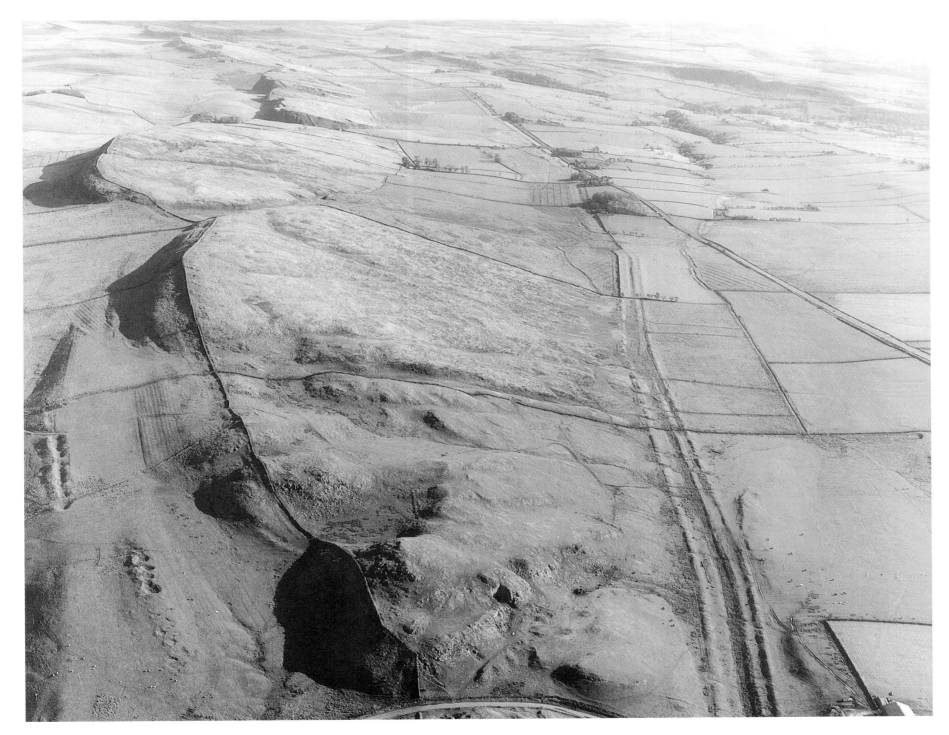

95

HADRIAN'S WALL Running 73 miles across the north of
England from the Solway Firth in Cumbria to the River Tyne in Northumberland,
Hadrian's Wall was built by the Romans to mark the northern boundary of their
empire. One of the best preserved sections follows the natural ridge of the Great Whin
Sill across the bare hills of Northumberland.

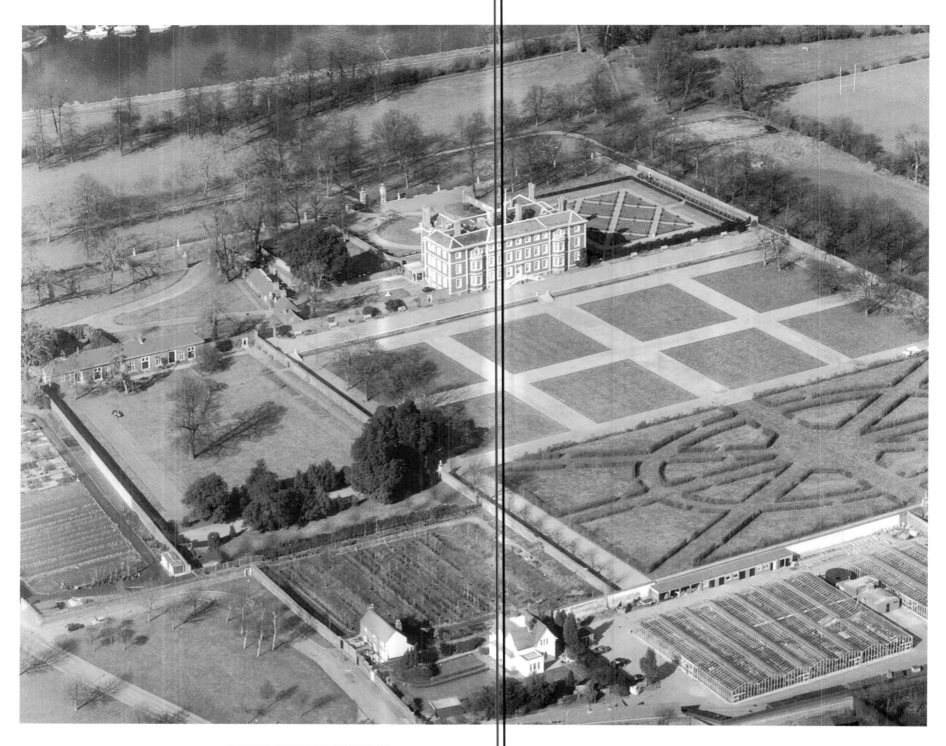

HAM HOUSE SURREY Ham House, on the banks of the
River Thames, is an outstanding example of a Stuart house. Built in 1610 and enlarged
in 1670 the building has remained virtually unchanged to the present day and retains
many original furnishings. The formal gardens in front of the house are being restored
to their original 17th century condition.

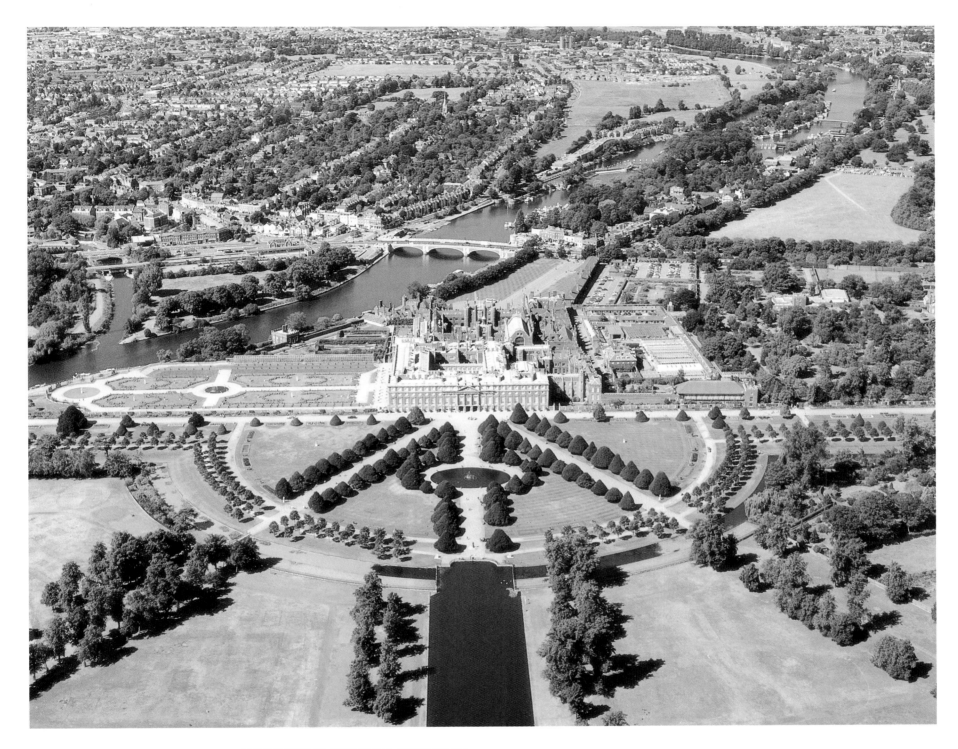

HAMPTON COURT MIDDLESEX Begun by Cardinal
Wolsey at the height of his power, the Thames-side palace of Hampton Court was
taken over by Henry VIII and remained a royal residence until the 18th century.
Christopher Wren later added two wings to the original Tudor palace. The gardens
include the famous Maze and Henry VIII's Real Tennis court. Each year it is the site of
one of the best flower shows in Britain.

h

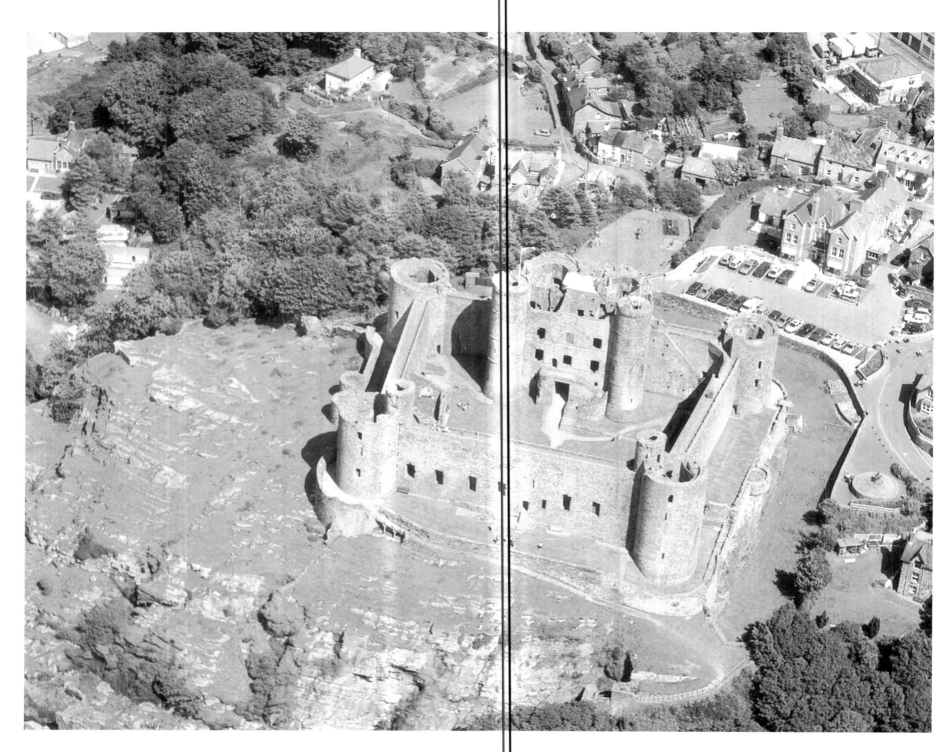

HARLECH CASTLE GWYNEDD WALES Set high on
a rock, Harlech Castle looks out over the surrounding marshes. The castle exemplifies
Edward I's system of concentric fortification and when originally built (1283–89) it was
served by the sea although the coast is now nearly two miles away. Owain Glyndwr
captured the castle in 1404 and for four years held his court here.

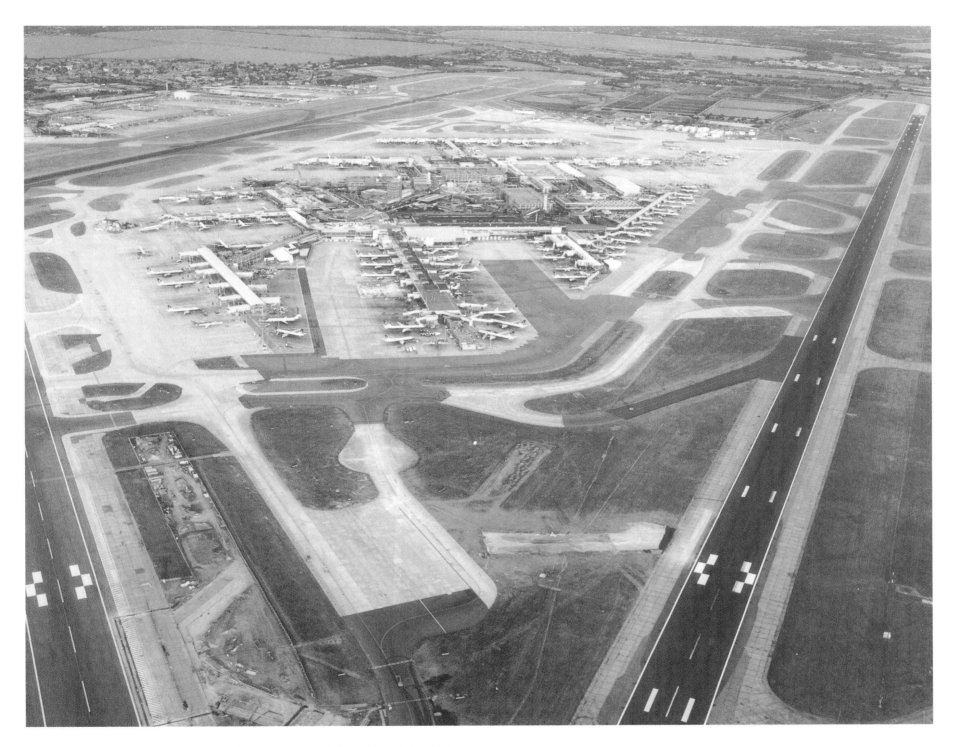

HEATHROW AIRPORT MIDDLESEX Heathrow is
today one of the busiest international airports in the world but it did not take over
from Croydon as London's main airport until after World War 2. Situated in Hounslow,
15 miles to the west of London, the airport has four terminals, with a fifth planned to
ease the congestion for the ever-increasing numbers of passengers.

h

HOOVER BUILDING PERIVALE MIDDLESEX Built
by the architects Wallis Gilbert & Partners in 1932 alongside the Great West Road, the
Hoover Factory typifies the Art Deco style. Construction of the Great West Road
through the western outskirts of London started in the 1920s and this section has a
number of striking 'modern-style' factories of the 1920s and 1930s.

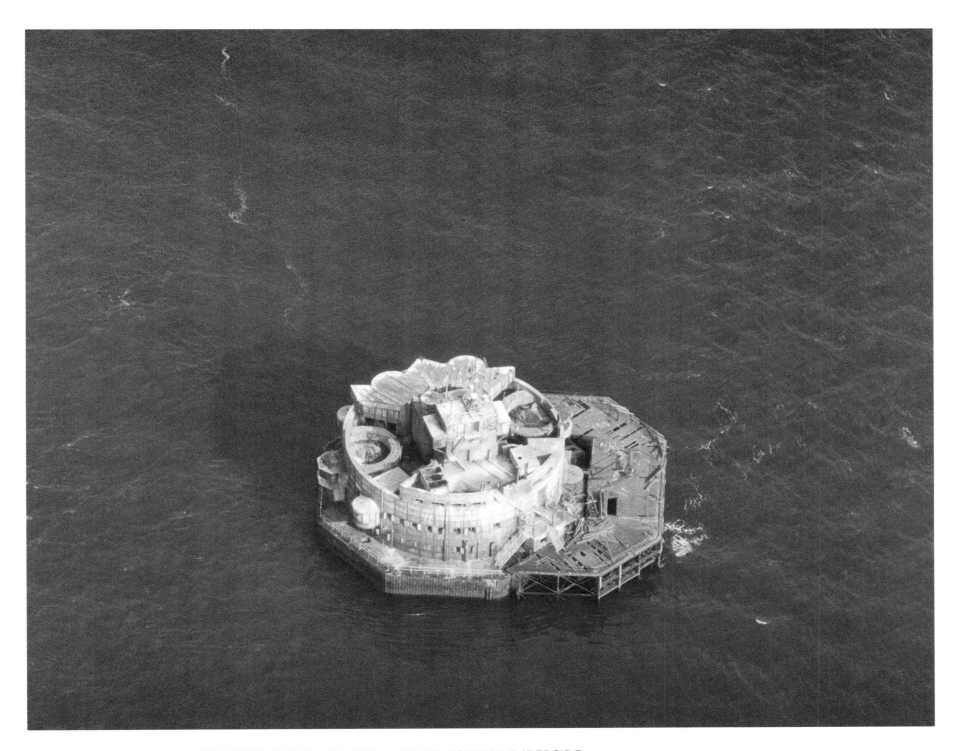

HUMBER ESTUARY BULL SAND FORT HUMBERSIDE

Bull Sand Fort lies in the mouth of the Humber offshore from Spurn Head. The estuary is seven miles wide at this point between the coastal towns of Grimsby and Cleethorpes and the eroding, shifting spit of land of Spurn Head at the southeast extremity of Yorkshire.

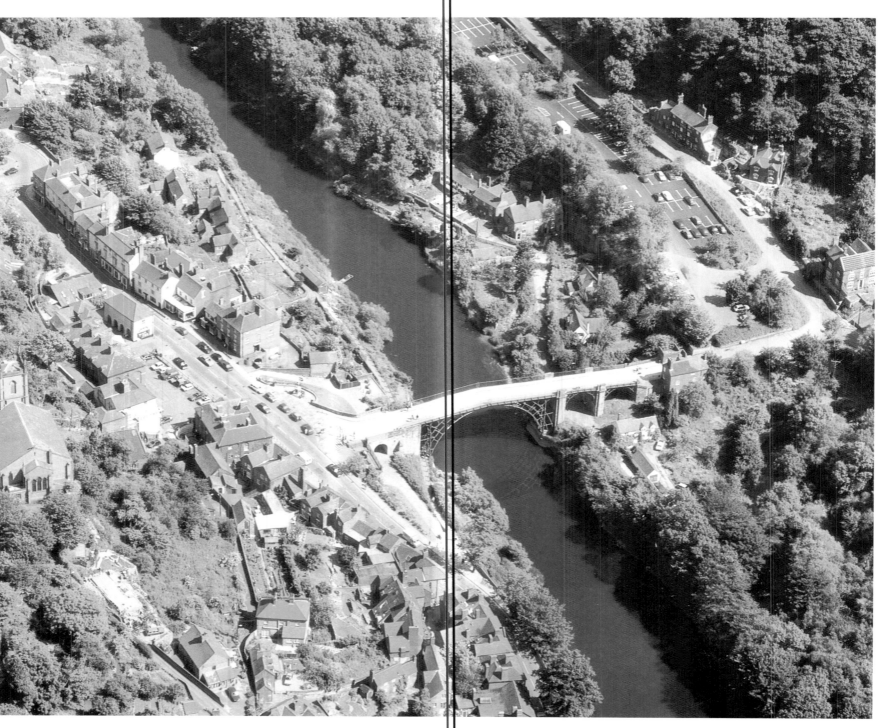

102

IRONBRIDGE SHROPSHIRE Ironbridge Gorge is the
cradle of the Industrial Revolution. The fast-flowing River Severn and rich mineral
deposits enabled Abraham Darby to pioneer the smelting of iron with coke rather than
charcoal at nearby Coalbrookdale at the beginning of the 18th century. The third
Abraham Darby built the world's first iron bridge across the river in 1779.

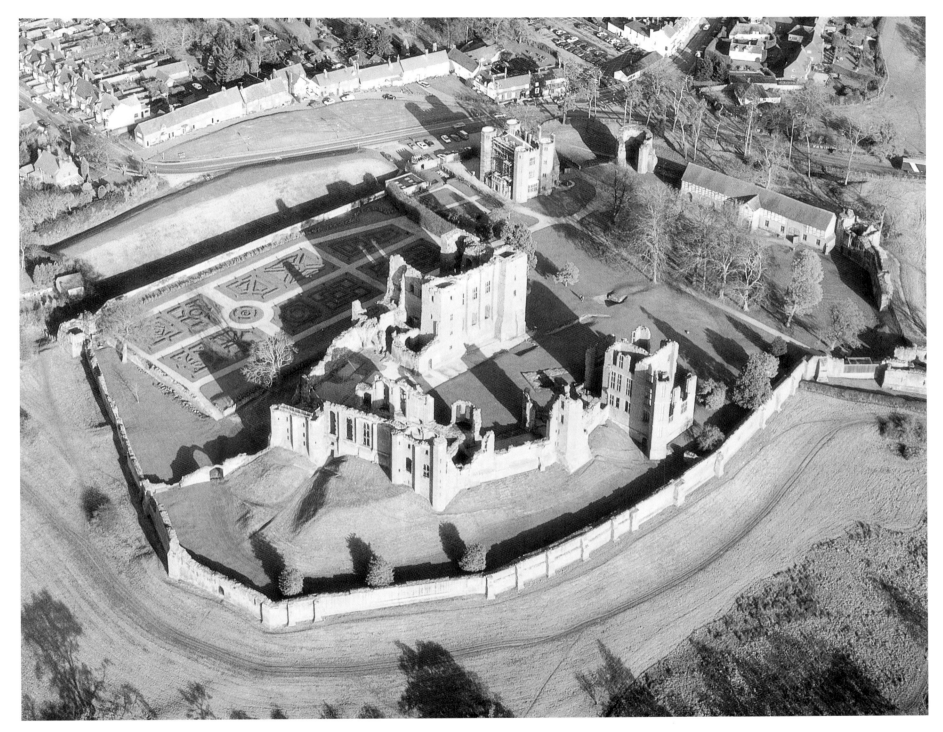

103

KENILWORTH CASTLE WARWICKSHIRE The largest castle ruin in England, Kenilworth's keep and outer walls were built in the 12th century. When the castle passed to John of Gaunt in the 14th century the Strong Tower, Great Hall and southern rooms were added. It then entered into royal possession until Elizabeth I gave it to the Earl of Leicester in 1563.

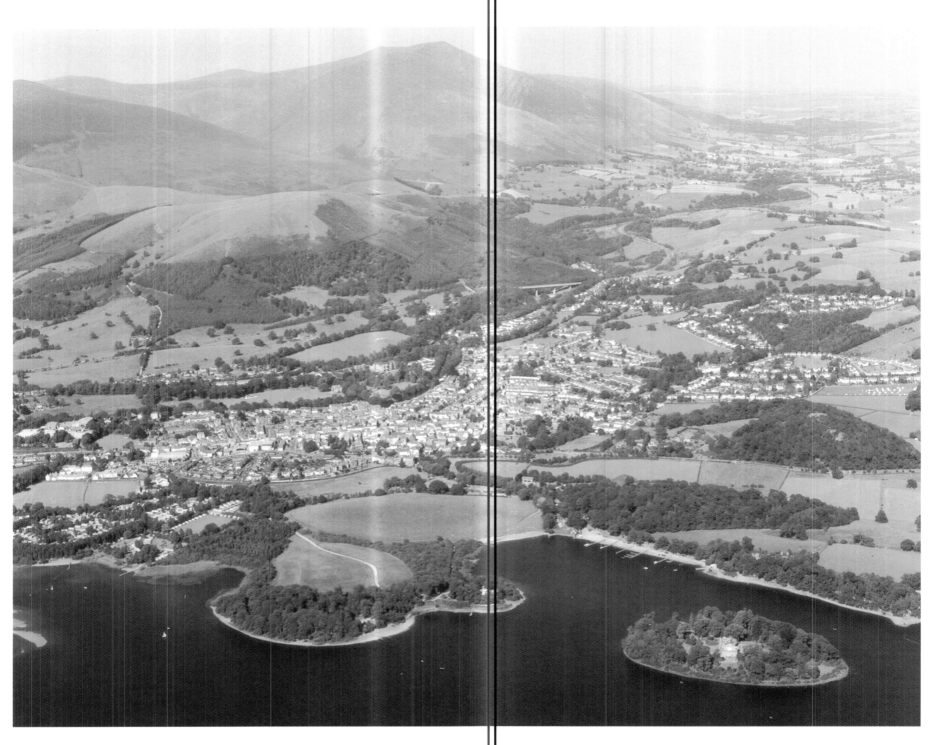

KESWICK LAKE DISTRICT CUMBRIA The small town
of Keswick lies on the north shore of Derwentwater. The northern fells, rising to the
massive outline of Skiddaw, 3,054ft above sea level, can be seen in the background.
This range of hills is the oldest in the Lake District, being made of Skiddaw slate, the
softness of which gives the fells their rounded shape.

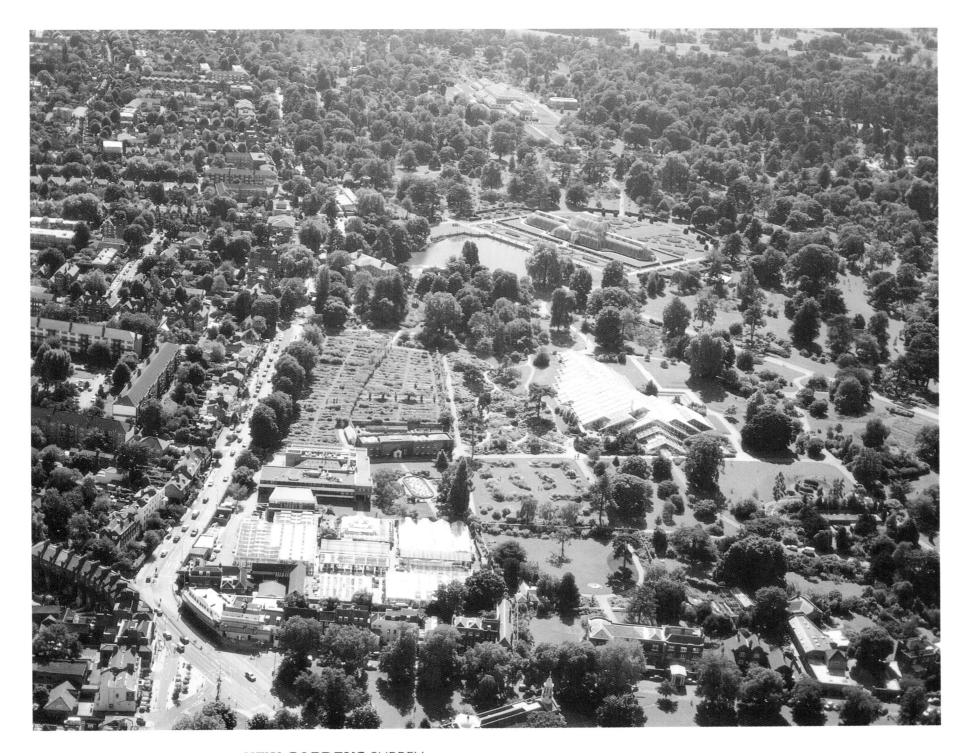

KEW GARDENS SURREY The Royal Botanic Gardens at
Kew were established in the grounds of Kew Palace in 1759. The 300-acre grounds
include Decimus Burton's two massive greenhouses—the Palm House (1844–48) and
Temperate House (1860–99)—as well as the Princess of Wales Conservatory, which
contains 10 different tropical climates.

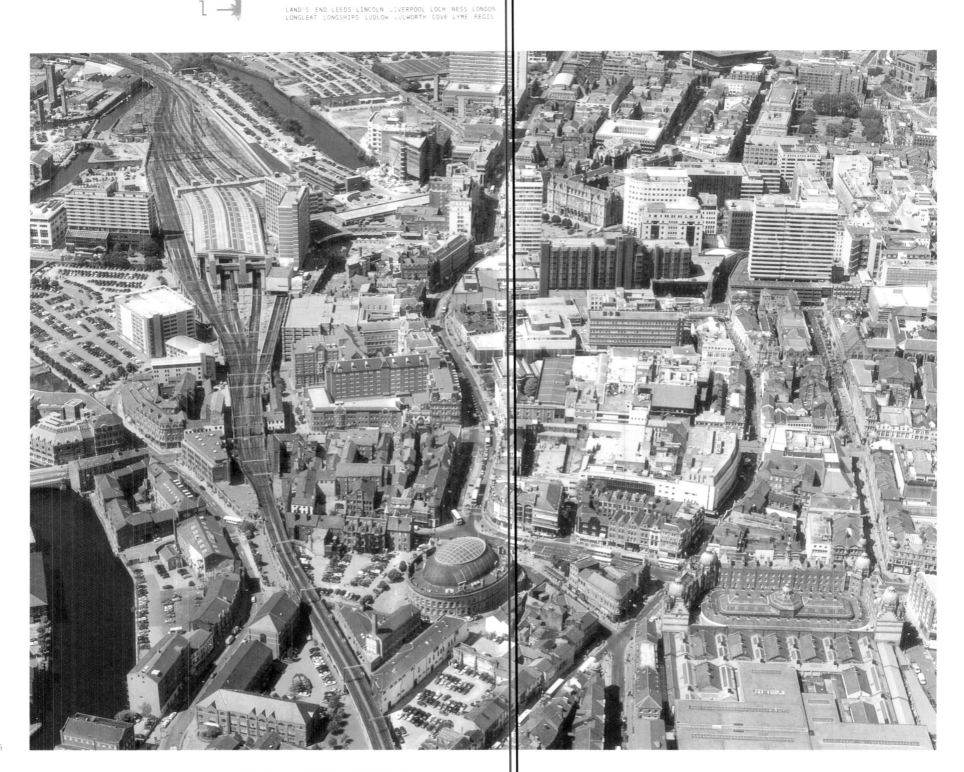

106

LEEDS WEST YORKSHIRE Founded on the textile trade, Leeds grew during the Industrial Revolution to become the commercial centre of Yorkshire. Although the city has been extensively redeveloped over the years the centre still contains some fine Victorian buildings including local architect Cuthbert Broderick's Town Hall and glass-domed Corn Exchange.

LAND'S END CORNWALL The southwestern extremity of mainland Britain, Land's End's cliffs (right) stand 200ft high. They mark the end of the granite mass of Cornwall's Penwith Peninsula, known for its ancient burial chambers, standing stones and Iron Age village of Chysauster.

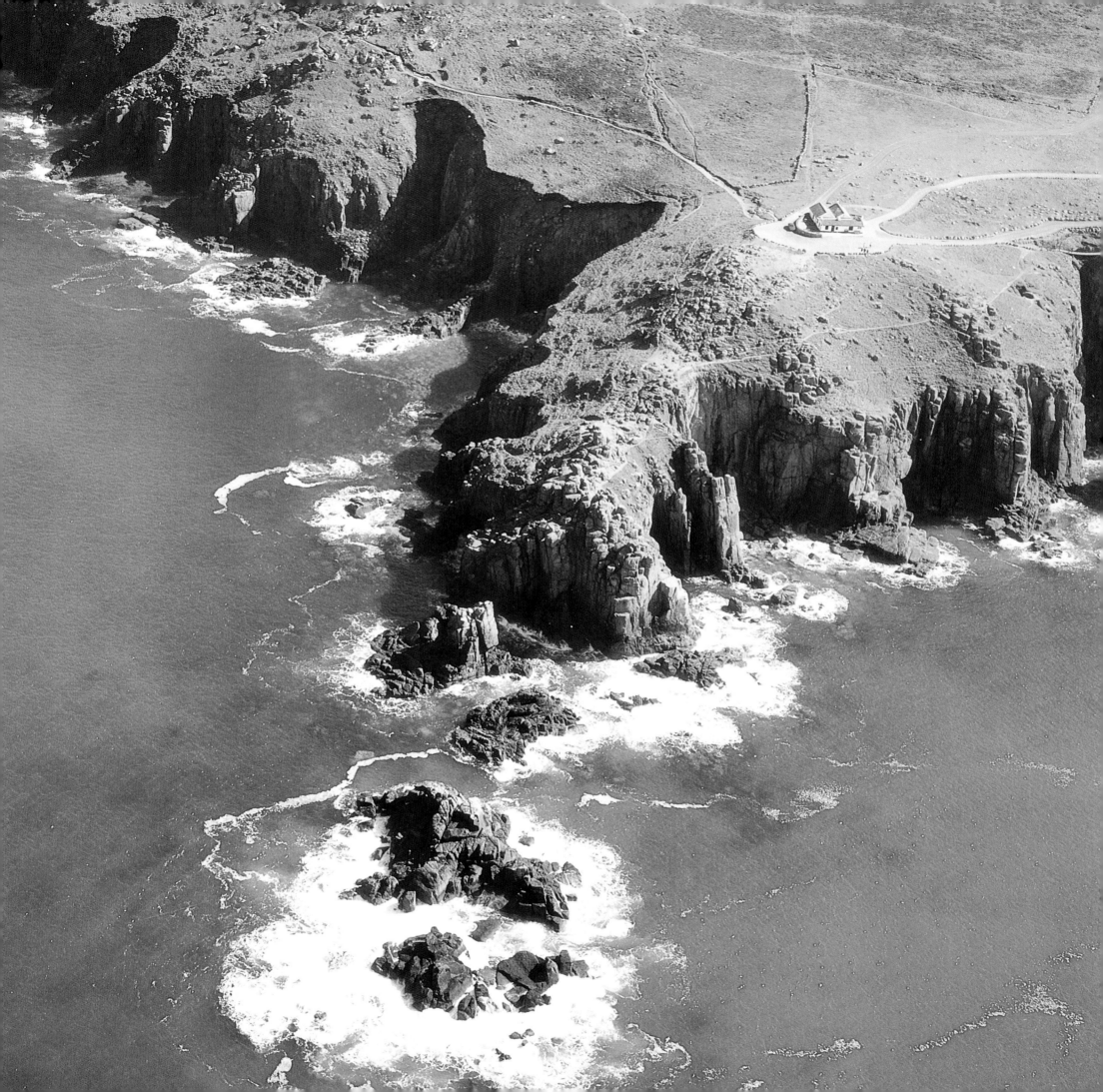

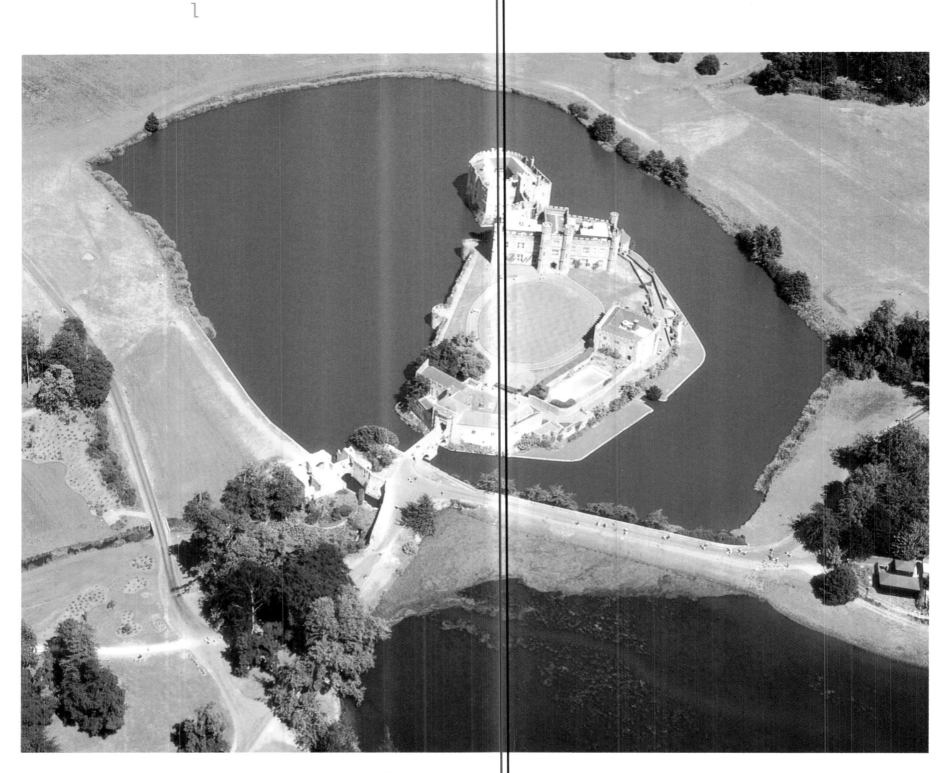

LEEDS CASTLE KENT Picturesquely situated on two islands in the middle of a natural lake, Leeds Castle was originally a Saxon manor house. Rebuilt in stone in the 12th century it became a royal possession in 1278 during Edward I's reign, at which time the gloriette (keep) rising straight out of the lake was built.

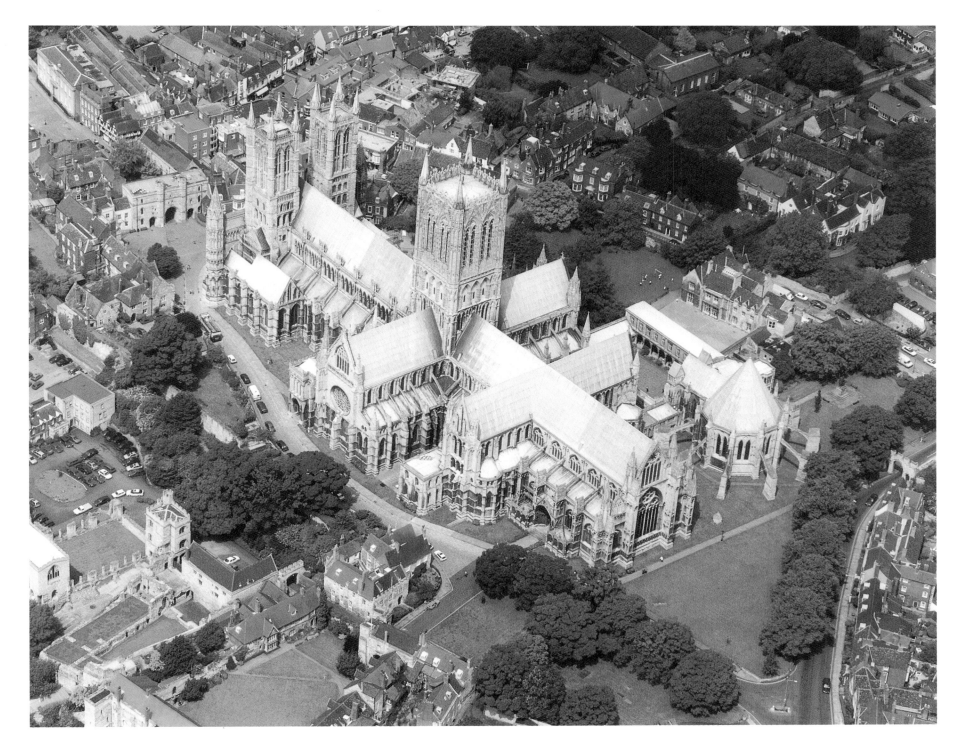

LINCOLN CATHEDRAL LINCOLNSHIRE Standing at
the top of a hill, Lincoln Cathedral dominates the town. It was rebuilt after the original
Norman cathedral was destroyed in an earthquake in 1185, and today's building was
largely completed 100 years later. The central tower, housing the 5.5-ton bell named
'Great Tom of Lincoln', stands 271ft high.

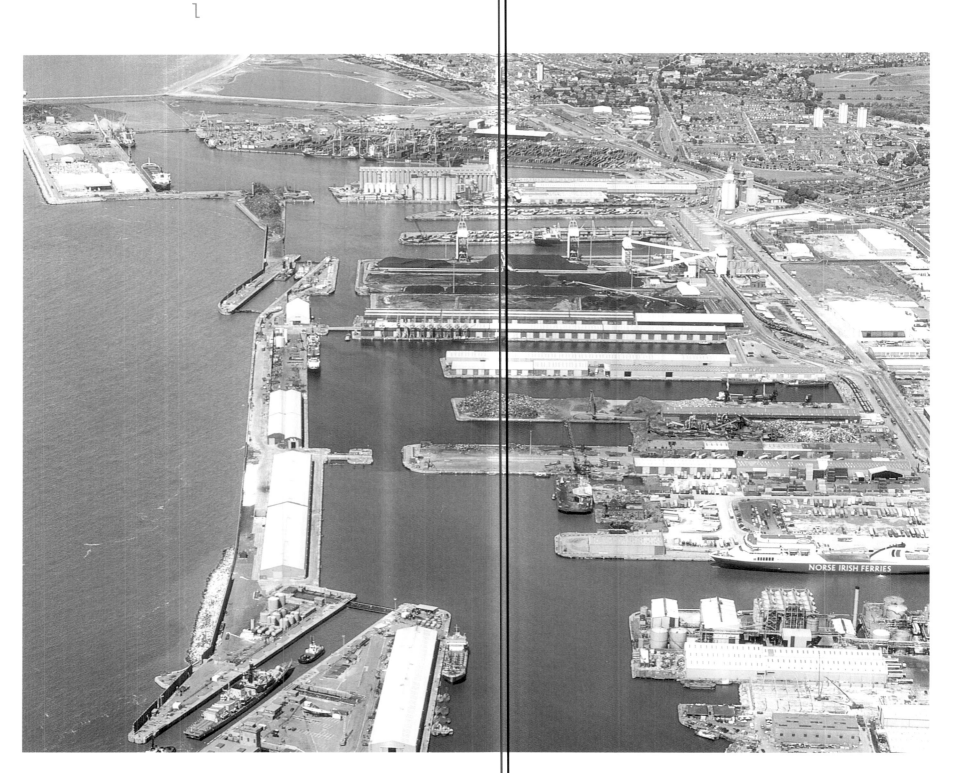

LIVERPOOL DOCKS LANCASHIRE Liverpool's prosperity was founded on transatlantic shipping using its large harbour on the Mersey estuary, which was not dependent on the tides. The old docks near the centre of Liverpool are no longer used by shipping but the new dock complex, further north towards Bootle, is a busy container and ferry port.

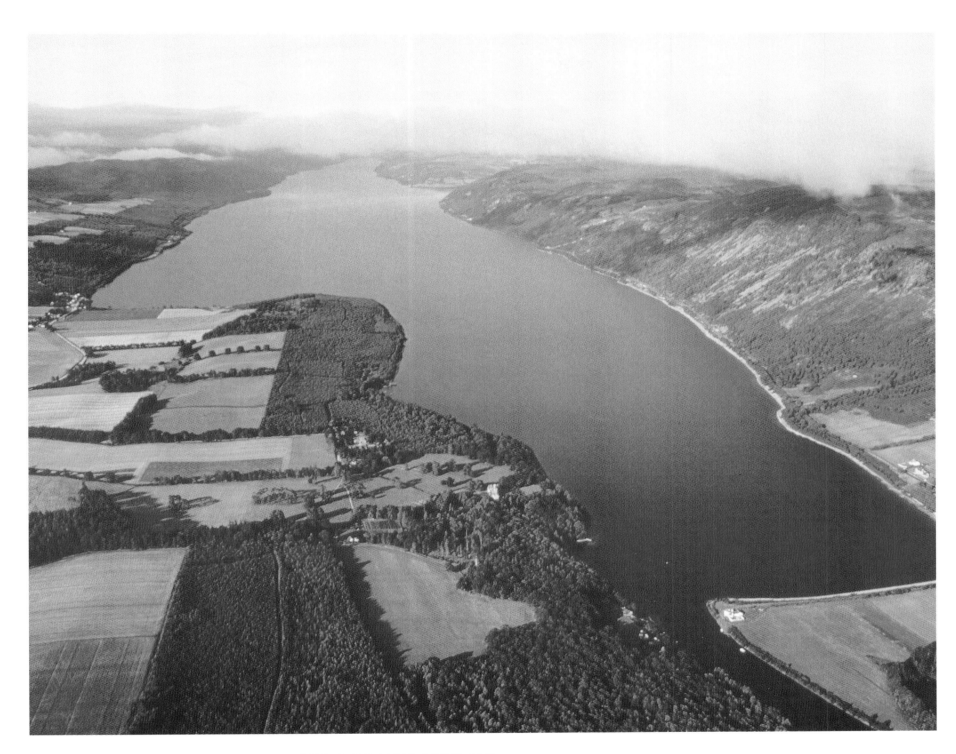

LOCH NESS HIGHLANDS SCOTLAND The Great Glen
is a geological fault almost splitting Scotland in two, the course of which is traced by
the Caledonian Canal, linking a series of lochs. Five miles southwest of Inverness lies
Loch Ness. Twenty-three miles long and a mile wide, with steep slopes on either side,
the loch is up to 900ft deep in places. It is, of course, famous for its legendary, elusive
monster.

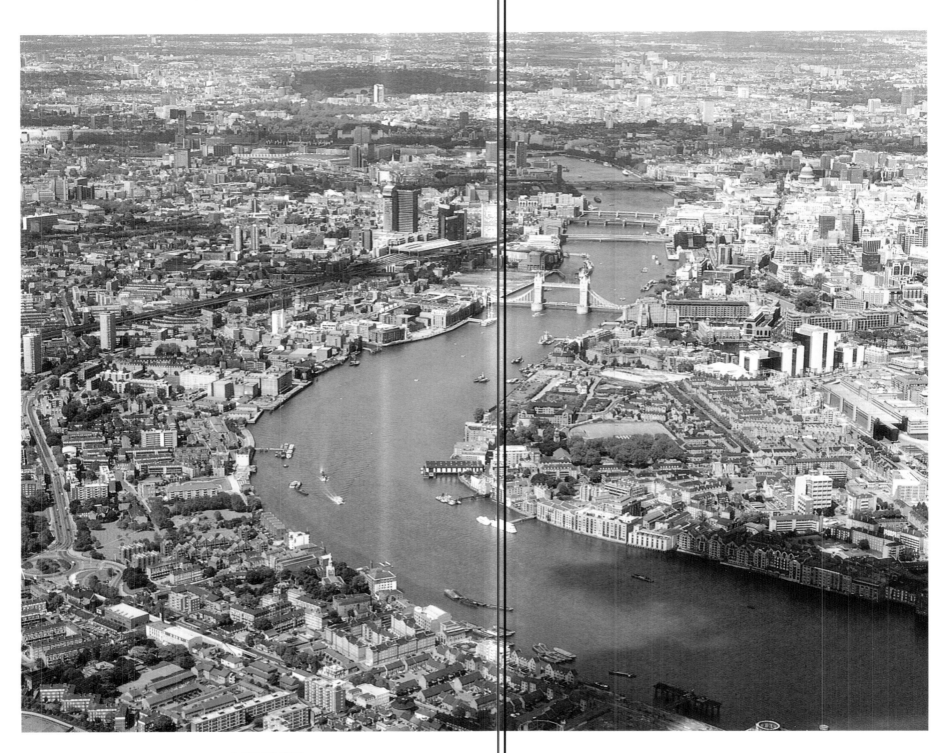

LONDON London grew up around the Roman crossing of the River Thames, which took place where London Bridge now stands. This bridge, now connecting the City of London with Southwark, was London's only crossing until one at Westminster was completed in 1750. Tower Bridge, opened in 1894, crosses further downstream by the Tower of London.

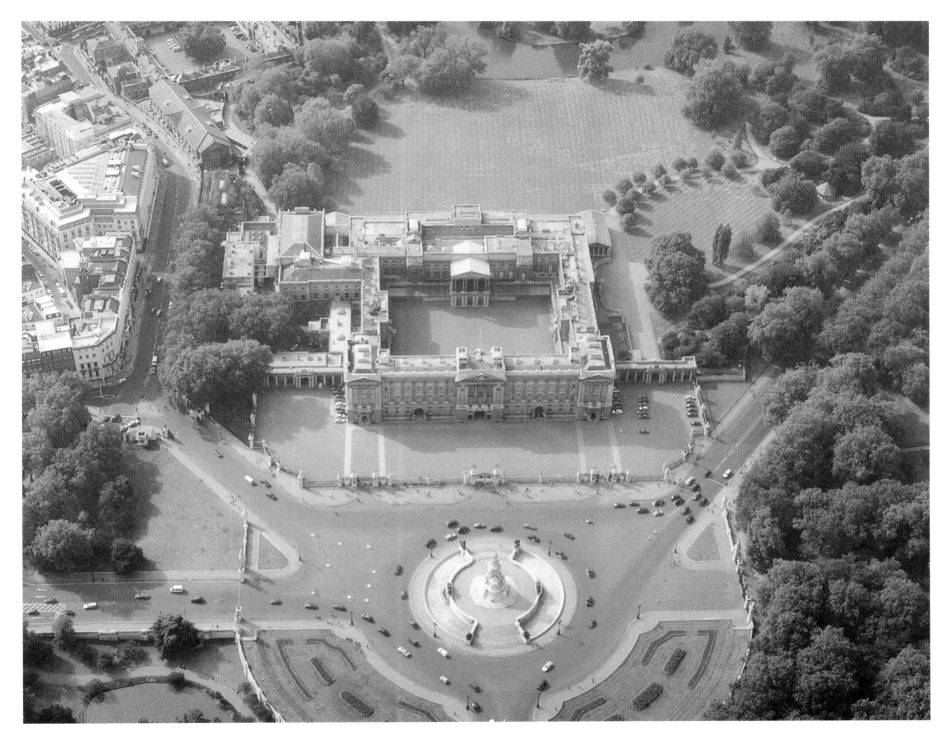

LONDON BUCKINGHAM PALACE Originally built
for King George IV, who died before its completion, Buckingham Palace went far over
budget and was the cause of much rancour. The next monarch, William IV, did not live
there either, but Queen Victoria gradually came to like the place and since her time it
has remained the first residence of the monarch, though having to undergo regular
improvements and refurbishments.

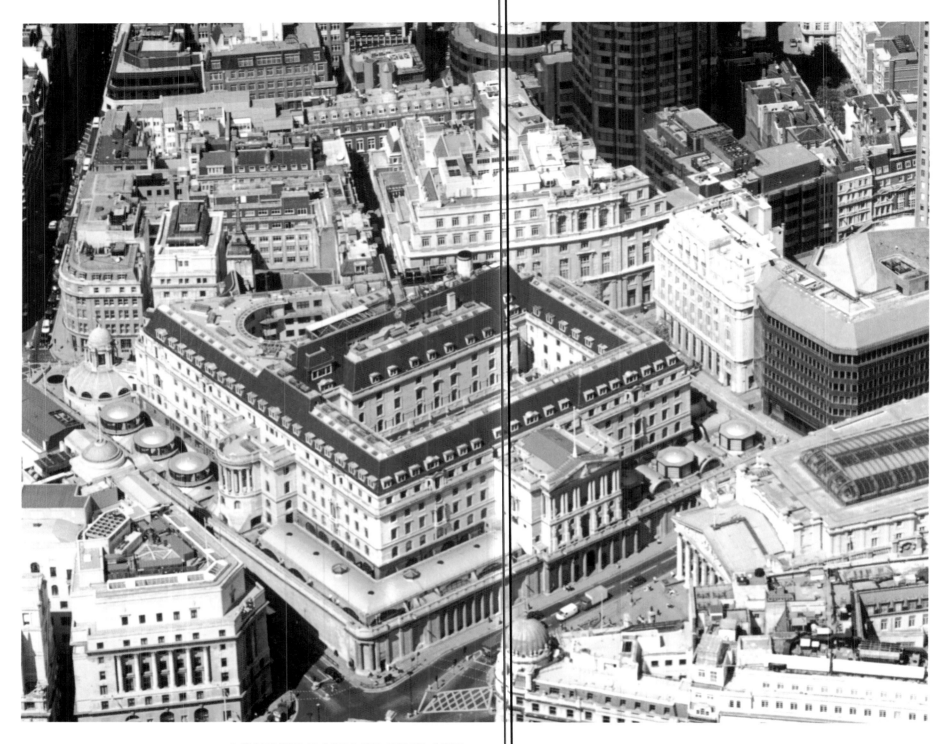

LONDON BANK OF ENGLAND The Bank of England is situated in the heart of the City of London, the capital's commercial district. Founded in 1694 by Royal Charter as a private company, the architect Sir John Soane rebuilt the Bank's Threadneedle Street premises at the end of the 18th century. They were again extensively redesigned in the 1920s and 1930s.

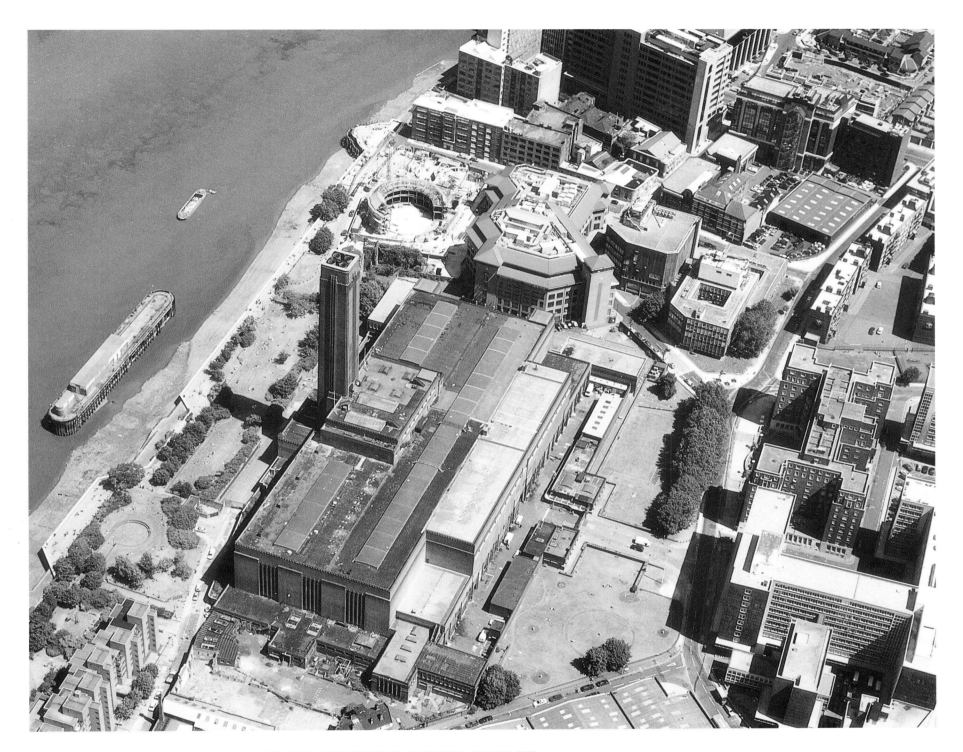

LONDON BANKSIDE POWER STATION

Standing on the south bank of the River Thames in Southwark, Sir Giles Scott's
Bankside Power Station, although opened in only 1963, is being converted to house
part of the Tate Gallery's art collection. Nearby in this photograph, the reconstruction
of Shakespeare's open air Globe Theatre is in progress, near the theatre's original site.
The Bankside development will include a footbridge across the Thames allowing access
to St Paul's.

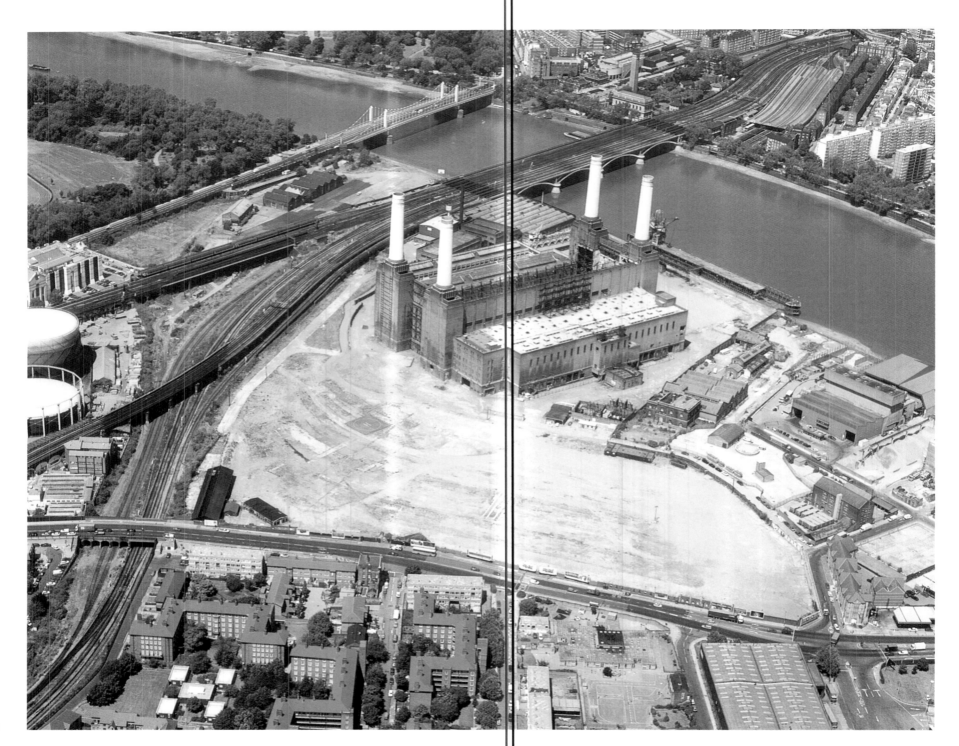

LONDON BATTERSEA POWER STATION This
massive brick structure, also designed by Sir Giles Scott, lies by the Thames in Battersea
in southwest London like an upside-down table with its chimneys being the legs. The
power station was opened in 1937 but now lies unused, its roof and part of one wall
dismantled.

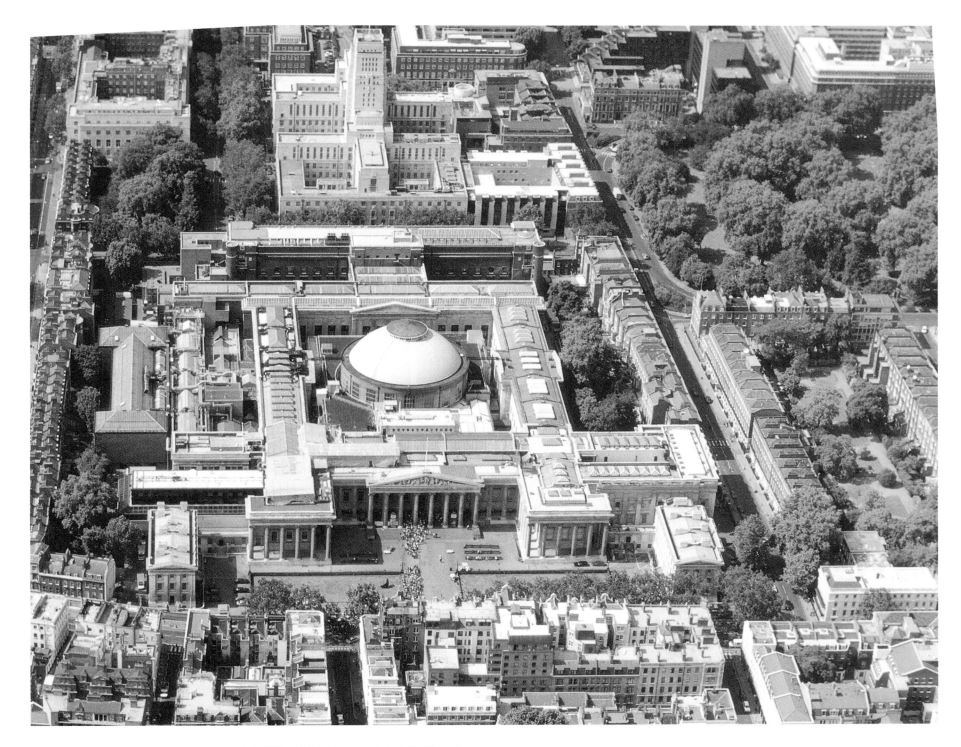

LONDON BRITISH MUSEUM The British Museum
houses an internationally significant collection of art and archaeological treasures. The
Greek Revival building in Bloomsbury in central London also includes the circular old
Reading Room of the British Library beneath the central dome. North of the museum
stands the University of London's 1930s Senate House.

LONDON DOWNING STREET A narrow road off
Whitehall leads to the British Prime Minister's residence at No 10 Downing Street. This
17th century building has been the Prime Minister's official home since 1732. The
neighbouring buildings are also owned by the Crown, No 11 being the Chancellor of
the Exchequer's residence.

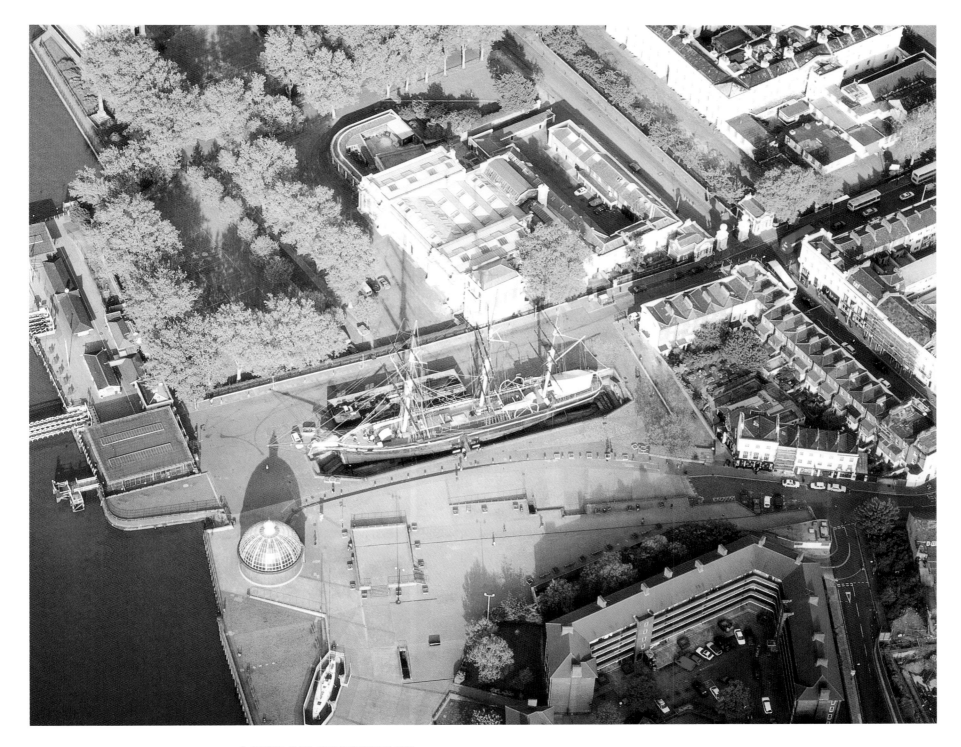

LONDON GREENWICH Greenwich's position near
London's Dockland has given the area many maritime connections. The famous tea
clipper *Cutty Sark* lies in dry dock on the river bank. Behind is the Royal Naval College,
begun as a new palace for Charles I in 1664 and continued by Sir Christopher Wren in
the 1690s. The smaller yacht at the bottom of the photograph is *Gypsy Moth* in which
Sir Francis Chichester circumnavigated the globe single-handed.

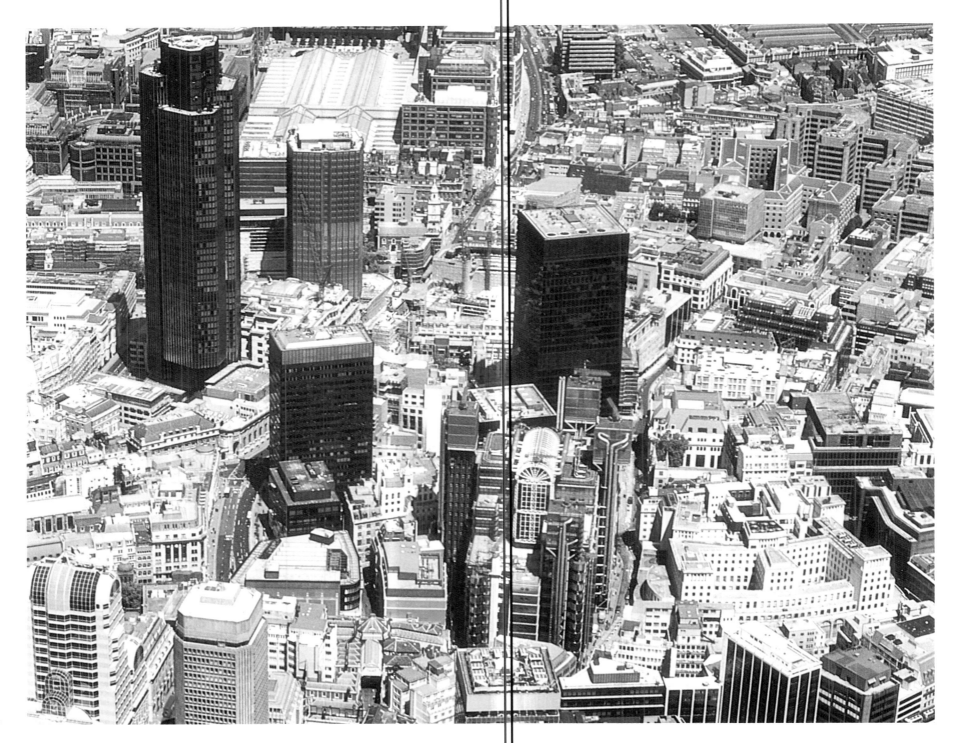

LONDON LLOYDS BUILDING Designed and built in 1986 by Richard Rogers, the Lloyds building is one of the most interesting modern structures in the city. Its exterior high-tech ducts and piping, reminiscent of Rogers' Pompidou Centre, are appreciated best when the building is floodlit at night.

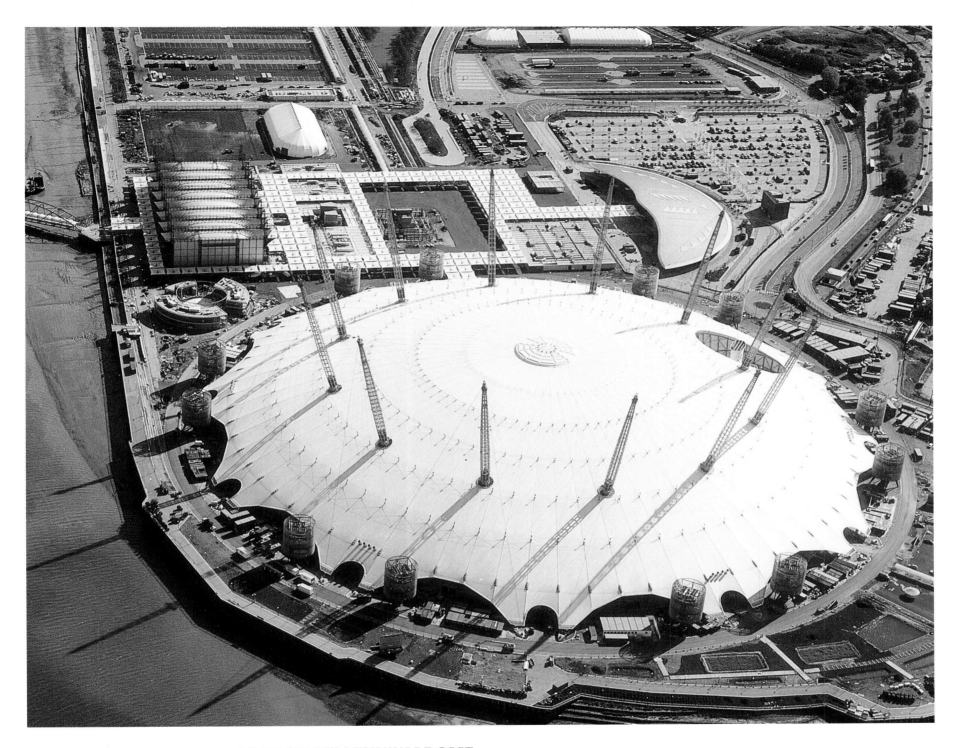

LONDON MILLENNIUM DOME Despite much
controversy about its contents, whether it would be open in time and spiralling costs,
the impressive dome is the largest construction in the world built to celebrate the new
millennium. Designed by the Richard Rogers Partnership, it is destined for a life of
approximately 25 years.

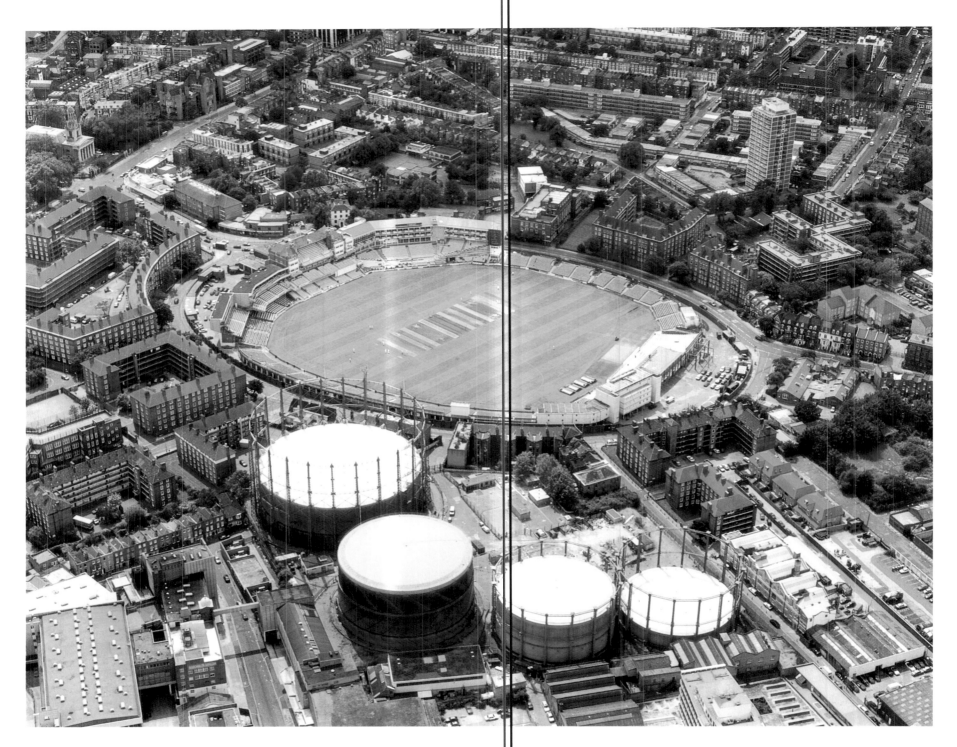

LONDON THE OVAL KENNINGTON This famous
cricket ground is the headquarters of Surrey County Cricket Club. Here the first Test
Match between England and Australia took place on 6–8 September 1880, England
winning by five wickets. Before becoming solely a cricket ground the Oval was an
important football venue, hosting most of the FA Cup semi-finals and finals between
1870 and 1892.

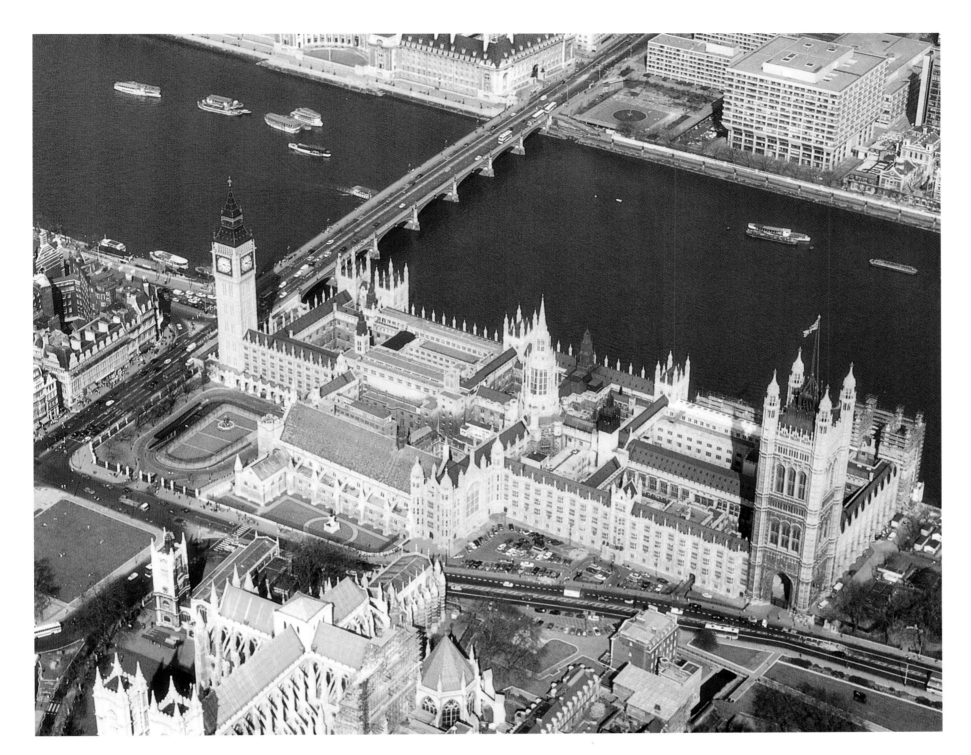

LONDON THE HOUSES OF PARLIAMENT

Recently restored and cleaned to a pristine state, the seat of Britain's national legislature stands on the spot of the old Palace of St Stephen's which was destroyed by fire in 1834. The present structure was designed specifically for its purpose by Sir Charles Barry and sumptuously decorated by A. W. Pugin. During World War 2 the building was quite badly damaged in over ten different air raids, but was restored immediately by Sir Giles Gilbert Scott.

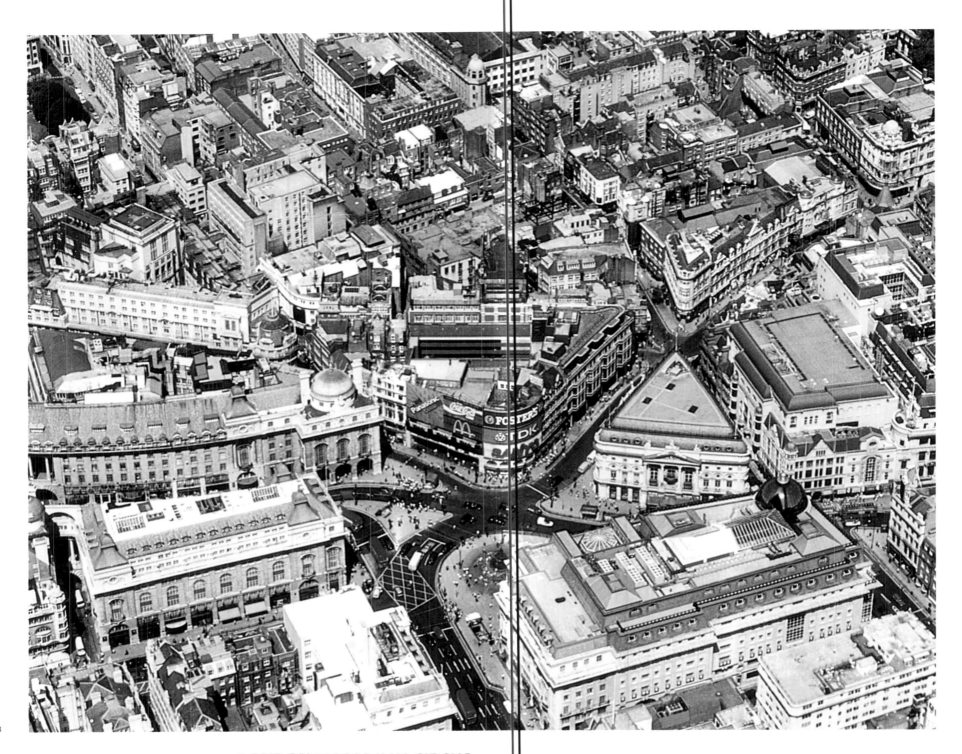

LONDON PICCADILLY CIRCUS Originally a symmetrical round-cornered intersection between Piccadilly and John Nash's Regent Street, the present Piccadilly Circus metamorphosed in the 1880s with the addition of the London Pavilion and Shaftesbury Avenue. At its centre stands the aluminium Statue of Eros, originally a fountain erected in memory of the philanthropic Lord Shaftesbury. This vortex of streets gained more of its contemporary character when advertisements were bolted onto some of the facades in 1910, becoming colossal by the 1920s. Recent changes mean that it is no longer a traffic island.

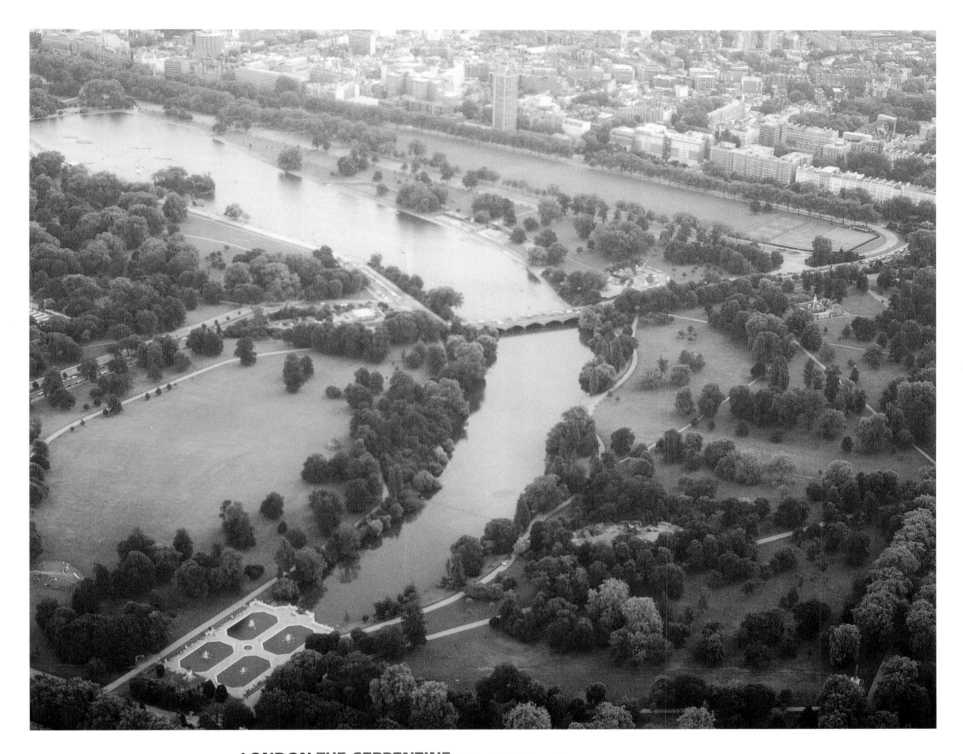

LONDON THE SERPENTINE Set in Hyde Park and
Kensington Gardens (where it is called Long Water), the Serpentine is a 40-acre artifi-
cial lake created by George III for his wife Queen Caroline in the 1730s. It is home to
many waterfowl and as well as a famous year-round bathing club. The bridge dividing
the lake was built in 1826.

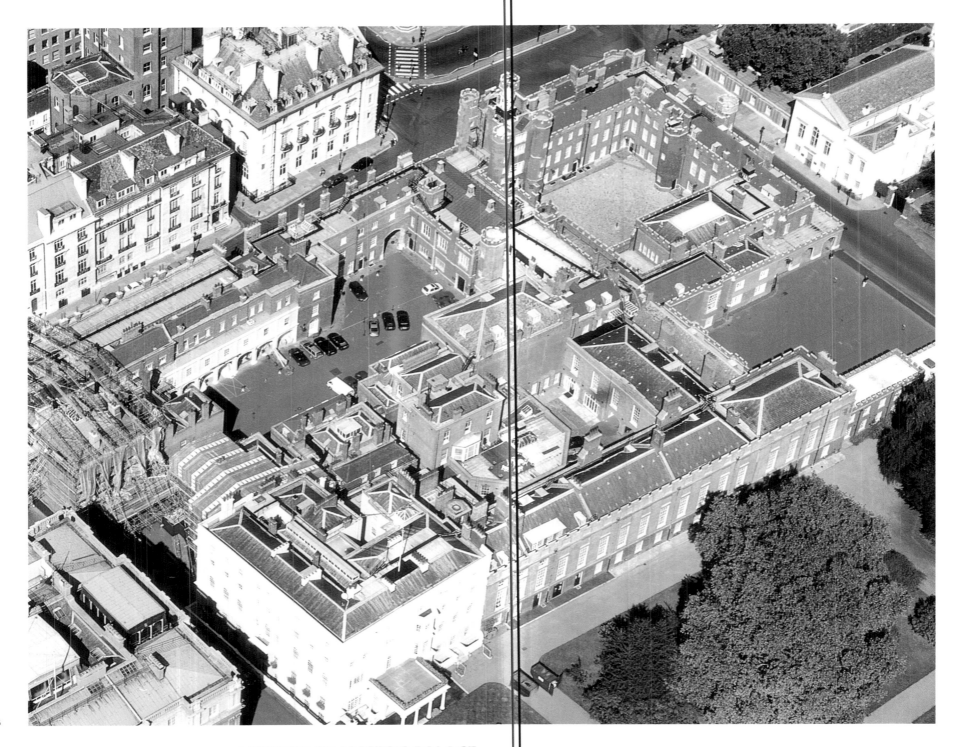

LONDON ST JAMES'S PALACE Built in red brick by
Henry VIII in 1532, St James's has seen interior and exterior alterations over the ages by
such luminaries as Wren, Hawksmoor, William Morris and Grinling Gibbons. It was the
main residence of the monarch in the 18th and early 19th centuries, eventually being
eclipsed by Buckingham Palace. It retains its historical pedigree by being the place from
which the accession of a each new monarch is proclaimed.

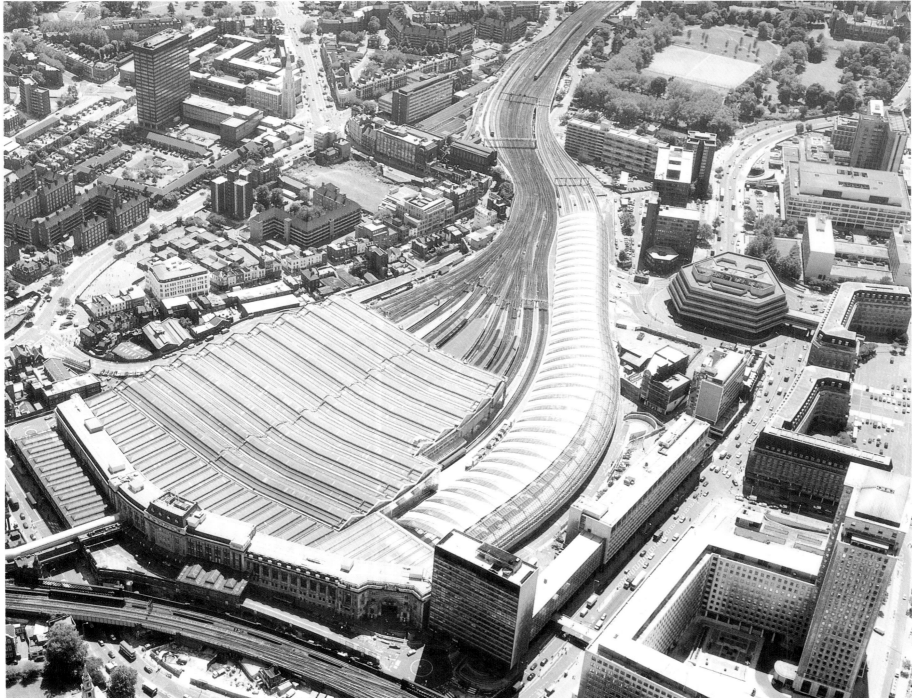

LONDON WATERLOO STATION Originally opened
in 1848 by the London & Southern Railway, busy Waterloo Station grew so haphazardly
that it was finally completely redesigned and rebuilt 1900–22. Since then little changed
until December 1990 when work started on the caterpillar-like addition of Waterloo
International Station over what used to be platforms 18 to 21. From here sleek Eurostar
trains run to Paris and Brussels via the Channel Tunnel.

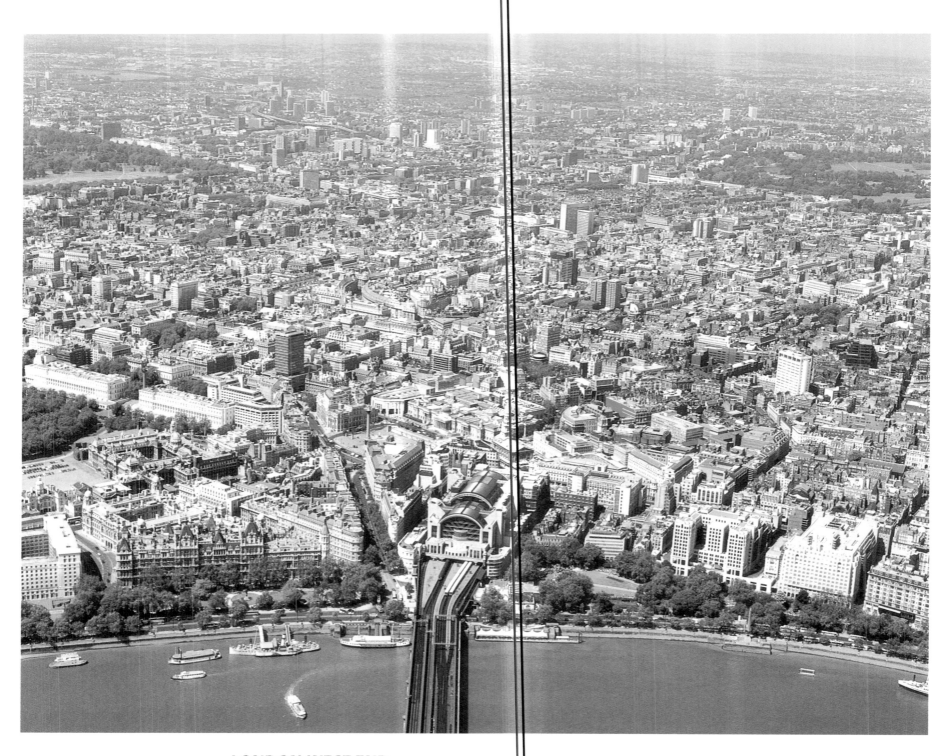

LONDON WEST END The City of Westminster, rather than the City of London to the east, contains the capital's main shops and theatres. At its centre is Trafalgar Square, visible in the centre of the photograph above the Art Deco-style Charing Cross railway station. To the left of the railway bridge lie the government offices of Whitehall.

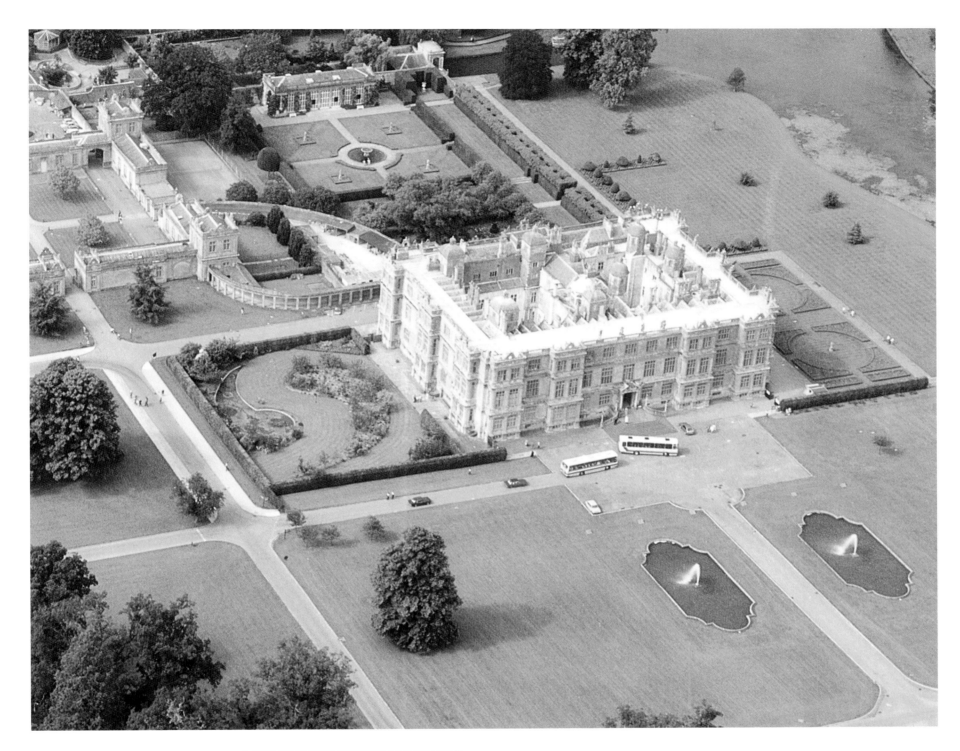

133

LONGLEAT HOUSE WILTSHIRE Built by Sir John
Thynne between 1554 and his death in 1580, Longleat House is a design classic of early
English Renaissance architecture and one of the greatest houses in the country. Its
gardens were later redesigned and turned into a seemingly natural park by Lancelot
'Capability' Brown, which though frowned on by purists at the time has since been
recognised as a work of art in the same league as the house itself.

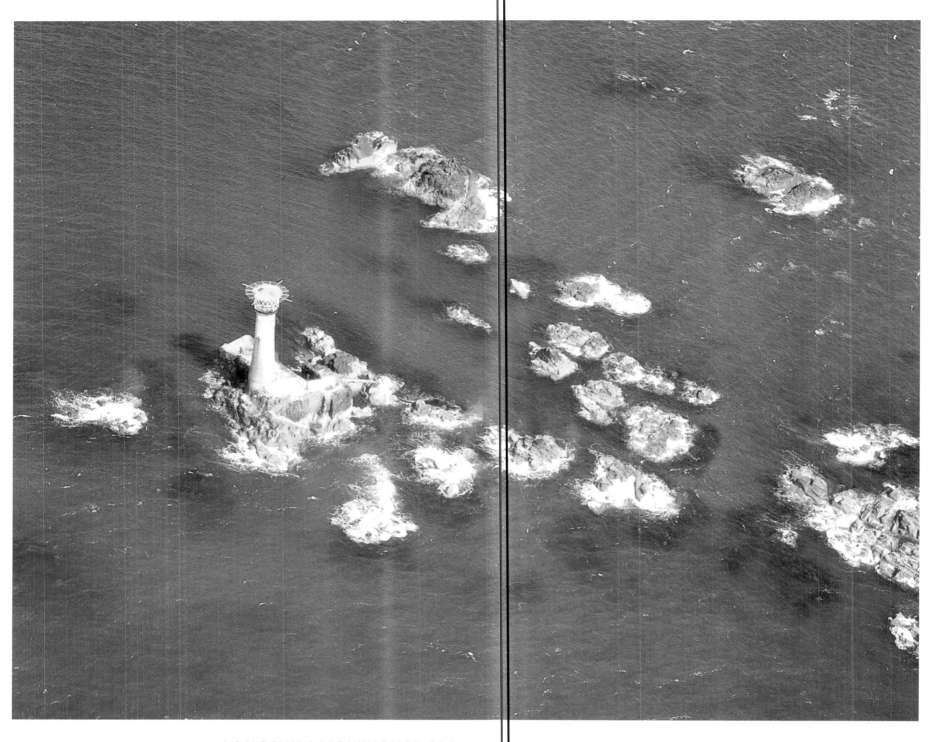

LONGSHIPS LIGHTHOUSE CORNWALL On a
lonely rock a few kilometres off the coast of Land's End in Cornwall, braving the wind
and wave storms of the Atlantic, stands the Longships Lighthouse. Except for the Isles
of Scilly some 25 miles distant there is nothing but ocean until the American continent
is reached some 3,000 miles away.

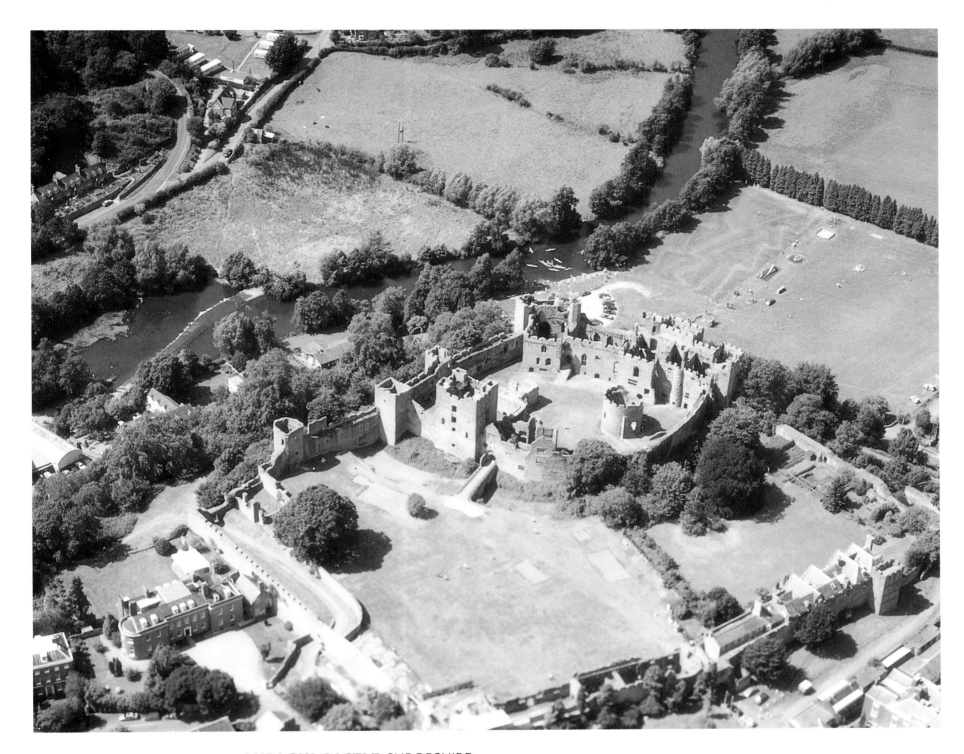

LUDLOW CASTLE SHROPSHIRE Overlooking the River
Teme, Ludlow is one of the great Welsh border castles, built by Roger de Lacy in 1085
as part of the Norman aim to contain and dominate the Welsh. Up until Tudor times
the castle was active and important, gaining royal status after the Mortimers dislodged
the Lacys and manoeuvred their way to the throne.

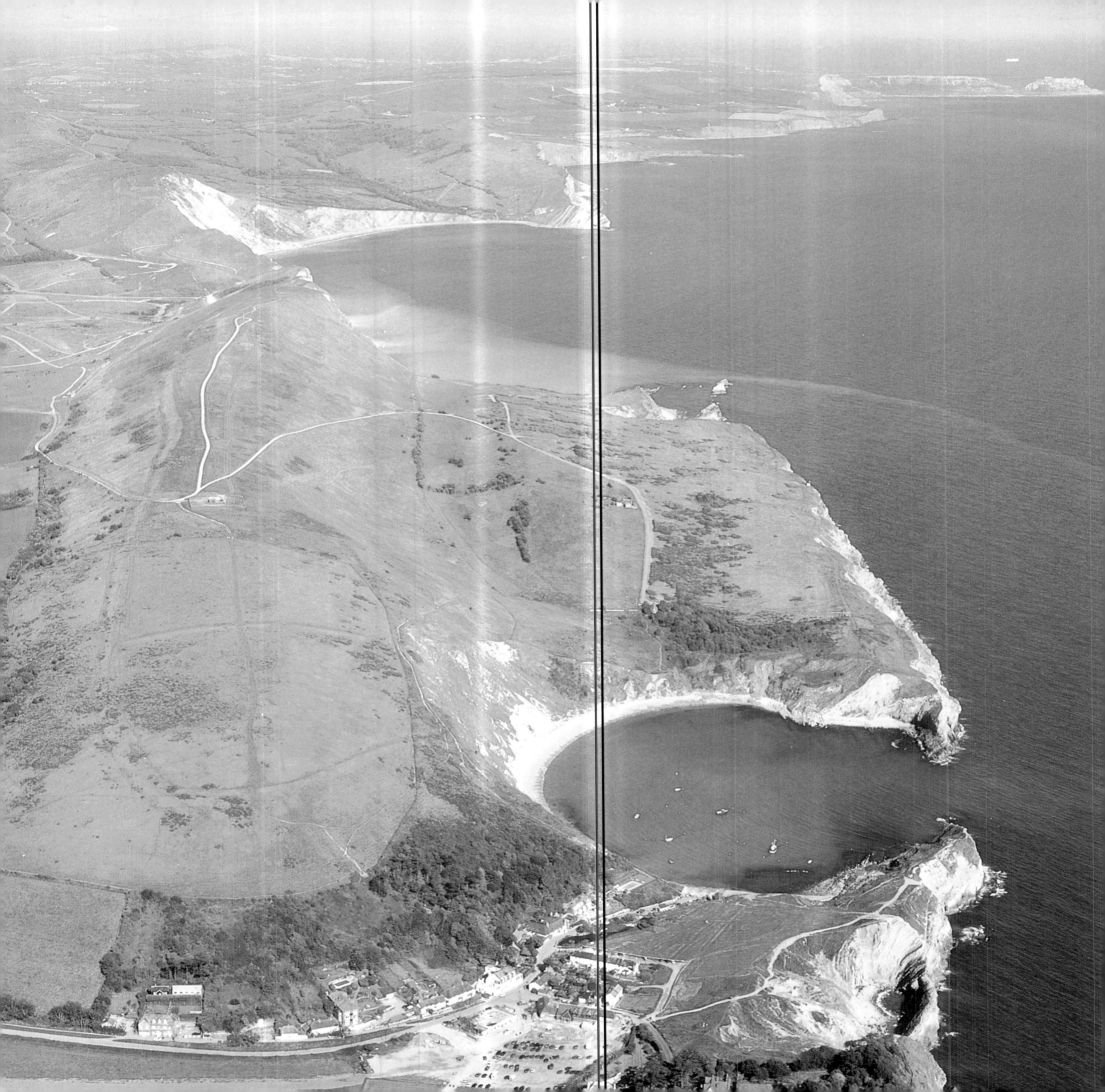

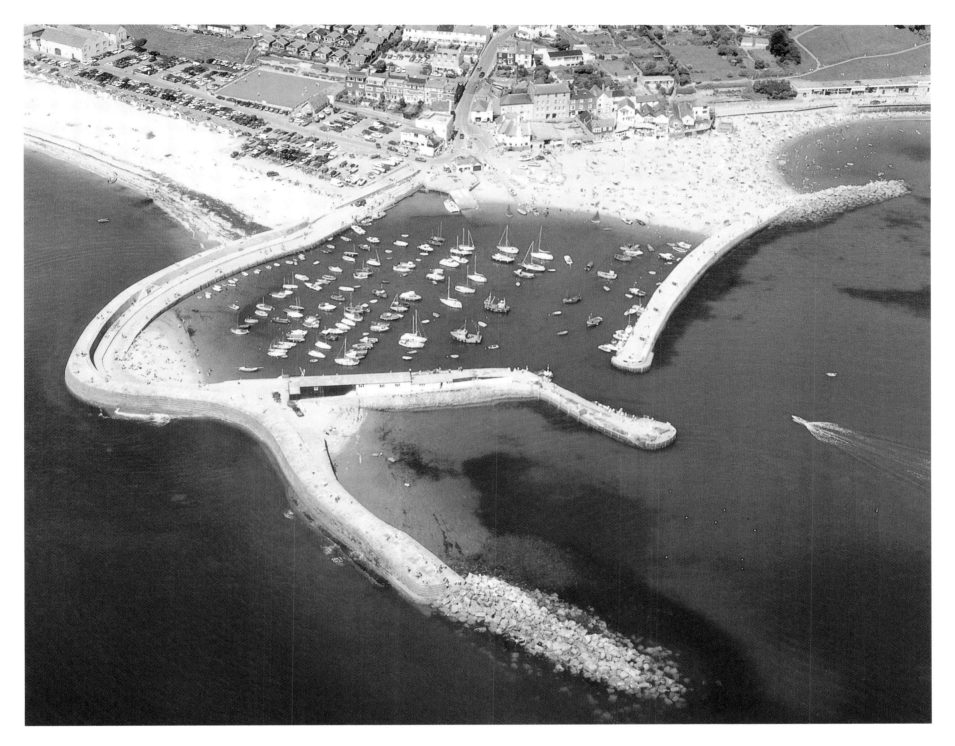

LULWORTH COVE DORSET Neatly scalloped by the sea out of the soft chalk after it had broken through the cliff barrier of limestone, Lulworth Cove (left) reflects clearly the process of erosion that occurs on this stretch of southern coastline. Just a little further west is Durdle Door—a great limestone arch, that will eventually become a stack.

LYME REGIS DORSET Formerly a medieval port of some importance, Lyme Regis fell into decline until the 18th century when it became fashionable as a seaside resort. It was further popularised by the novelist Jane Austen, who set and wrote part of her novel *Persuasion* there.

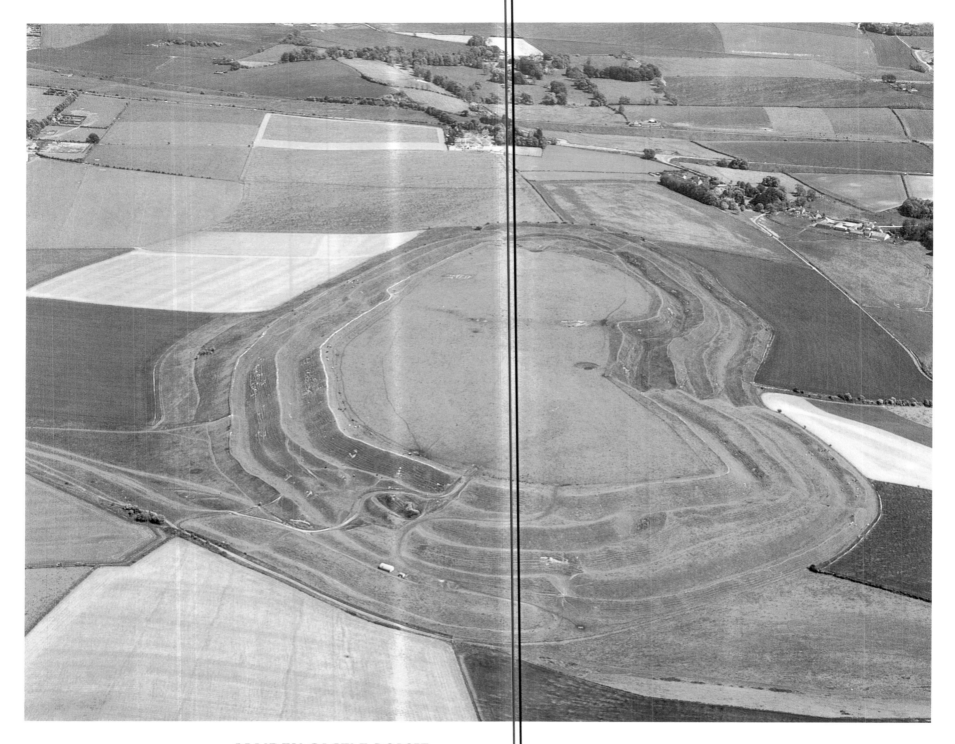

MAIDEN CASTLE DORSET Perhaps the largest pre-
historic construction in England (right), its concentric ditches and ramparts are over a
mile in circumference and the whole structure covers 47 acres. Hilltop forts such as this
were abandoned soon after the Roman Conquest and Maiden Castle's impregnability
was disproved when it was stormed with little trouble by Vespasian's Legion.

MALMSBURY CASTLE & ABBEY WILTSHIRE
Set on a high rocky hill between the rivers Avon and Inglebourne, Malmesbury holds a
strategic position that ensured its continued settlement. Six bridges lead into the town,
built predominantly of wonderful glowing gold Cotswold limestone.

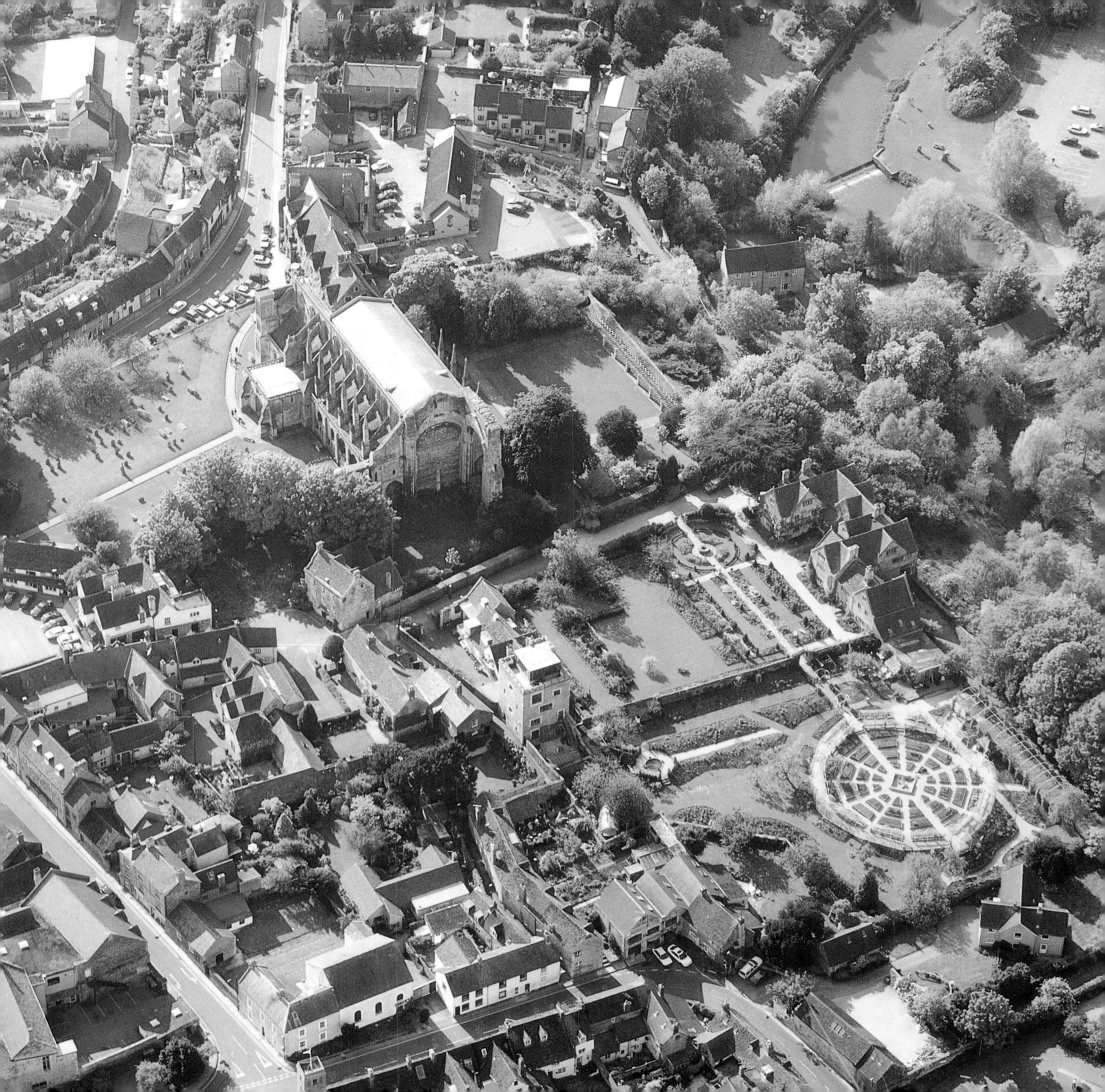

m

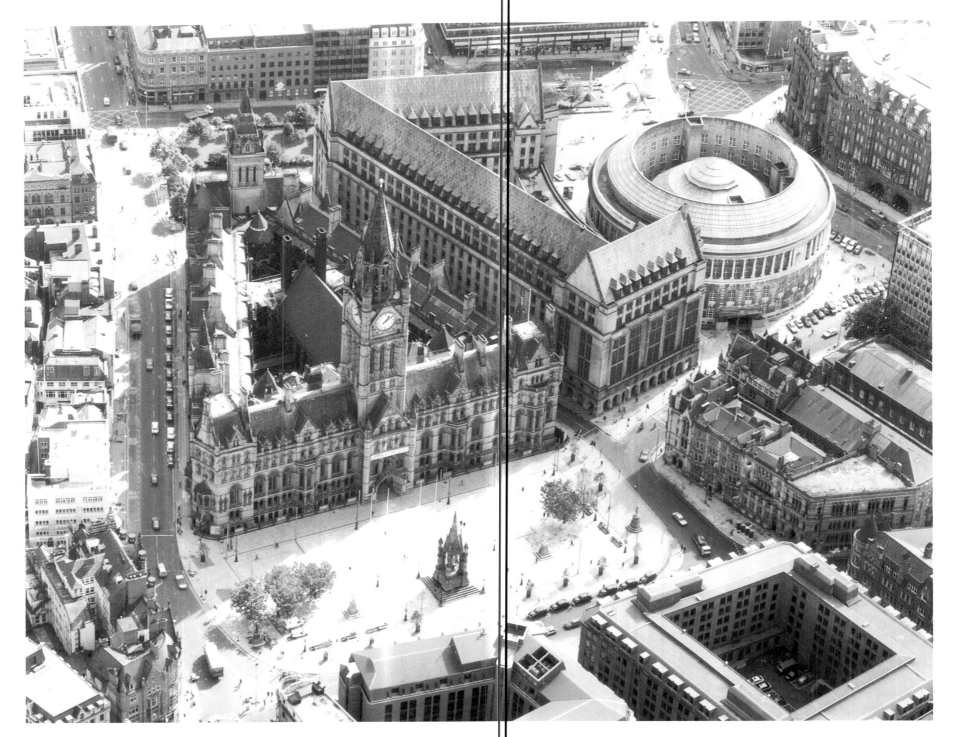

140

MANCHESTER TOWN HALL LANCASHIRE

A tribute to the Victorian Gothic style, Manchester Town Hall is also a monument to
the city's Victorian prosperity. Designed by Alfred Waterhouse and completed in 1877,
it is elaborately decorated and has a 280ft tower containing a carillon of 23 bells.

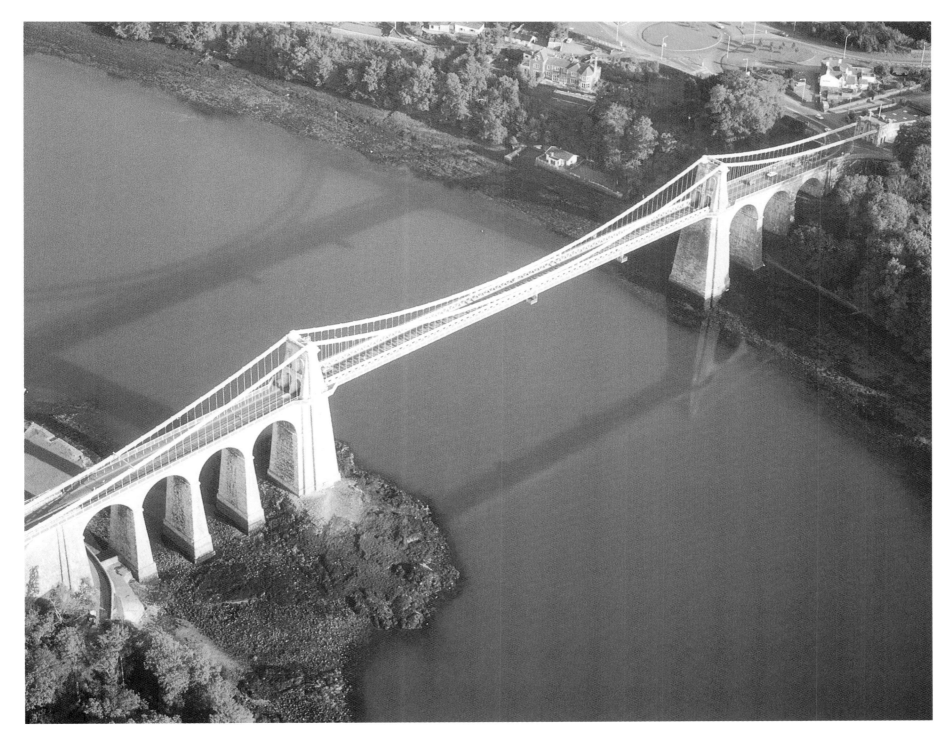

MENAI BRIDGE GWYNEDD WALES The Menai
bridge links the Isle of Anglesey to mainland Wales and was designed and built by
Thomas Telford in 1826. It crosses the channel 100ft above the water with a single span
of 579ft and provides stunning and spectacular views.

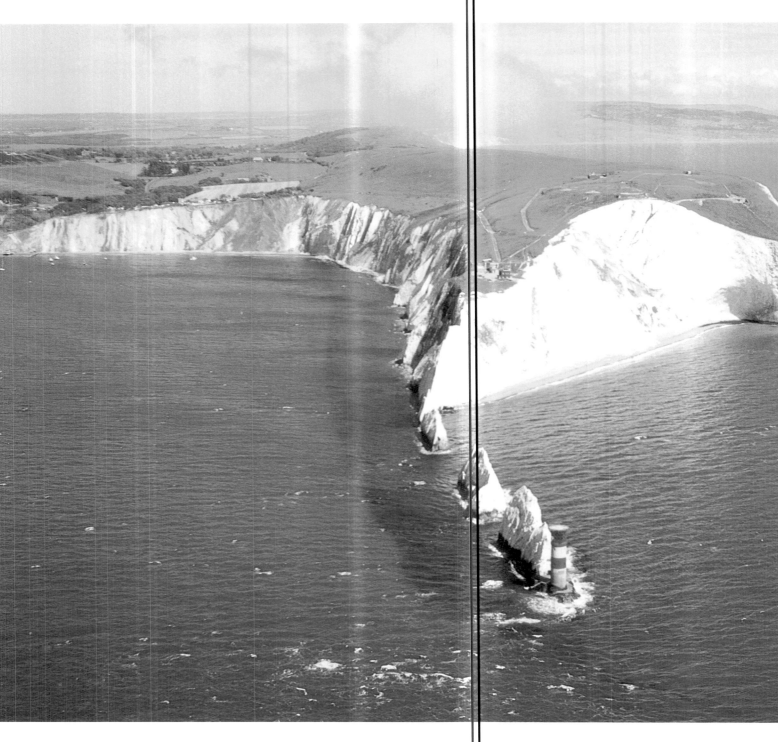

142

THE NEEDLES ISLE OF WIGHT The Needles are huge
chalk stacks whose links have been eroded. They stand just off the westernmost tip of the
Freshwater Peninsula. Tennyson Down which leads to them, is named after the famous
poet who lived locally and walked there daily.

NEWCASTLE METRO CENTRE TYNE & WEAR
Although it has declined considerably from its great industrial past, Newcastle has a
refocus of civic pride at Gateshead some four miles out of the town proper in the form of
the ultra-modern Metro Centre (right) shopping mall. Built on the American archetype its
huge bulk contains a self-sufficient world of shopping for the consumer's benefit.

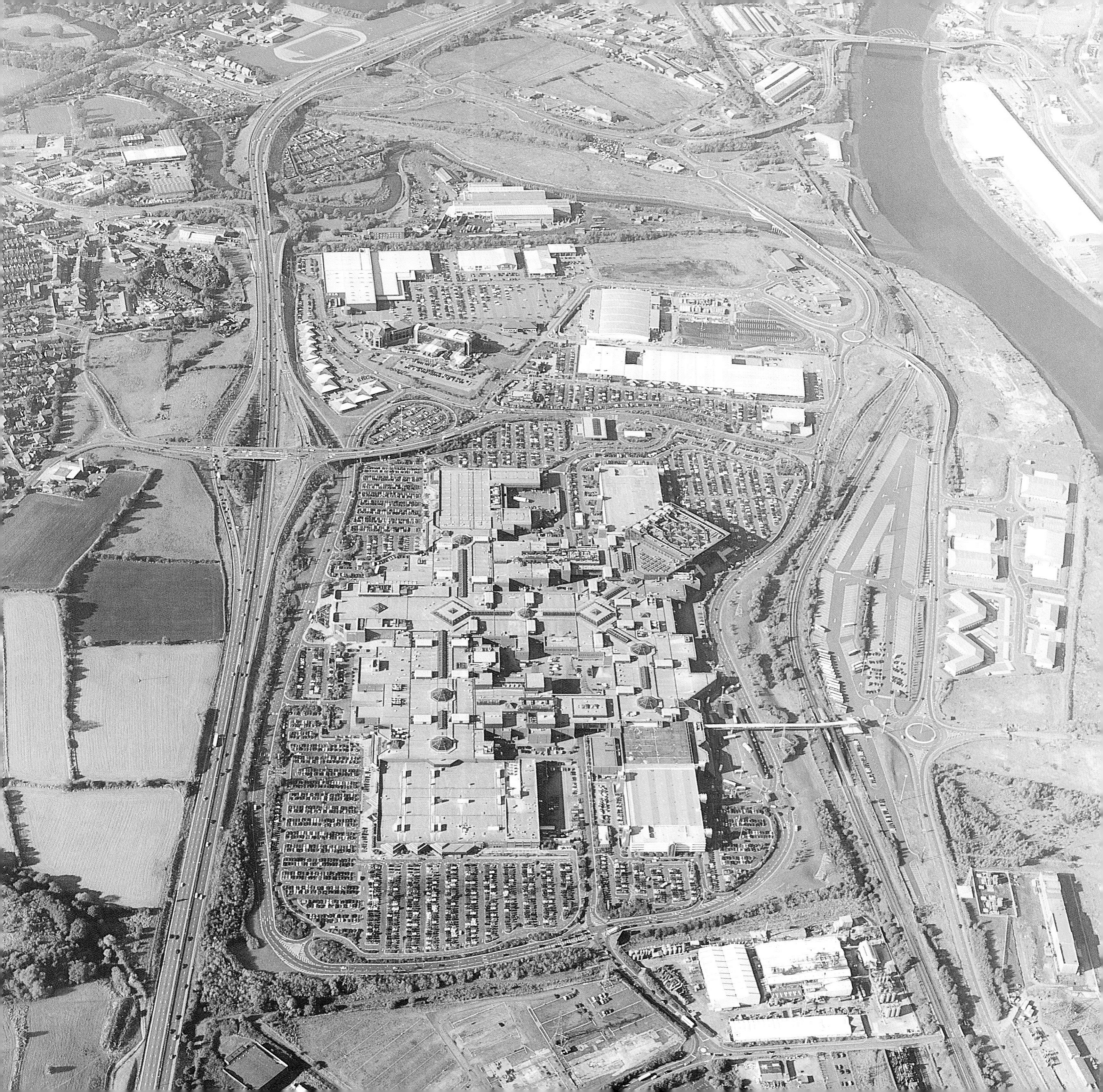

n

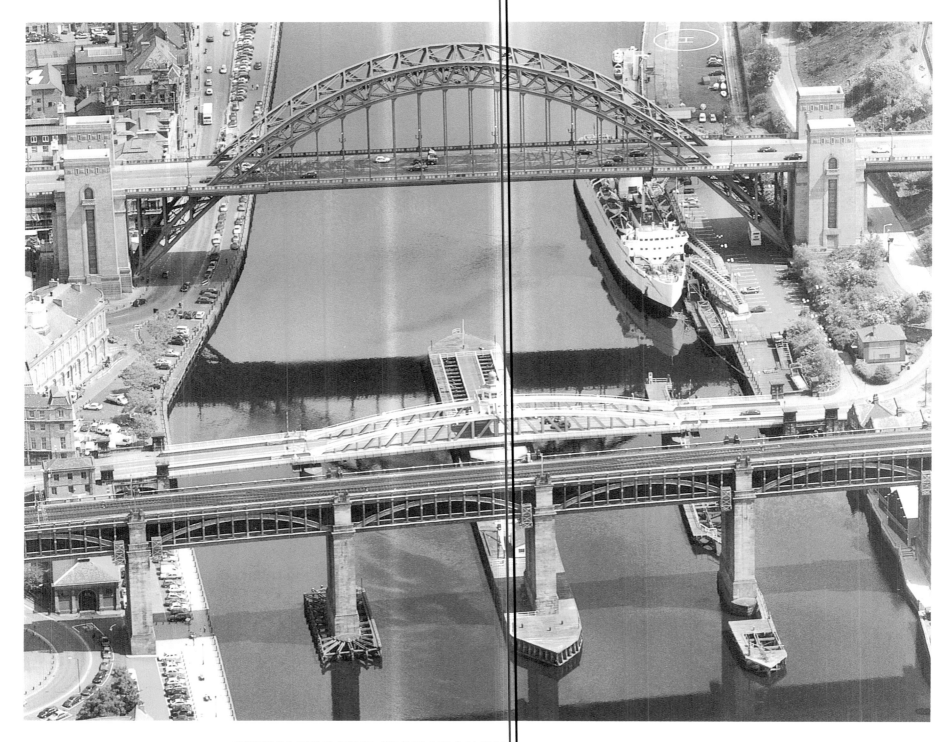

NEWCASTLE BRIDGES TYNE & WEAR No fewer
than six bridges span the River Tyne at Newcastle. They are testament to the rapid
expansion over the last two centuries of this busy industrial city. A seventh is on its way
in the form of a pedestrian bridge for the Millennium, but the most famous—and a key
part of Newcastle's identity—is the Tyne Bridge (uppermost of the three seen in this
picture). Older is the High Level Bridge, at the bottom. Built in 1849, it provided
Newcastle with its first rail link to London—and its lower-level roadway was an innova-
tion for its time. The 1876 Swing Bridge, just above it, employed a hydraulic swivel
mechanism to allow taller-masted vessels to make their way upriver.

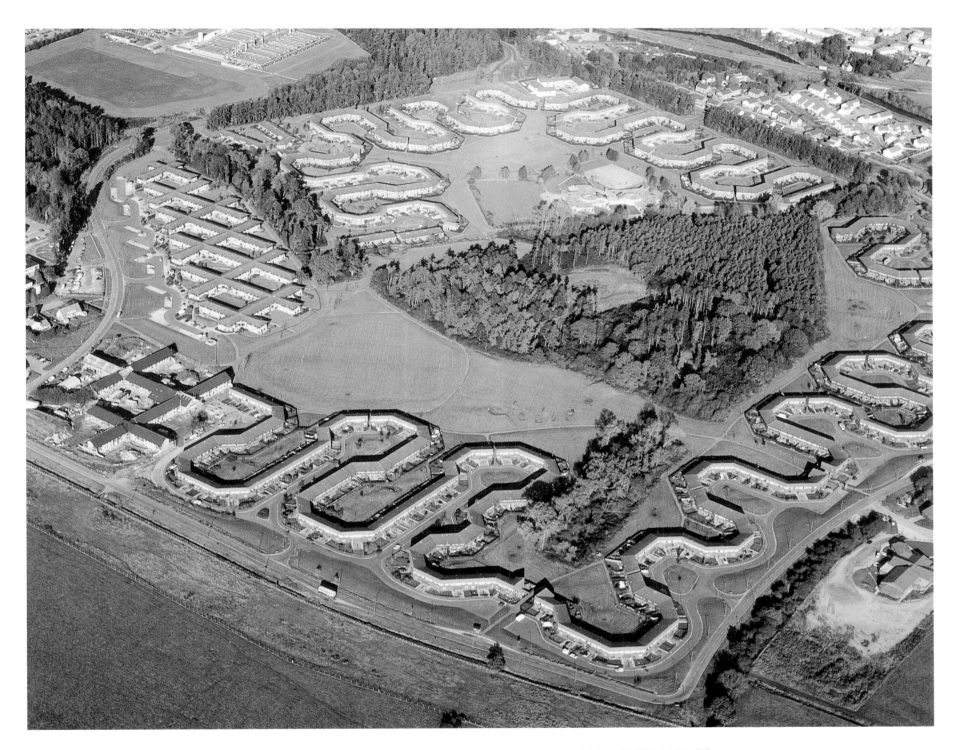

145

NEWPORT CONTINUOUS HOUSING ESTATE NEWPORT SOUTH WALES

In common with many British towns and cities coping with the decline of traditional industries and their subsequent related problems, this Welsh seaport has had to try to redefine itself. With a history dating back to Roman times, and a gateway position between England and Wales, the town's 137,000-strong community is pressing for 2002 city status to reflect is relative size and importance in Wales. The third largest conurbation in Wales, Newport is not alone in Britain in needing ever more ingenious solutions to the problems of housing without dehumanisation. Enormous housing estates such as this are indicative of the attempts Britain has made to move on from the high rise solutions of the 1960s.

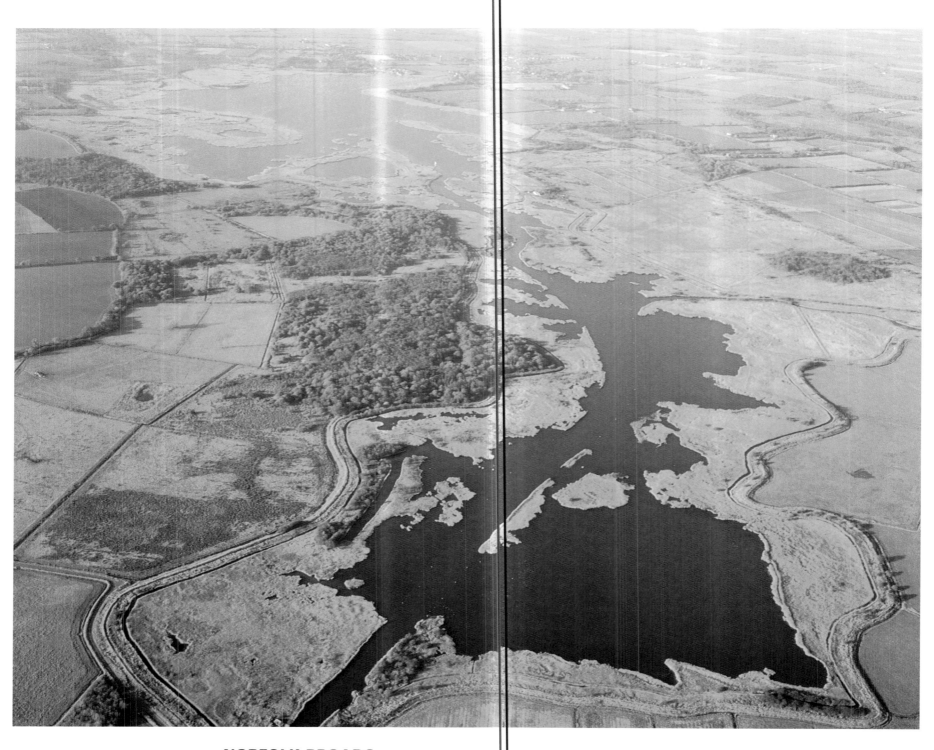

NORFOLK BROADS People travel from far and wide to witness at first hand the tranquillity of Norfolk's Broads. Hickling Broad is the largest of these: an area of outstanding natural beauty, the broads have become an extremely popular holiday destination, with their great stretches of water and peaceful, secluded canals. Heigham Sound is the smaller stretch of water leading up via a canal to Hickling Broad. Hickling itself is very shallow, and boats are guided through the deepest parts by strategically placed posts. The spot is an ideal haven for birds, and consequently for bird watching.

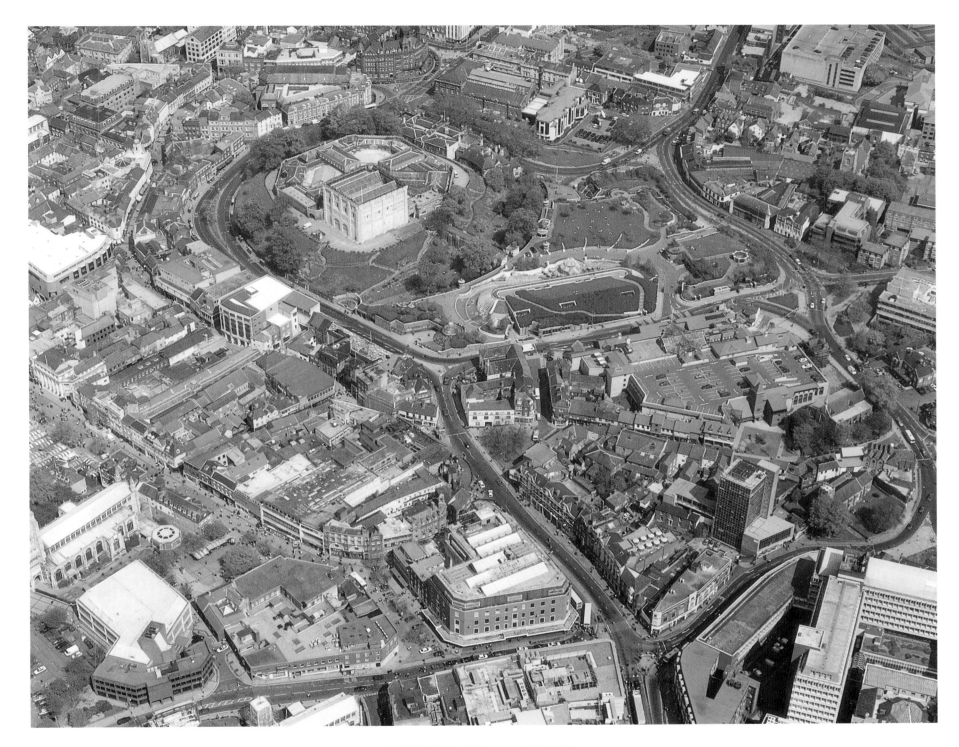

NORWICH CASTLE HILL & TIMBER HILL NORFOLK

This large city has a very long lineage, and once ranked among Britain's most important towns. The castle was begun in 1125, and is of Norman origin. Stone was imported from Caen in Normandy to supplement the local flint. Not only is the castle in excellent condition, but also the city walls enclose a larger area than those of any other walled city in Britain. No less than 30 parish churches nestle within those walls; and many of the city's streets bear names reflecting its Norse origins.

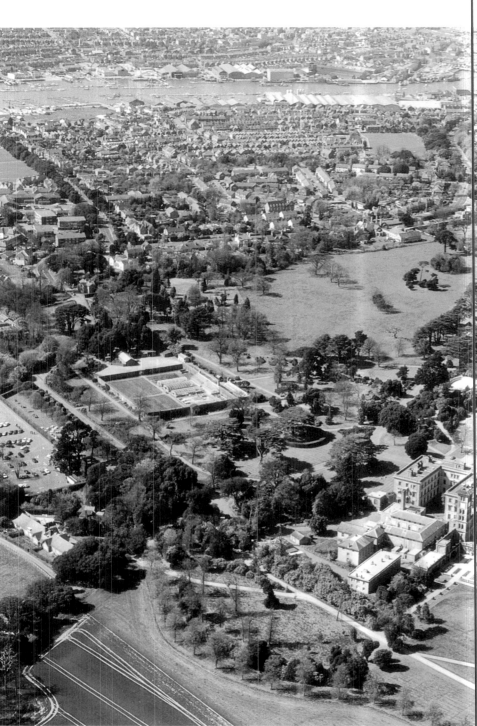
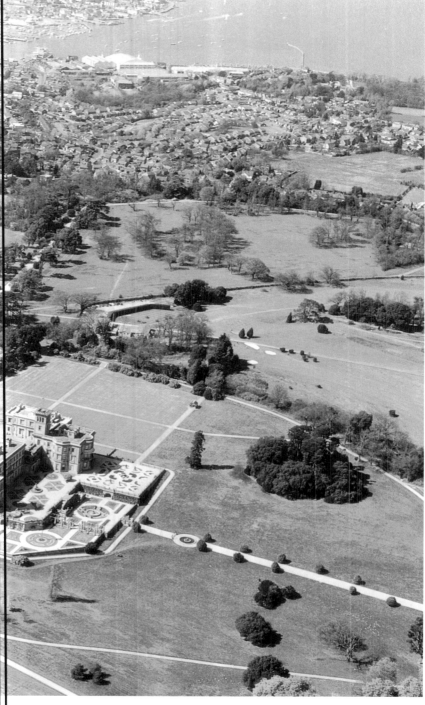

148

OSBORNE HOUSE & PARK ISLE OF WIGHT

Queen Victoria and her husband Albert sought a home a little less formal than those at
Windsor and in London, and perhaps a little more their own. With this in mind Albert
commissioned architect Thomas Cubitt to build this house on the Isle of Wight.
Completed in 1851, it was a summer and Christmas home to Victoria's large family of
children and, later, grandchildren, and was her great solace well into her widowhood.
She died there in 1901; today Osborne House and its park are open to the public.

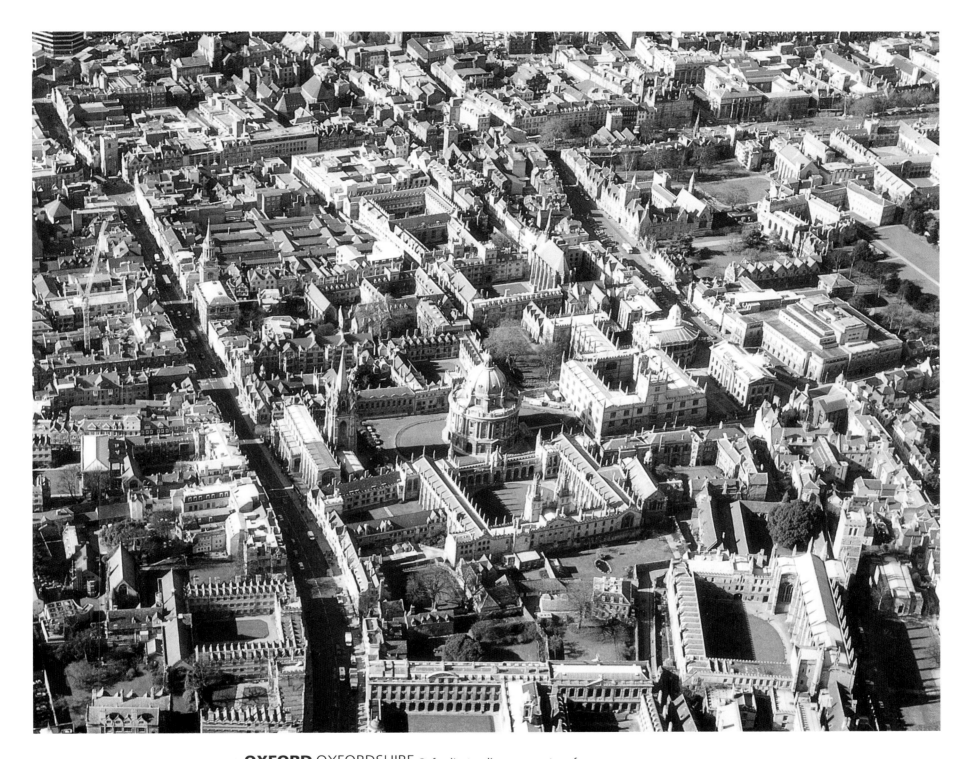

OXFORD OXFORDSHIRE Oxford's standing as a centre of learning is unquestioned. One of two old university towns, the list of famous names that have emerged from its colleges reads like a roll call of the great and good of all walks of life. Oxford is formed of a collection of 36 different colleges and five halls, such as Magdalen, Jesus, Corpus Christi, and Trinity colleges. The town was established at the point of a crossing of the River Thames, and its teaching foundations lie in the monasteries that first encouraged learning there by the building of halls for the accommodation of students of theology. Besides its colleges, Oxford is also home to the Ashmolean and Pitt Rivers museums, and the Bodleian Library.

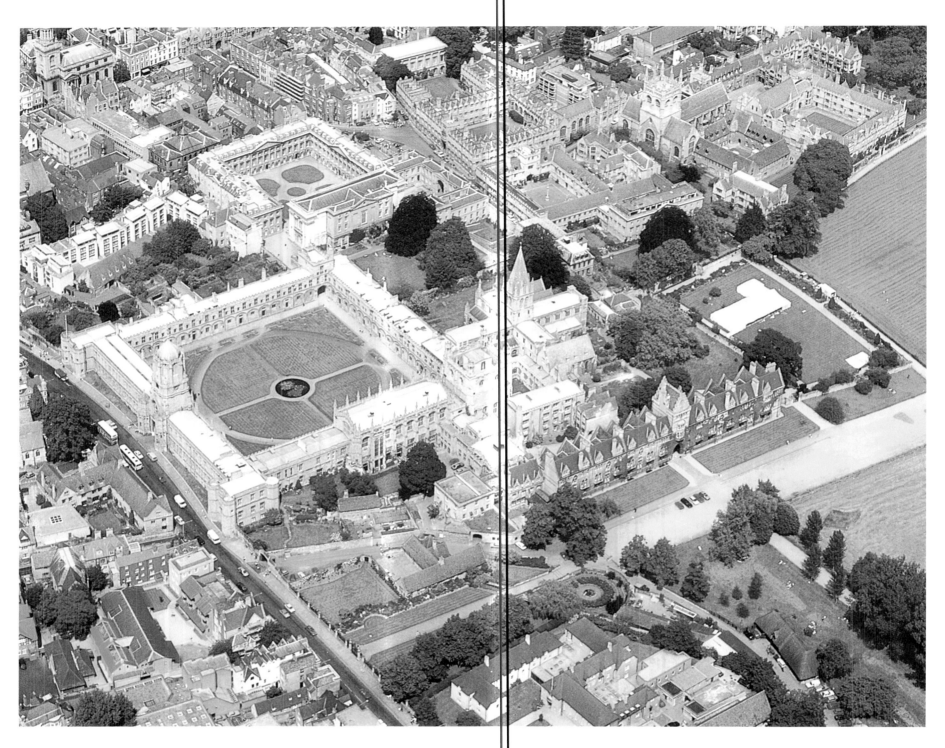

OXFORD CHRIST CHURCH OXFORDSHIRE The founding of
Christ Church is credited to Henry VIII, but it began as the brainchild of Cardinal
Wolsley, who built what was first known as Cardinal's College on the site. Christ Church
has a special stature within Oxford, having a unique dual role as a college and the
cathedral of the diocese of Oxford. Previous attendants of Christ Church include
William Gladstone, John Wesley and Lewis Carroll.

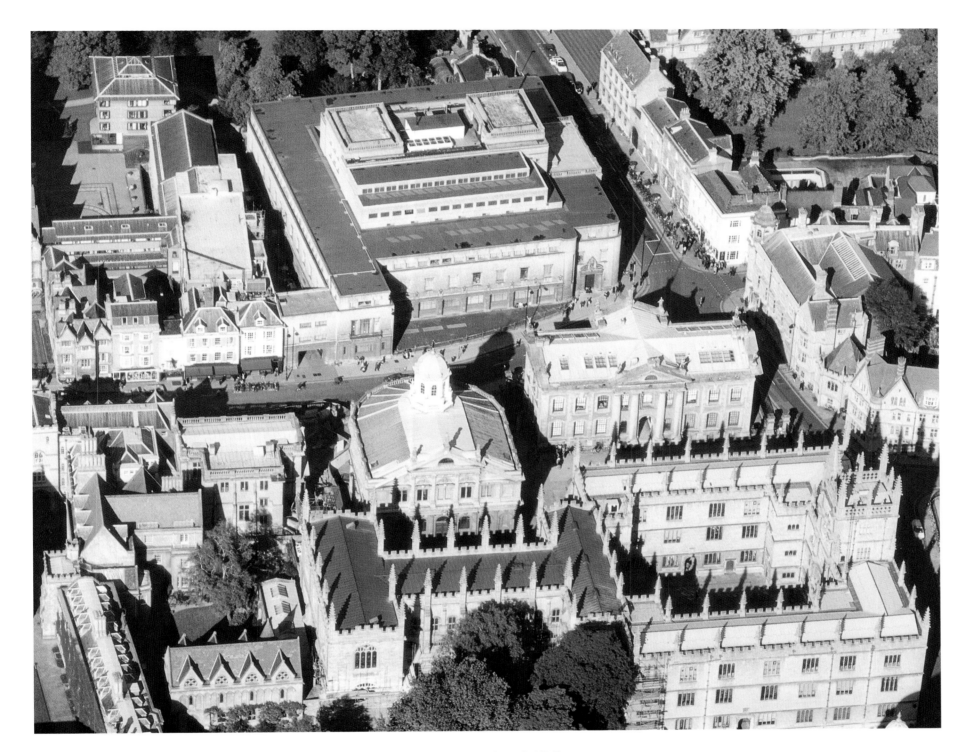

OXFORD SHELDONIAN THEATRE OXFORDSHIRE Just one of Oxford's many architectural delights, the Sheldonian Theatre (seen in this picture from the back; its projecting rounded front in the middle of the picture) takes its name from Gilbert Sheldon, Chancellor of the University of Oxford during the 17th century, who provided the funds to build it. The design was by Sir Christopher Wren. Completed in 1668, the Sheldonian Theatre's function has changed little in centuries: to provide a venue for public ceremonies and meetings at the University.

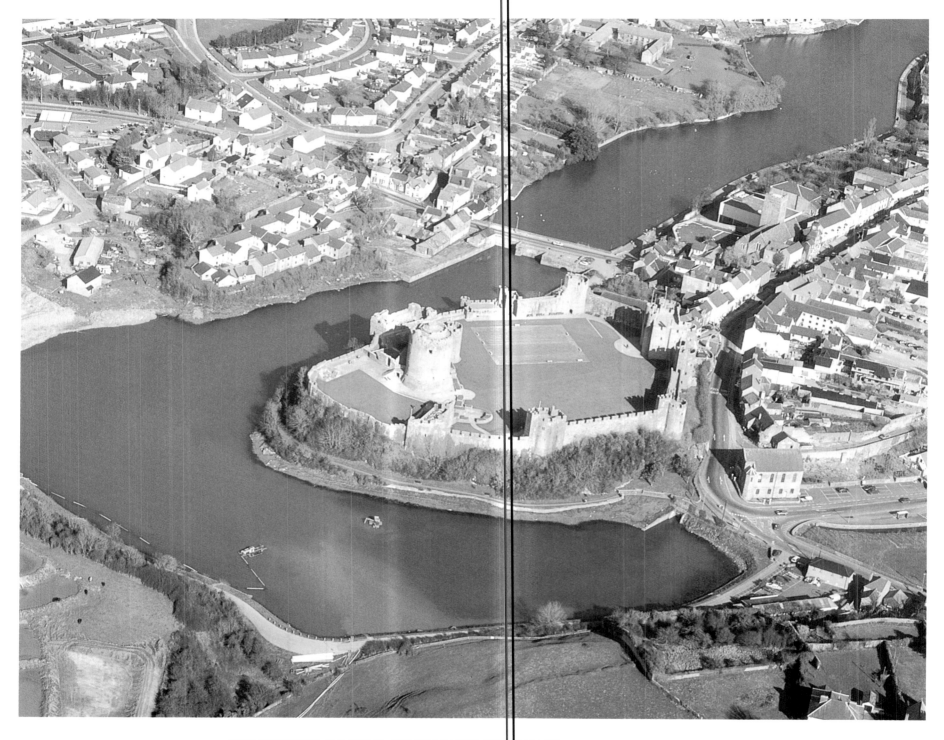

PEMBROKE CASTLE PEMBROKESHIRE WALES

With a past as tumultuous as it is old, this ancient castle was begun in the 12th century.
Its 75ft tower, which was built to be completely self-sufficient in case the rest of the
castle was taken, has entertained illustrious figures of Welsh history, including early
members of the Tudor family and Oliver Cromwell. Taken and retaken during the Civil
War, it was the family seat of the Earls of Pembroke for 300 years, and its solidity has
well repaid the labour that must have gone into building it.

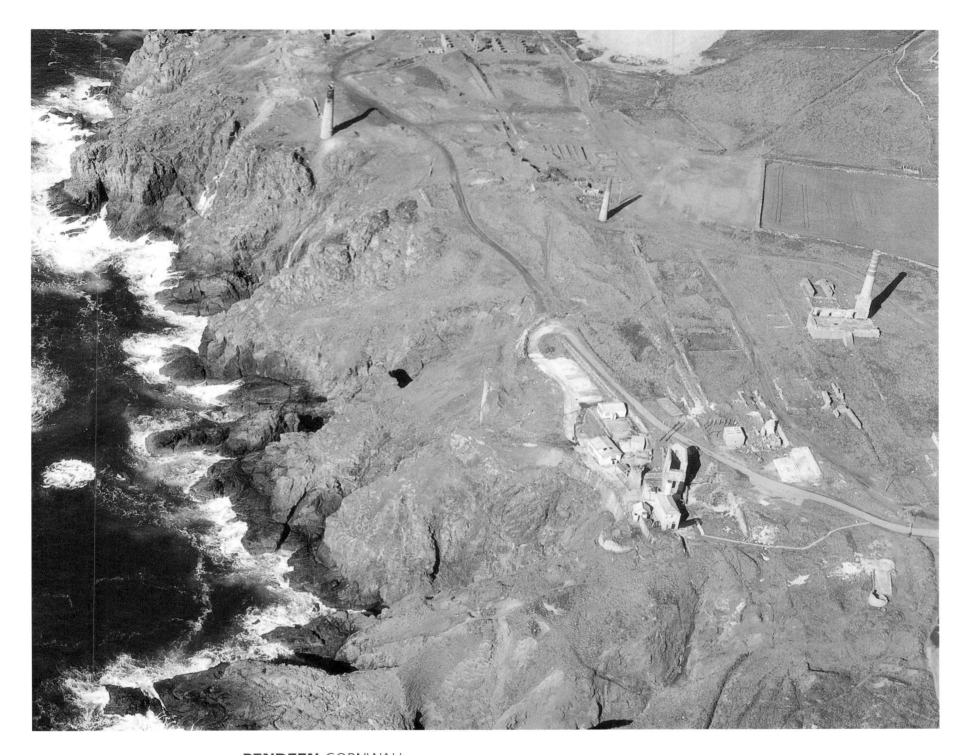

153

PENDEEN CORNWALL There was a time when Cornwall and tin and copper mining were synonymous. Pendeen, on the coast of north Cornwall, forms part of a local mining community that goes back some 2,000 years. It was only in the 19th century, however, that Cornish tin and copper mining began, with the addition of steam engines, to yield high volume. But a steady and downward drop in the price of these minerals, coupled with the dangers inherent in vertical shaft mining, took their toll on the industry. Geevor, pictured, was the last tin mine in that area to close down in 1986. The Levant Beam Engine with which Geevor is coupled, is now in operation as a museum.

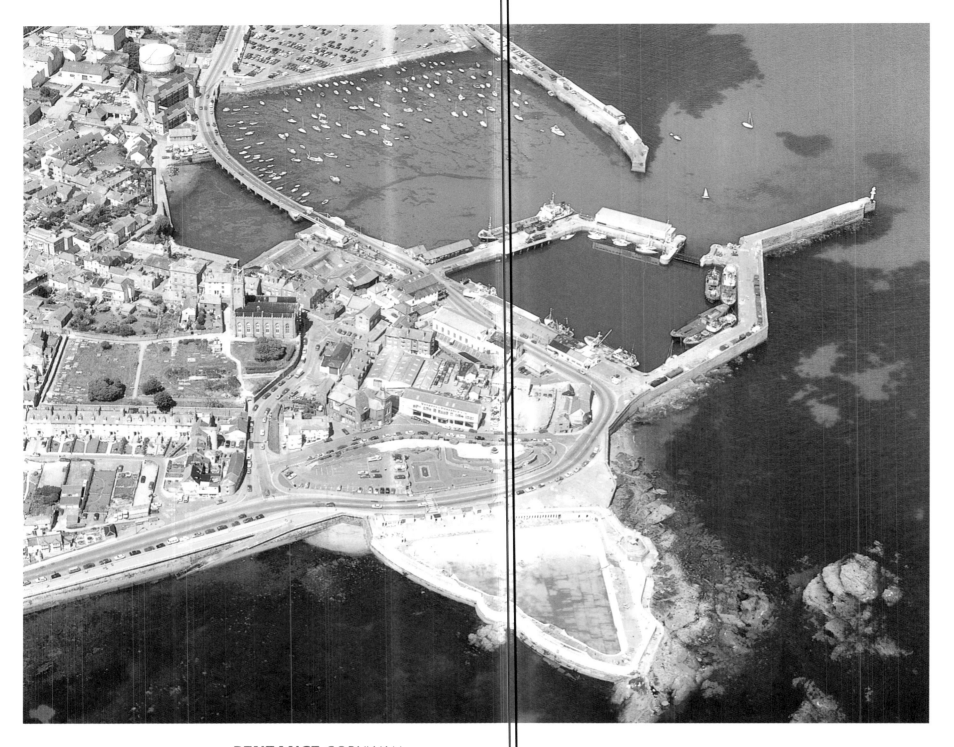

PENZANCE CORNWALL Busy market town Penzance has survived attack from many quarters, including the Spanish in the 16th century and the French in the 18th century—in fact the long arms of its pier were built in the 17th century to keep out raiders. The 19th century fashion for bathing and sea air helped Penzance to a share of the elegant Georgian and Regency architecture enjoyed by many coastal towns. The whole town is peppered with reminders of its maritime past, and proudly remembers citizen such as Maria Bramwell, mother of the Brontë sisters, and Sir Humphry Davy, inventor of the miner's lamp.

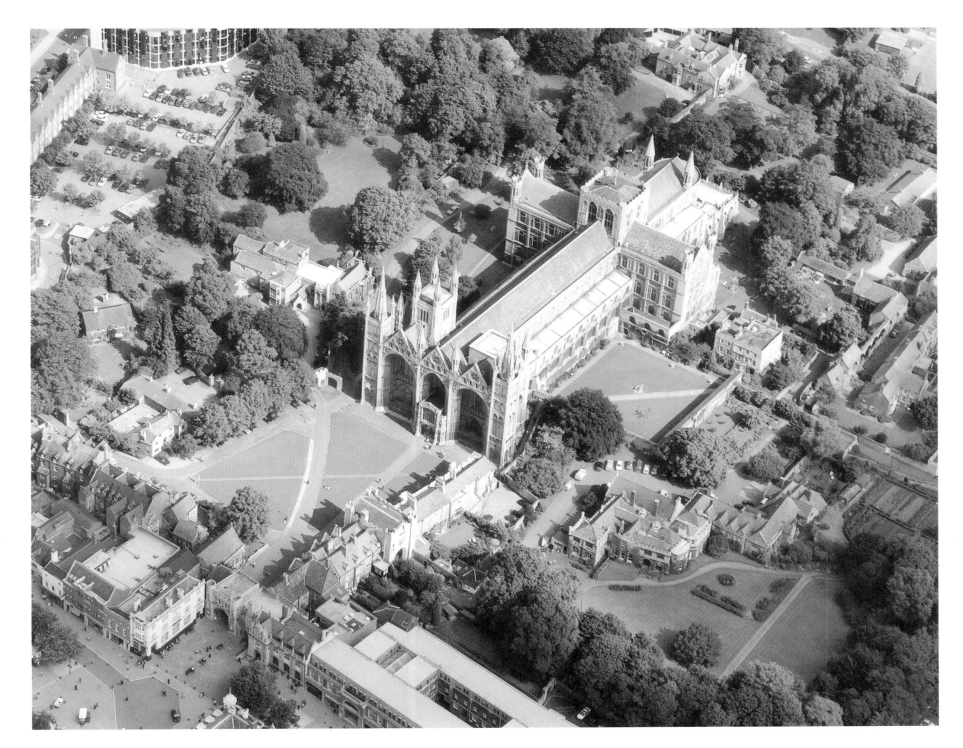

PETERBOROUGH CATHEDRAL CAMBRIDGESHIRE

Dedicated to Sts Peter, Paul and Andrew, Peterborough is built on foundations that date back
to Saxon times—c. 655 when it was founded by Peada, King of Mercia. Two Saxon churches
burned down before the Normans started building in 1117: they would produce a master-
piece that today is one of the most finest examples of Norman architecture in England.

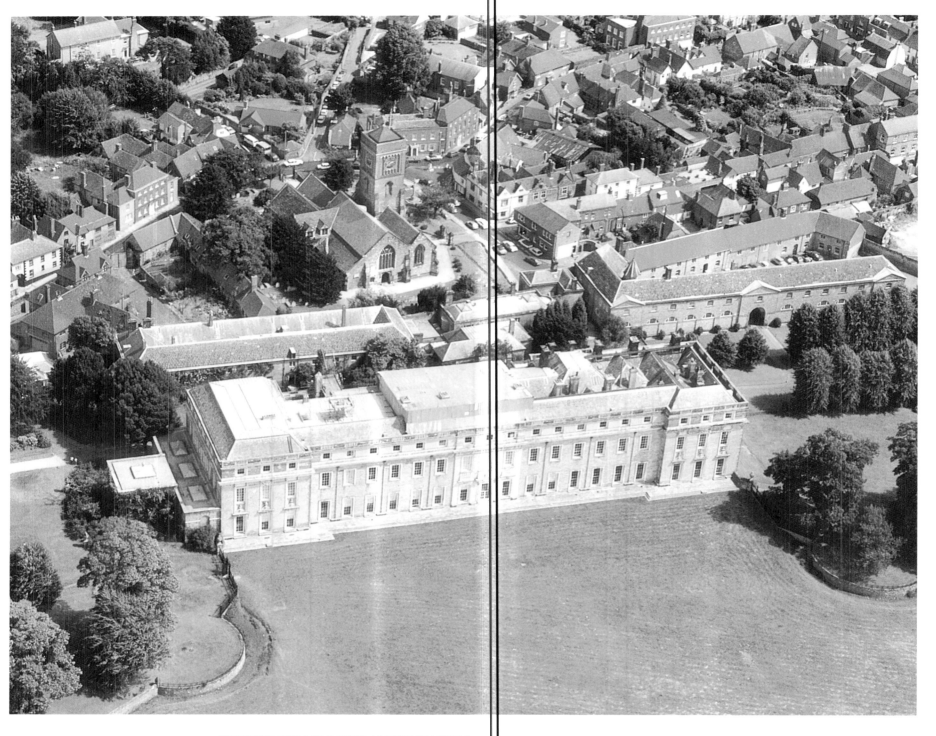

PETWORTH HOUSE WEST SUSSEX This imposing house dates from the 17th century, and boasts impressive aesthetic credentials. It contains an extraordinary collection of art by the likes of Gainsborough, Van Dyck and Reynolds. Turner, who was also a visitor to the house, painted it. The house has a further claim to interest, however: its gardens and deer park were landscaped by Lancelot 'Capability' Brown in 1752. From this work at the start of his career, 'Capability' Brown's name continued to be associated with the great houses of Britain, including Blenheim, Chatsworth and Hampton Court. Petworth Park remains a deer park today.

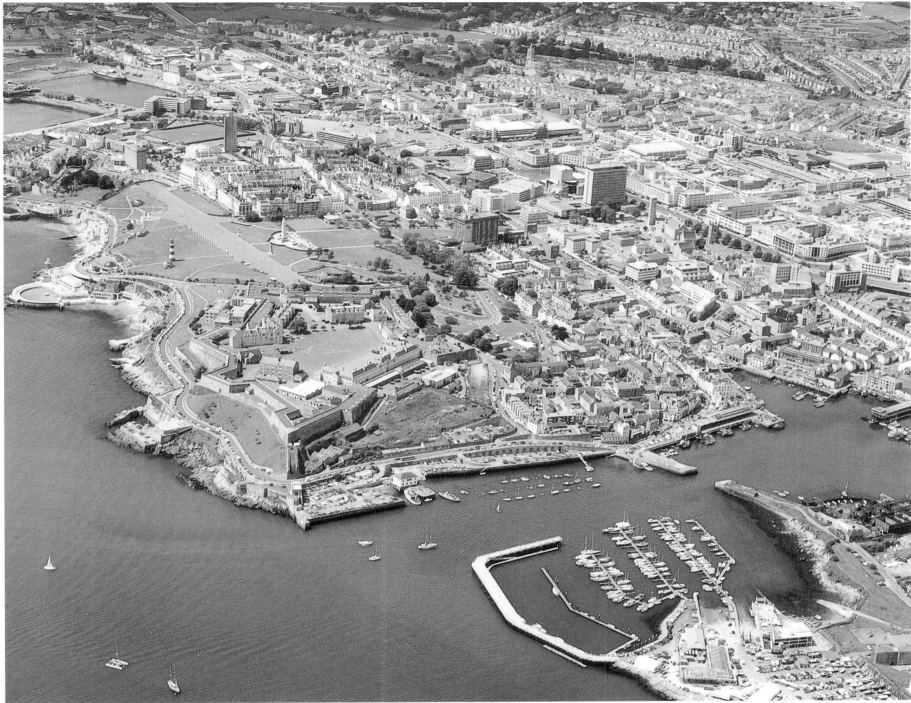

PLYMOUTH DEVON Plymouth fared badly during World War II: much of its architecture was destroyed, and later replaced with modern, grid-patterned town planning. What is left, however, proudly reflects Plymouth's part in British seafaring history. The town's historic Barbican area, with its boat-crammed marina, was believed to be the home to Sir Francis Drake, and later saw off the Pilgrim Fathers. Lying at the mouth of the harbour is the Citadel, an imposing fortress designed in the time of Charles II to warn off invaders. Further round the point is Plymouth Hoe—the site of Drake's game of bowls, played as the Spanish Armada came into view in 1588.

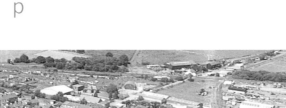

p

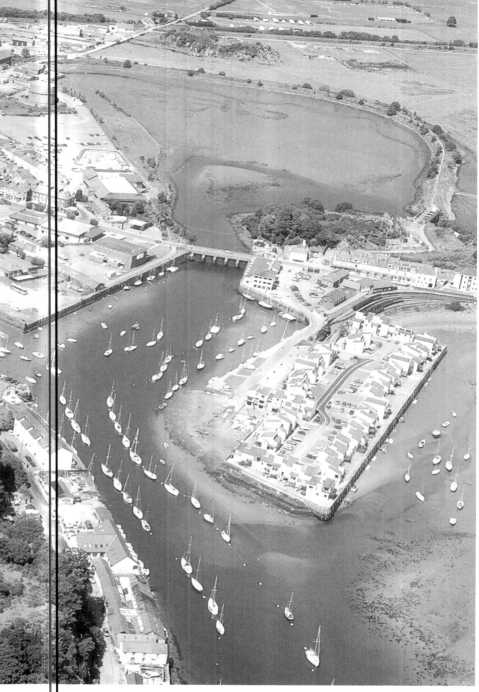

158

PORTHMADOG GWYNEDD WALES This pleasant
town only came into existence in the 19th century. Local MP William Maddocks caused
an embankment to be built across the mouth of the River Glaslyn, thereby creating the
natural harbour that came to be called Port Madoc and, latterly, Porthmadog. It played
a key role in the transformation of the slate mining industry. The hills which are its
backdrop have long been the site of slate mines; it became the terminus of the
Ffestinog Railway, which enabled slate to be transported down to the sea in far greater
quantities than ever before. Now a pleasant tourist destination, the Ffestinog Railway
gives excellent coast views on the way up the hills.

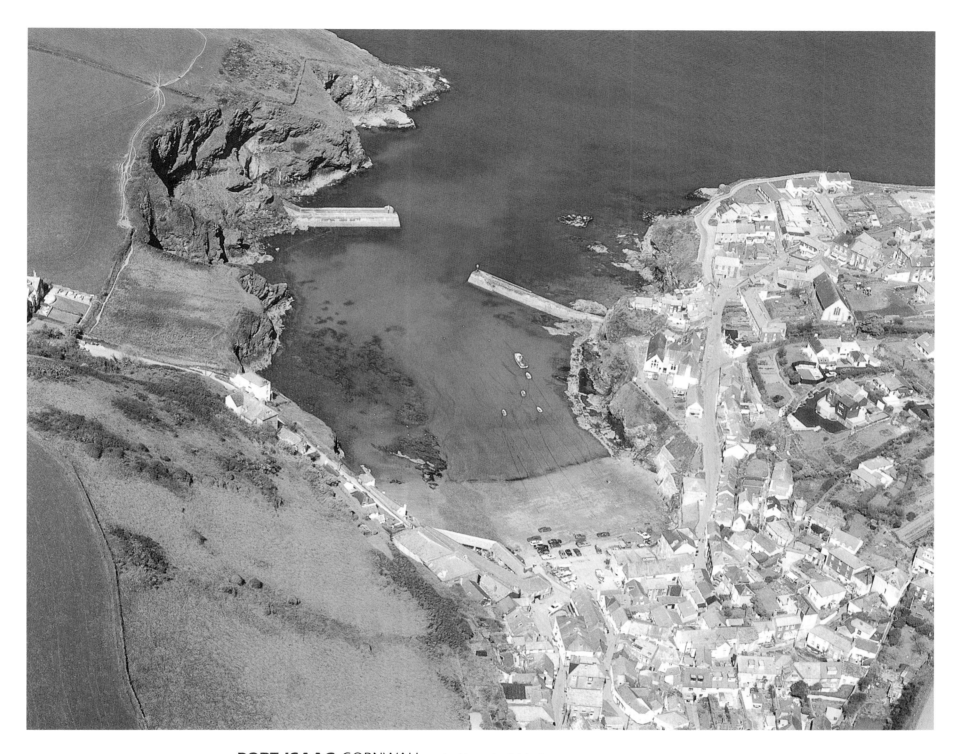

PORT ISAAC CORNWALL Tucked into the fold of steep cliffs, Port Isaac on the north coast of Cornwall is an archetypal Cornish fishing village, and a pleasant tourist destination. It boasts a 700-year-old fishing heritage that includes a pier built during the reign of Henry VIII. The harbour is still a working one, and the old fish cellars still exist; one has been converted into the present day lifeboat station. The town itself is quietly attractive, with narrow streets flanked by white-washed houses.

p

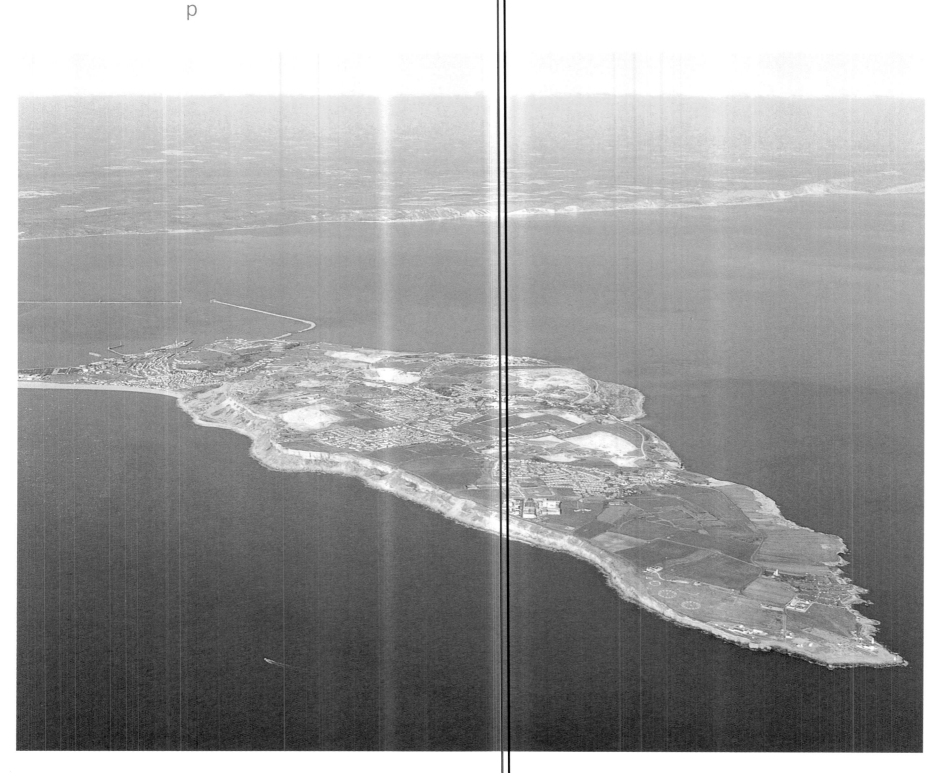

PORTLAND DORSET Ugly but unique, Portland is almost an island and sits at the end of Chesil Beach protecting Weymouth from westerly weather. Portland is best known for its quarries—many of Britain's great buildings have stone from here—its prison, its Henry VIII castle, its naval base, the splendid Georgian church, St George Reforne, at Easton, its tidal race and, of course, Portland Bill's inclusion on the regular shipping forecasts.

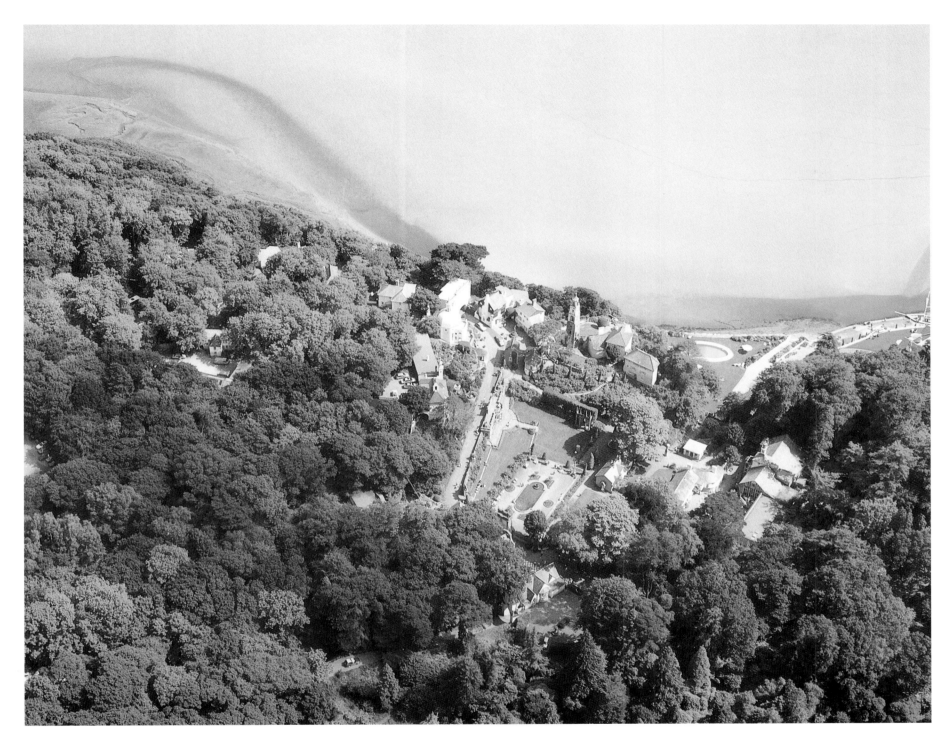

PORT MEIRON GWYNEDD WALES The vision of Sir Clough Williams-Ellis, this extraordinary village came to life after Sir Clough bought the estate of an eccentric lady, finding in the site all he hoped for to realise his dream of a village built entirely in sympathy with the natural contours of the land. Having converted the existing house into a hotel in order to fund his venture, he set about building a series of Italianate follies, which have fired the imagination of many a television and film director. Most famously, Portmeirion was the location for the TV series 'The Prisoner' in the 1960s. Portmerion was given listed building status in 1973, and continues to be a popular tourist attraction.

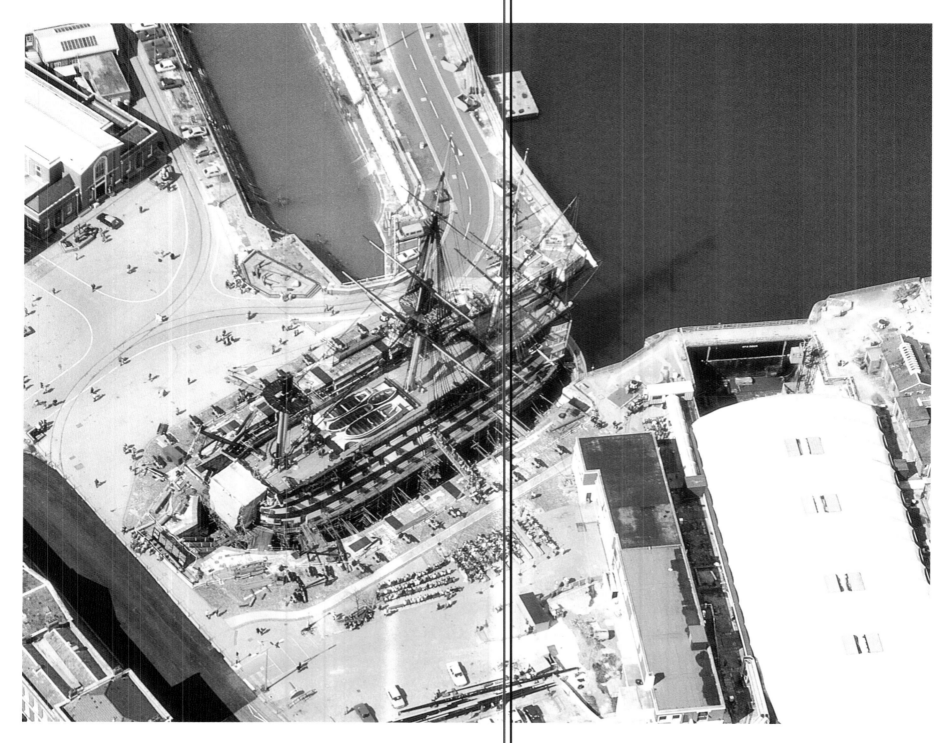

PORTSMOUTH HMS *VICTORY* HAMPSHIRE This ship, Nelson's flagship, forms a fundamental part of the rich naval history of Portsmouth (which is also home to Henry VIII's *Mary Rose* and the first iron battleship, HMS *Warrior*). Destined forever to be linked with the fate of Horatio Nelson, *Victory* was ordered in 1758, the year of Nelson's birth, and her renowned speed and excellence of design helped that famous admiral to victory at Trafalgar in 1805. The oldest commissioned warship in the world, HMS *Victory* has her own dry berth at Portsmouth, and the spot where Nelson was shot—and the site of his death, below deck—can be visited today.

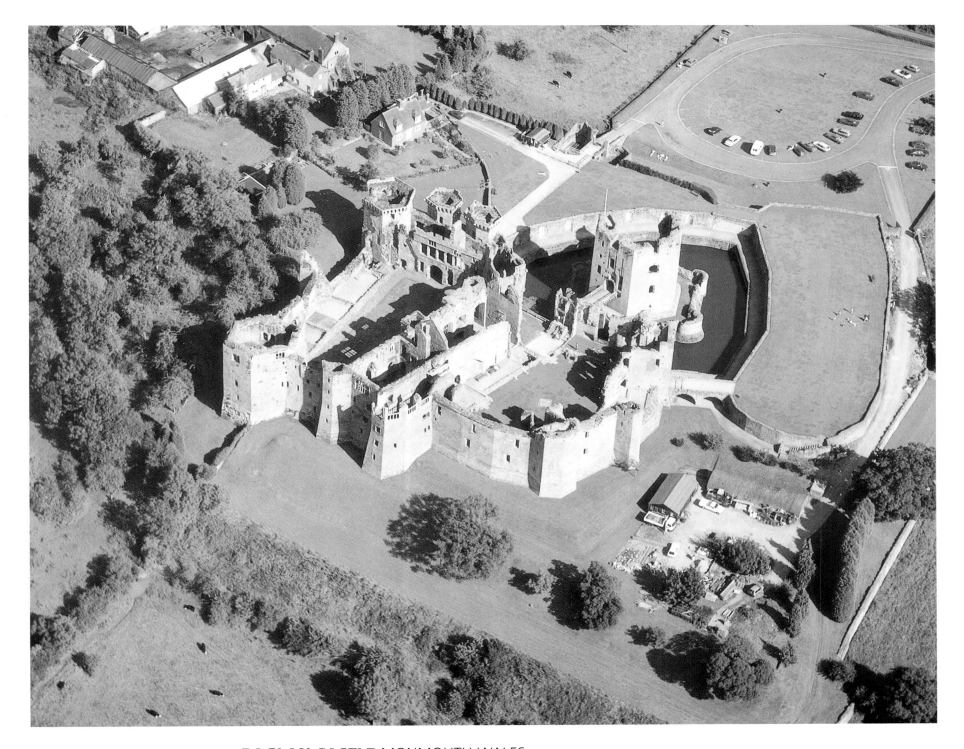

RAGLAN CASTLE MONMOUTH WALES Raglan's weather- and war-beaten walls have protected many a nobleman. Begun in the 15th century by Sir William ap Thomas, the Great Tower was planned unusually as a hexagon, with a single room occupying each floor. Its double drawbridge and elaborate decoration reflect ap Thomas having been a veteran of the French wars, and having seen much of France's castles. Built with native sandstone it became known as the 'Yellow Tower of Gwent'. Raglan was finally brought to its knees in the Civil War; Cromwell's armies first ensured its surrender, then set to work destroying its great walls.

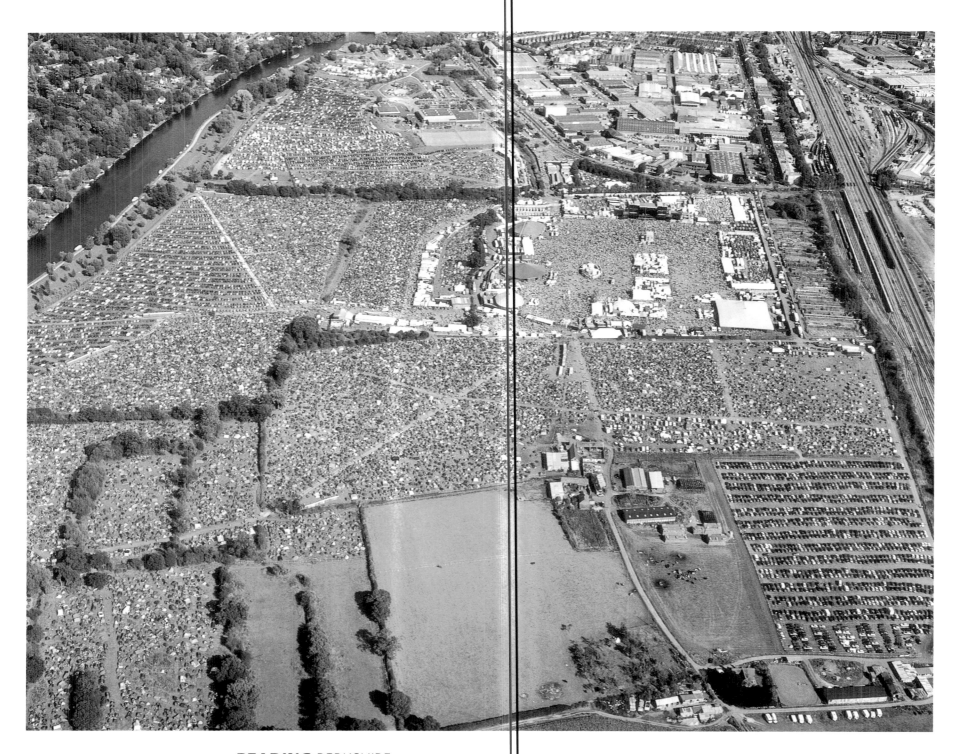

READING BERKSHIRE Since its inception in 1971 with an audience of 20,000, the Reading Festival has gone from strength to strength, proving the nation's love of outdoor music—whatever the weather. Once a year, lovers of indie and rock music head with their tents to this riverside site in Berkshire, to watch current bands head a weekend of music and other entertainment. It has a faithful following and draws ever-increasing numbers.

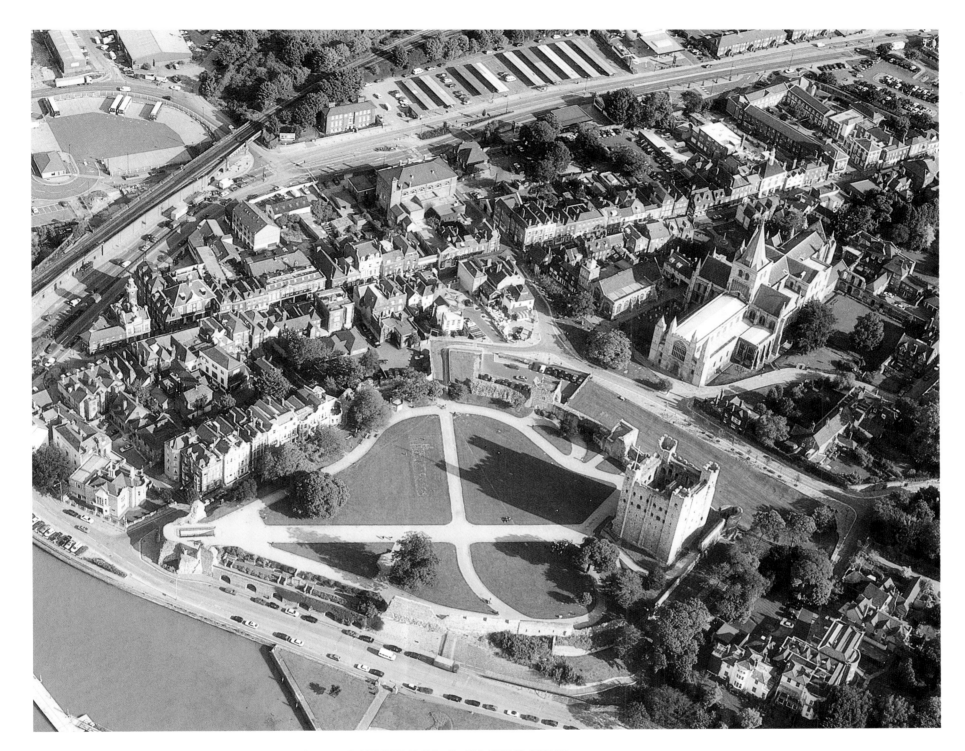

ROCHESTER CATHEDRAL & CASTLE KENT The
site of Rochester Castle was known by the Romans; their fortifications were used as a
pattern when William I's architect, Bishop Gundulf, built his Norman castle here. With a
castle keep that, at 113ft high, is the tallest in England, its defences were put to the
test by King John in 1215, after rebel knights had taken the castle against him. A two-
month siege decided the matter. Rochester Cathedral is another magnificent example
of Gundulf's architecture, begun in 1077. Fourteen centuries of worship have not
dimmed the importance of this cathedral; the Diocese of Rochester, of which it is a
part, today watches over one million people.

ROMNEY MARSH ROYAL MILITARY CANAL KENT The
threat of invasion by Napoleon in 1804 caused Britain to build this defensive canal through
Romney Marsh, Britain's most south-easterly point. The project was dogged by criticism and
ridicule, however, as costs and concern over its strategic efficacy escalated (it finally cost
£234,000, an immense sum for the day). The opportunity to prove its worth never came:
Napoleon never reached Kent, and the canal took on a more peaceful role. It had one impor-
tant side-effect, though, for the area; the requisite draining of the surrounding marshes to
build the canal wiped out the marsh fever that had reigned there.

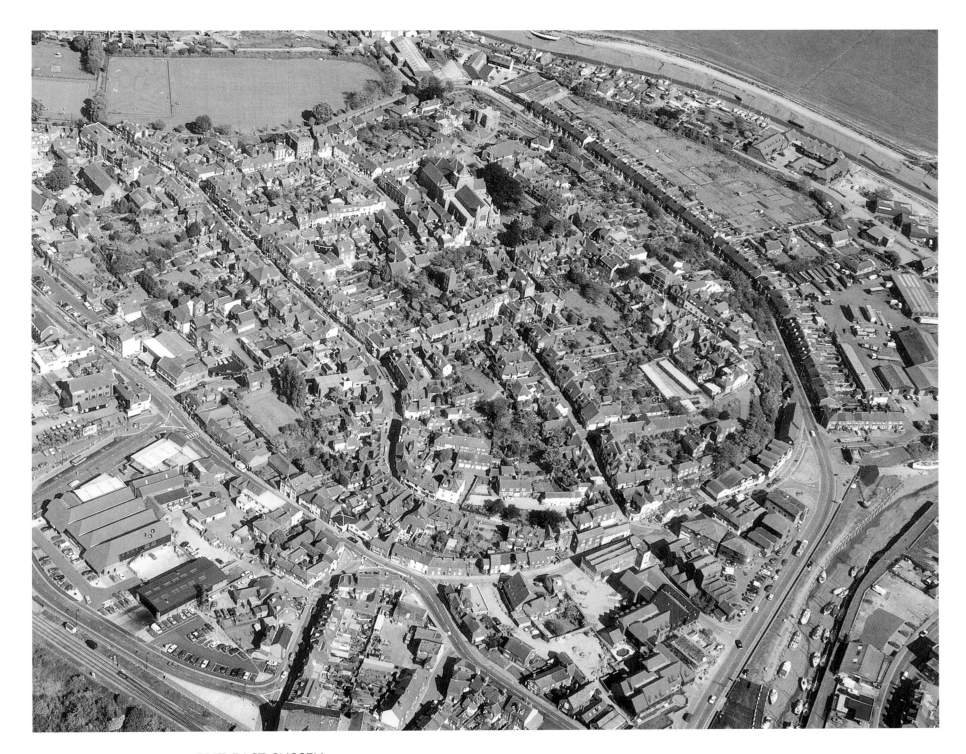

167

RYE EAST SUSSEX During the 10th century Rye and Winchelsea became part of an ancient confederacy—the Cinque Ports—which consisted of Sandwich, Dover, New Romney, Hythe, and Hastings. These ports protected the passage of ships in the Strait of Dover and the Channel, and were presided over by the Warden of the Cinque Ports. Until Tudor times they were almost the only navy England had, and the honour of being warden continues today, long after the powers and privileges have disappeared. Winston Churchill was Warden 1941–65 and the present incumbent is HM the Queen Mother.

S →

SALISBURY SCARBOROUGH SEVERN SHREWSBURY SNOWDON ST AUSTELL ST DAVID'S
ST MICHAEL'S MOUNT STONEHENGE STRATFORD-ON-AVON SUNBURY SWANSEA

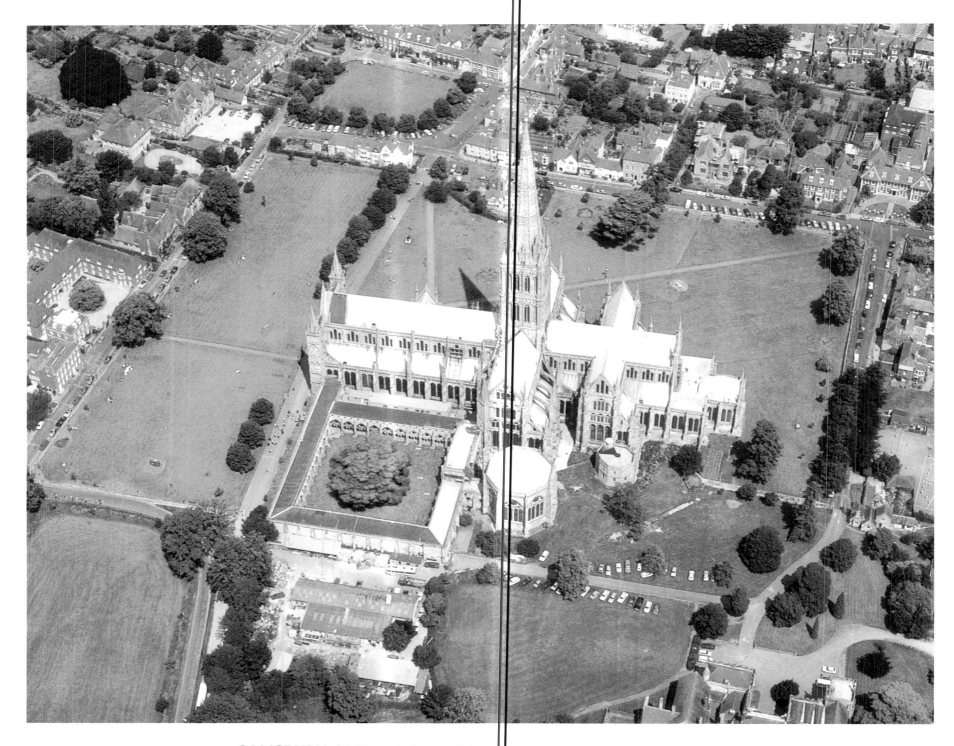

SALISBURY CATHEDRAL WILTSHIRE Soaring
gracefully 404ft over its beautiful Cathedral Close, the spire of Salisbury Cathedral has
inspired many English poets and painters, perhaps most memorably John Constable.
Started in 1220 and consecrated in 1258, the exterior of the cathedral is possibly the
finest example of Early English Gothic architecture anywhere. Inside it has not fared as
well, particularly after the depredations of the 'destroyer', James Wyatt, at the end of
the 18th century.

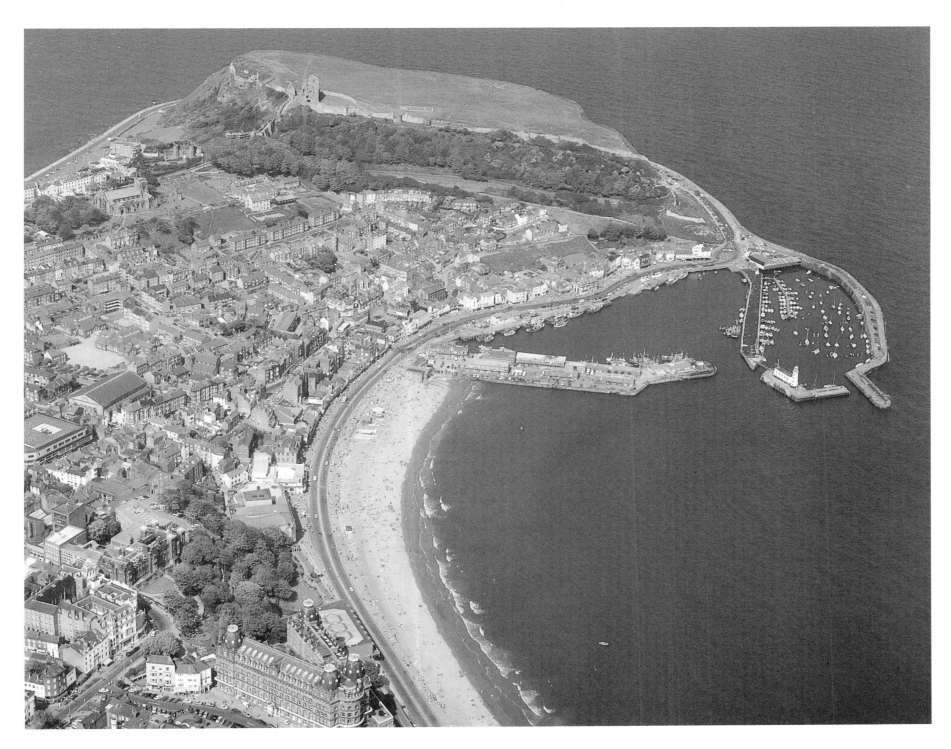

SCARBOROUGH NORTH YORKSHIRE Scarborough is
a holiday town of luxury hotels and fine promenades with special memories for those
who have visited the cricket festival and remember a time when unequal matches took
place between regular county champions Yorkshire and the Rest of the World. It is said
that Scarborough was founded by the Vikings: certainly the town was burned by
Harald Hardrada, as he headed towards battle with King Harold in 1066. The Normans
built the fine castle visible in this photograph; it was never taken by force of arms
although besieged a number of times, and was only slighted by the Parliamentarians in
the Civil War.

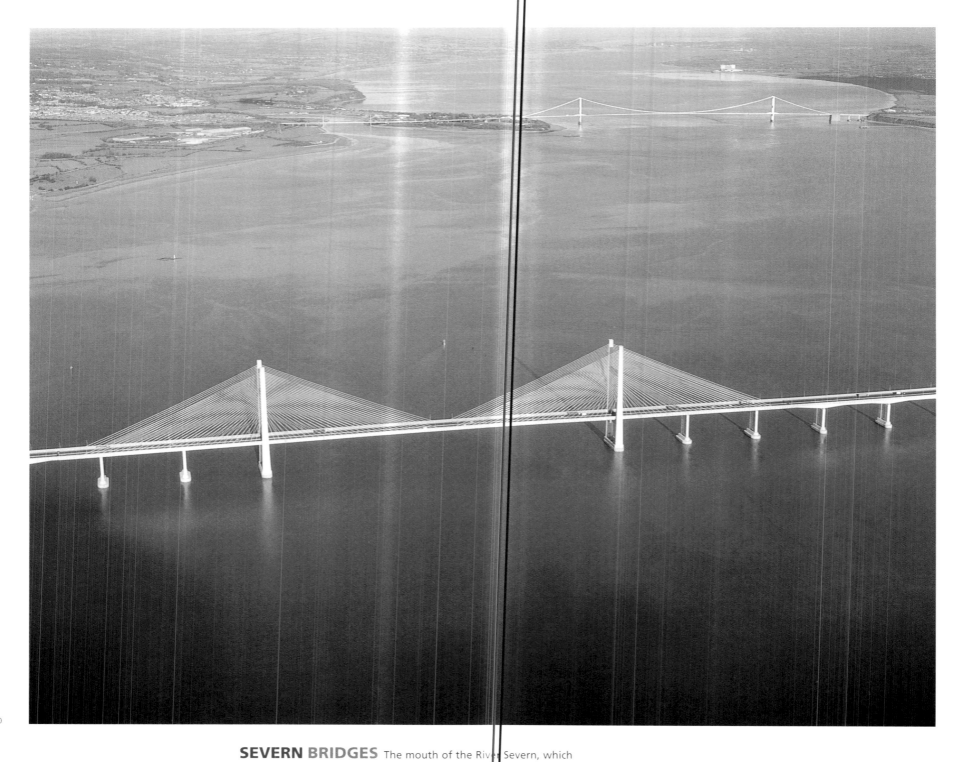

SEVERN BRIDGES The mouth of the River Severn, which boasts the highest tides in the British Isles—over 50ft—is today crossed by two bridges and a tunnel. The bridges were built in 1966 and 1996; the tunnel, through which trains cross the estuary, was built in 1873–86. Joining Avon in England and Gwent in Wales, the bridges made a substantial difference to travelling times to south Wales.

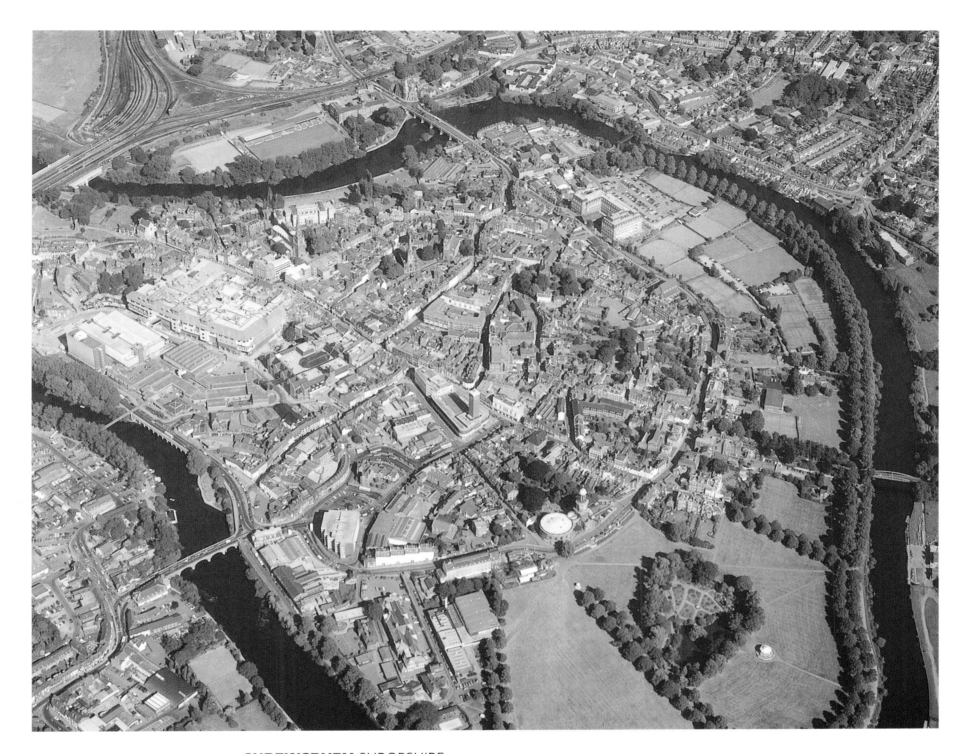

SHREWSBURY SHROPSHIRE A wonderful town with a
long history, Shrewsbury lost many buildings of worth in the 1960s but still has much
fine architecture. Built on a loop of the River Severn as long ago as the 5th century AD,
Shrewsbury boasts a Plantagenet castle that was refurbished by Thomas Telford in the
late 19th century, one of the tallest church spires in England (St Mary's built c. 1200), a
statue to its famous school's most famous pupil, Charles Darwin, and a host of medieval
timber-framed buildings. In recent years it has also staked a literary claim to fame
being the location for Ellis Peters' Cadfael medieval whodunnits.

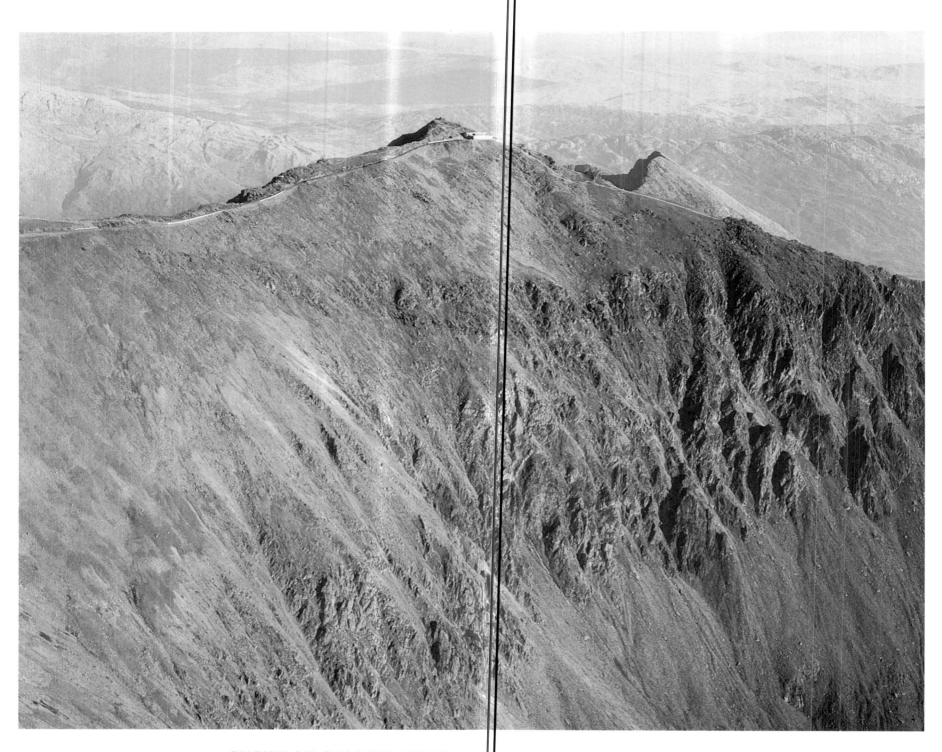

SNOWDON GWYNEDD WALES Surrounded by the Snowdonia National Park, the Snowdon group of mountains contains four peaks over 3,000ft and some of the most spectacular mountain views in Wales. For those who want to expend less energy than climbers there's a steam-driven mountain railway from Llanberis.

ST AUSTELL CORNWALL Centre of Britain's china-clay industry and second only to China in clay production, St Austell (right) sits among massive white spoil heaps. St Austell is named after St Austol, an evangelist in Brittany in the 6th century. His feast day is on 28 June: a good date to visit!

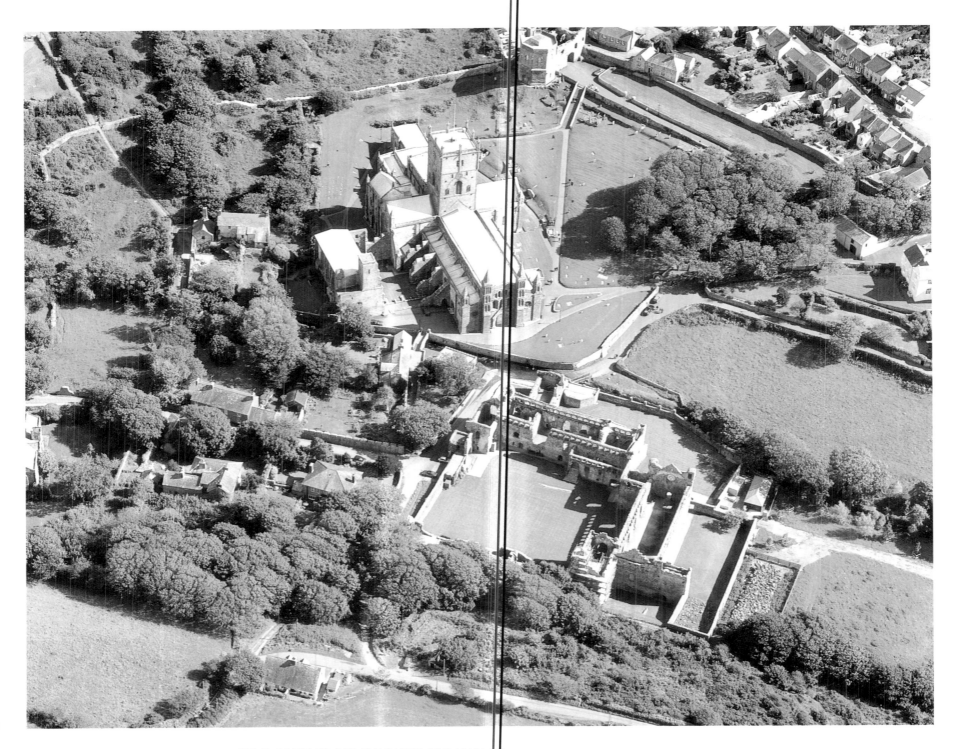

ST DAVID'S PEMBROKESHIRE WALES The smallest
cathedral city in Britain by some distance, St David's Cathedral was a bishopric for many
years before the current building was started in 1180. It is said to have been founded
by the exceedingly strict patron saint of Wales, St David, in AD550. The cathedral has
survived sacking by the Norsemen in 1180, the collapse of its central tower in 1220, and
damage during the Civil War: it was renovated and restored by Nash and Scott in the
18th and 19th centuries.

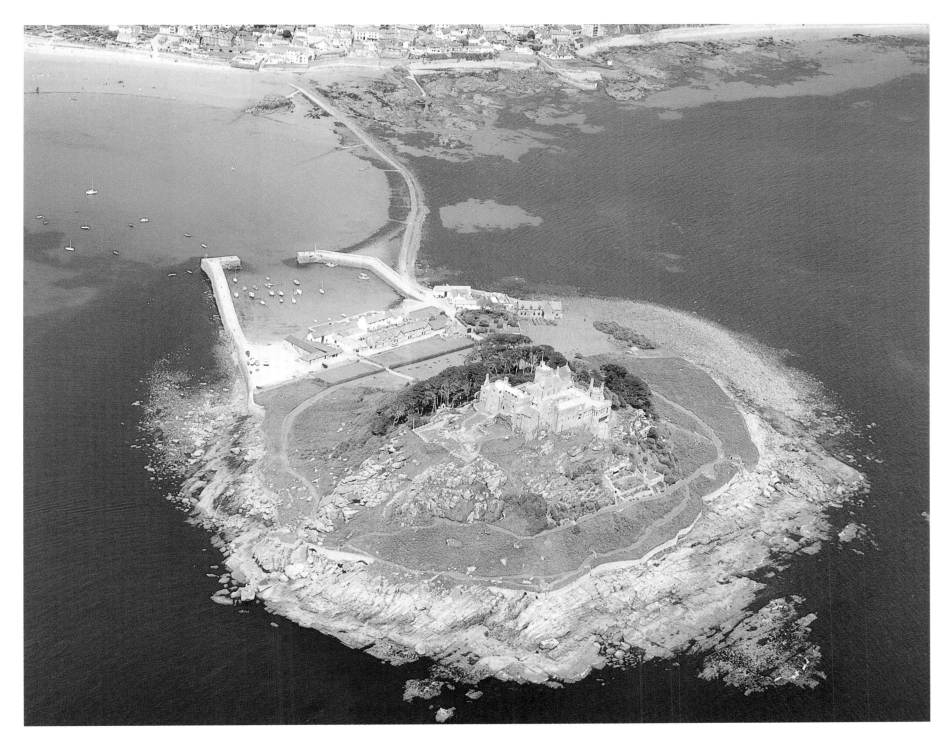

ST MICHAEL'S MOUNT CORNWALL A magical
place, St Michael's Mount possesses a long history and many legends—particularly of
the Mount Giants who would wade ashore to steal from the mainland. Associated with
the island Ictis mentioned by many classical writers, including Diodorus in c. 30BC, it's
possible tin was exported from here to the Mediterranean. Little is known for sure until
after the Norman Conquest when it was run by the abbot of the monastery of Mont St
Michel in Normandy, continuing in ecclesiastical ownership until it passed into the
hands of the monarch in the 15th century.

S

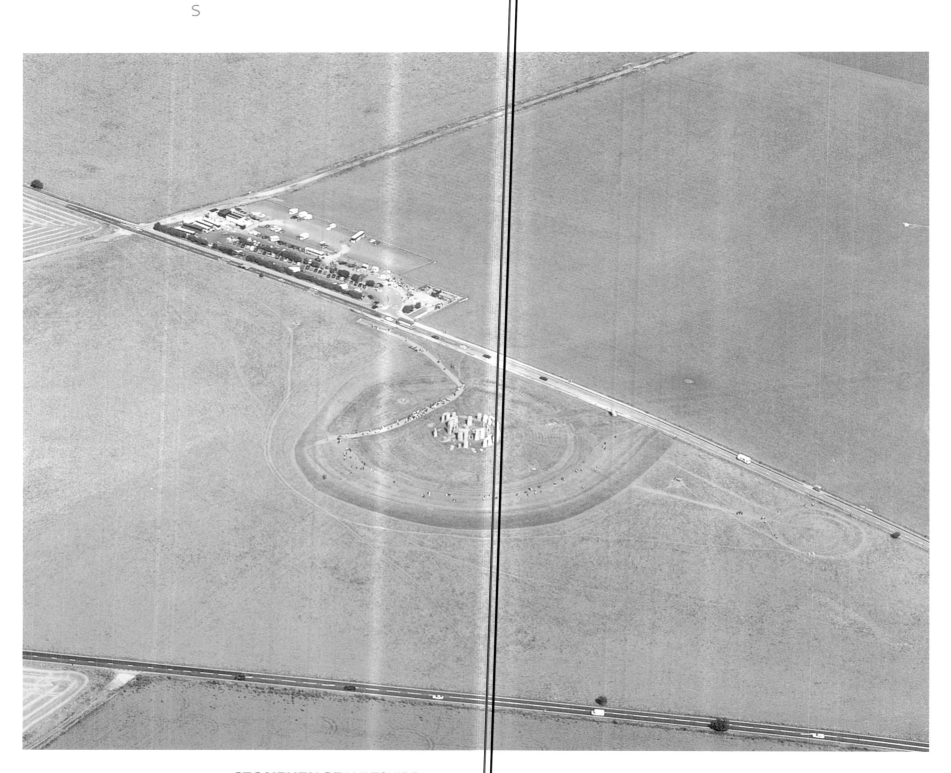

STONEHENGE WILTSHIRE A World Heritage Site and
one of the most famous megalithic structures in the world, Stonehenge is a remarkable
sight despite its rudimentary vistors' facilities and crowds of visitors and latter-day
druids. While no one can be sure of its purpose, nor indeed whether the famous blue
stones were indeed transported from Wales, there's no doubt that careful measure-
ment of the heavens went into its planning and it has a strong connection with the
solstices.

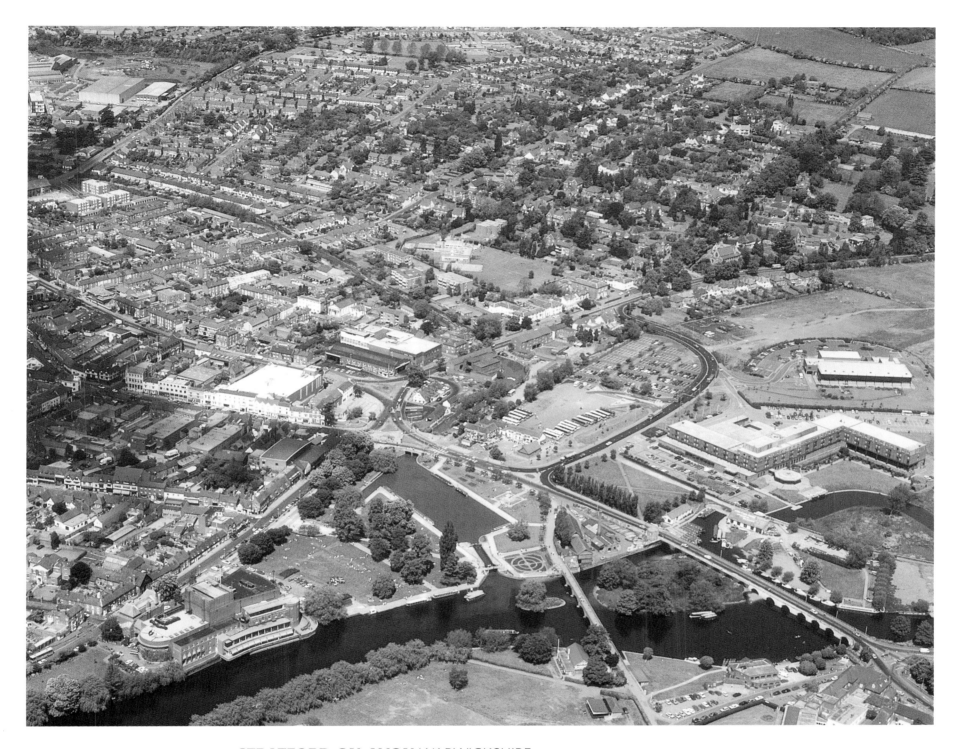

STRATFORD-ON-AVON WARWICKSHIRE A pretty market town with a wealth of timber-framed houses, Stratford is revered and visited from around the globe by people interested in seeing the birthplace and final resting place of William Shakespeare—the Bard of Avon. His birthplace is in Henley Street; his tomb is in Holy Trinity Church where he was baptised; his wife's (Anne Hathaway) cottage is at Shottery.

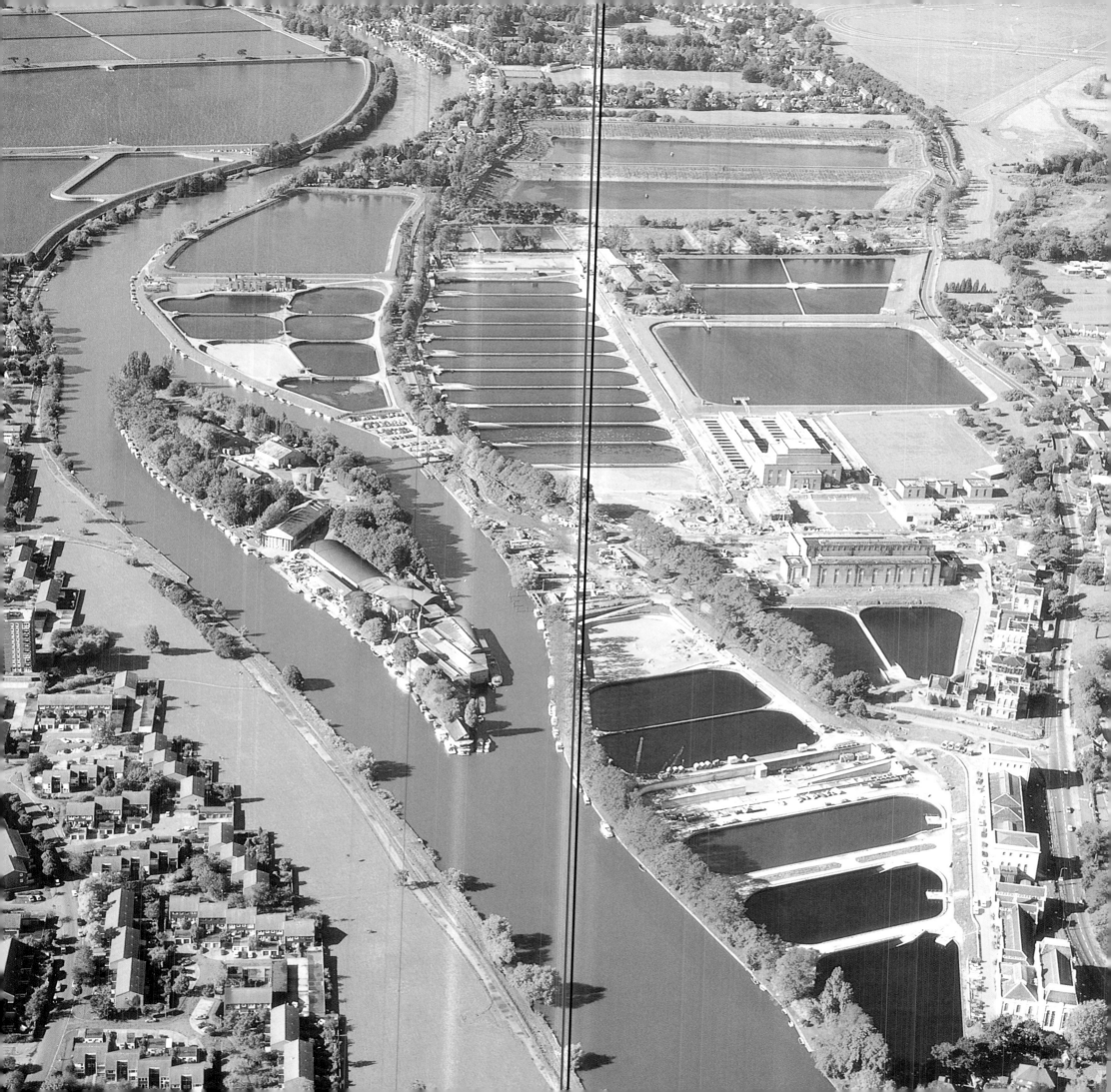

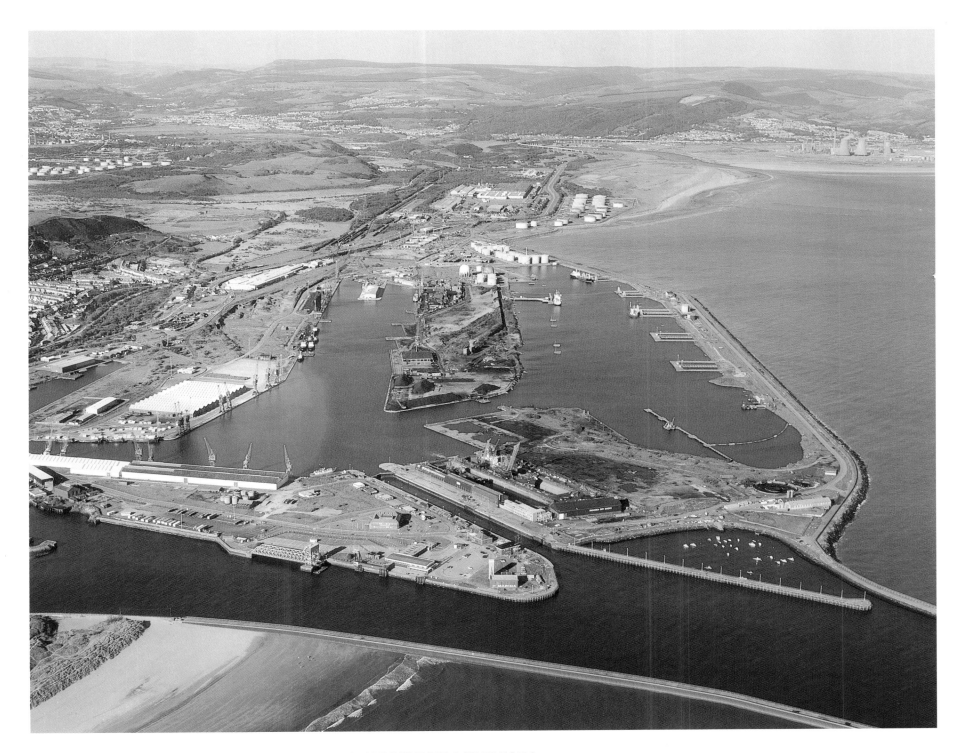

SUNBURY AND HAMPTON MIDDLESEX From the
air waterworks stand out much more clearly than from the ground as is shown in this
view over Hampton towards Sunbury (left).

SWANSEA DOCKS SWANSEA WALES Sitting at
the mouth of the Tawe (thus its Welsh name Abertawe), Wales' second city dates back
to its possible settlement by Vikings in the 9th century. Its story is the story of Welsh
trade—coal mainly, but then coke, tinplate, iron, steel, cement, flour and oil. Despite
the attentions of the Luftwaffe during World War 2, Swansea's harbour continues to
play a significant part in its fortunes.

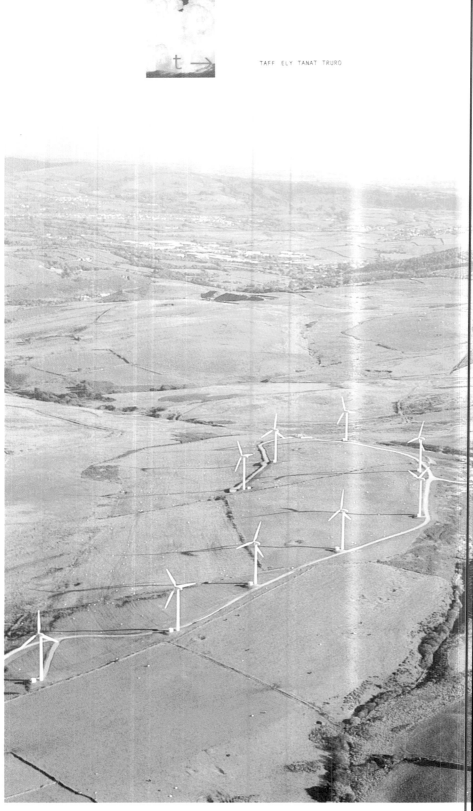
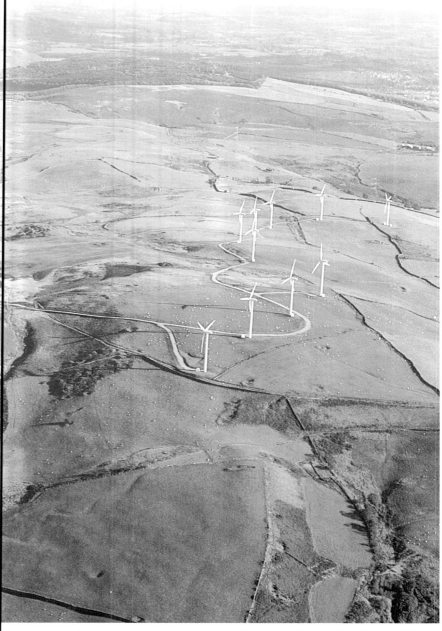

TAFF ELY WIND FARM BRIDGEND WALES The idea of harnessing the power of the wind is by no means new; yet it has taken global concern over the depletion and ever-increasing cost of fossil fuels to trigger a rethink about wind power. Now nations worldwide are keen to consider investment in this clean and renewable energy source. The proud owner of some of the windiest sites in Europe, Britain is well placed to provide a far greater proportion of this power in future. Suitable sites tend to be located on areas of moorland in Cornwall, Wales and Scotland. Taff Ely Wind Farm, with 20 wind turbines, lies north of Bridgend in Wales and has been in operation since 1993.

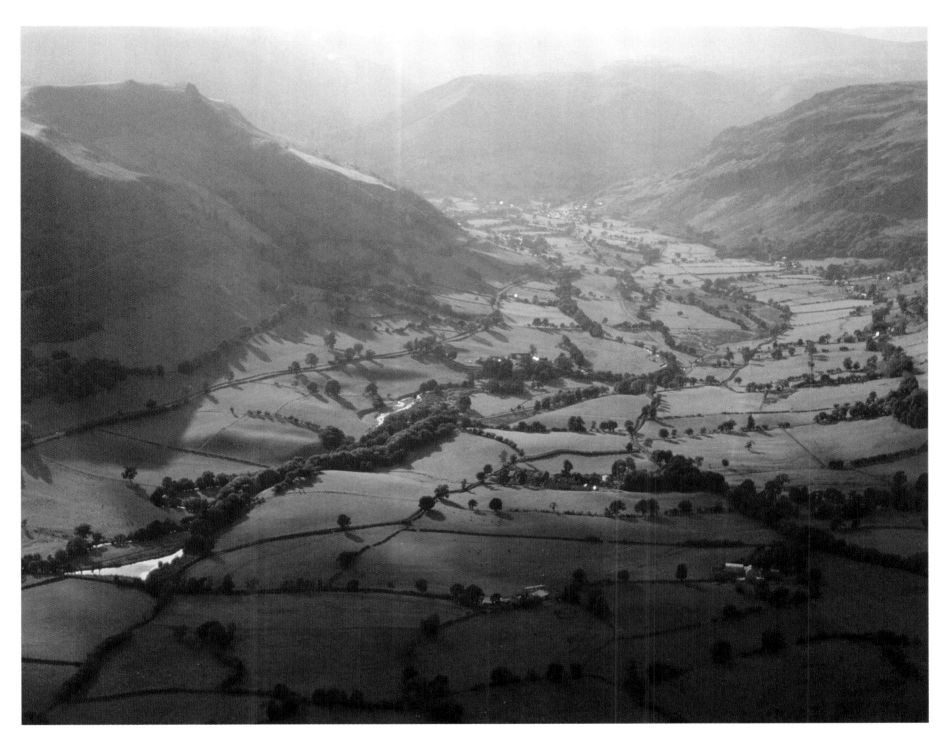

TANAT VALLEY SWANSEA WALES The River Tanat
starts but a few miles southeast of Bala Lake as the crow flies, as a waterfall on the
slopes of Cyrniau Nod, and flows eastward towards Oswestry. En route it flows past the
Norman church of Pennant Melangell, in which are two 14th century effigies (one of
which is said to be of a Welsh prince); St Melangell (or Monacella) is remembered as
the patron saint of hares after one chased by a Prince of Powys successfully evaded
capture by hiding under her dress.

t

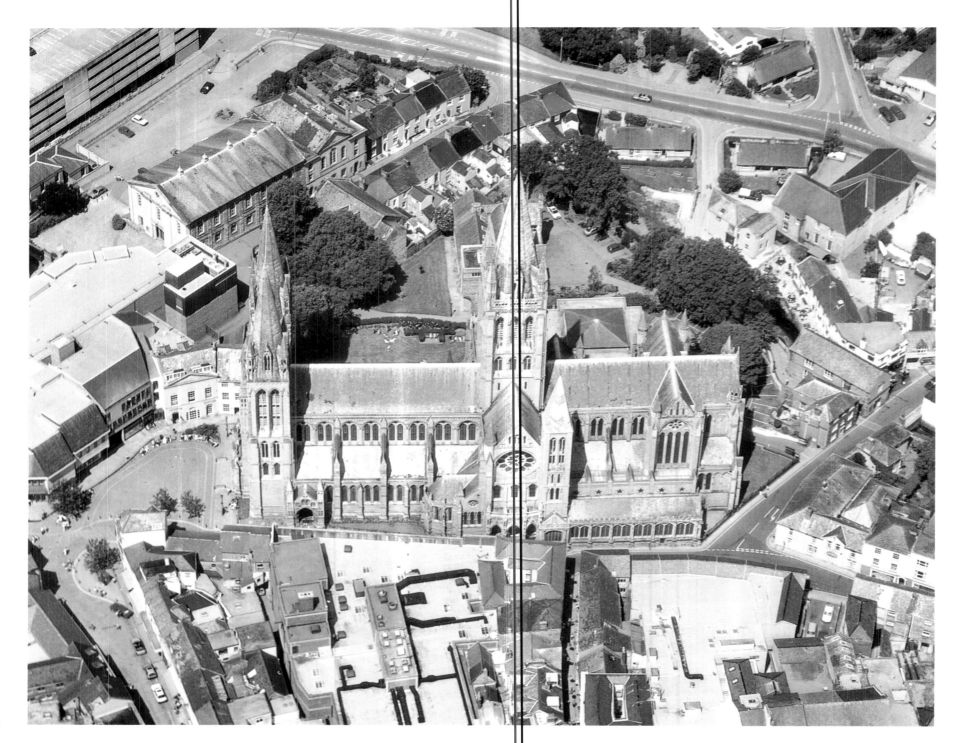

TRURO CORNWALL The small county town of Truro was
originally a medieval inland port on the Fal estuary. It was given borough status in a
charter of c. 1173 which signified its importance as a mineral centre. Truro was one of
Cornwall's four stannary or coinage towns from the early 13th century right through
until 1752 (the others were Liskeard, Lostwithiel and Helston) where all smelted tin was
tested for quality and then taxed accordingly. Copper and tin brought wealth to the
Truro which became a city in 1877. The Early English style cathedral was started soon
after in 1880 and was finally finished in 1910.

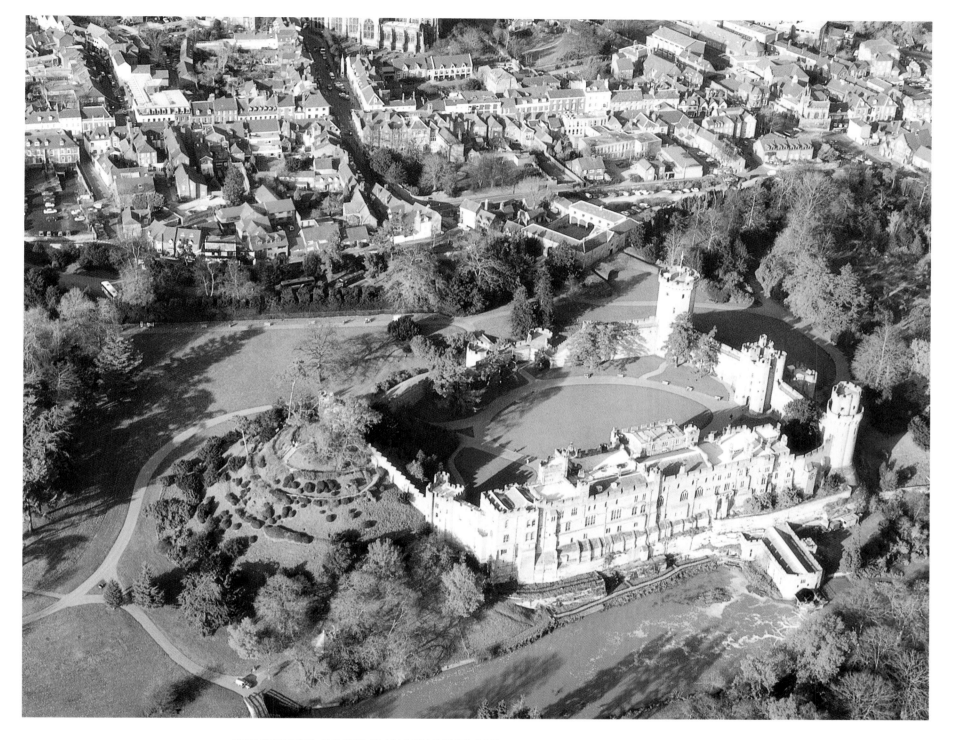

WARWICK CASTLE WARWICKSHIRE One of the
most magnificent castles in England, Warwick looms above Warwick on a cliff along the
River Avon. An important town from the earliest times, a fortress had been on the site
long before the castle was started in 1068 by William the Conqueror. The castle was
improved and developed over the centuries, although the bulk of the building dates
from the late 14th century and the ambition of Earl Beauchamp. His line died out in
the 16th century at which time Elizabeth I gave the earldom of Warwick to the Dudley
family who still hold it today.

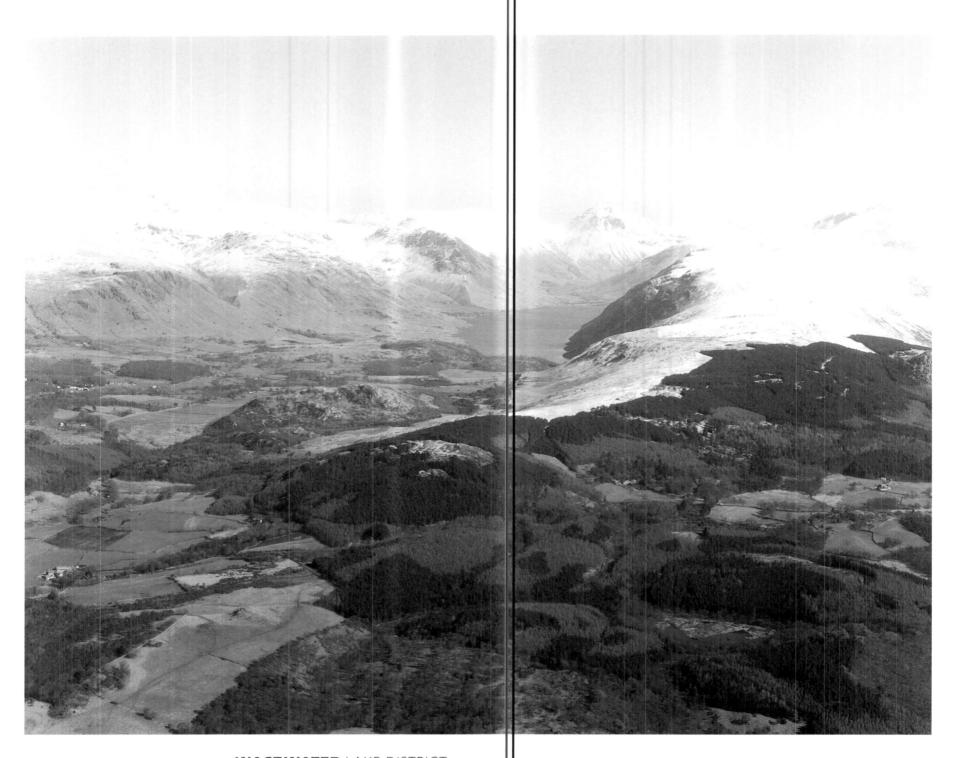

WASTWATER LAKE DISTRICT Surrounded and almost enclosed by forbidding fells, Wastwater is the deepest lake in England, in parts almost 260ft deep. The fells are the remains of ancient volcanic activity known as the Borrowdale Volcanic Series, which produced enormous lava flows and ash falls in the middle of the Ordovician period. Part of the Lake District National Park, Wastwater itself is a narrow lake almost three miles long and a popular location for walkers and climbers.

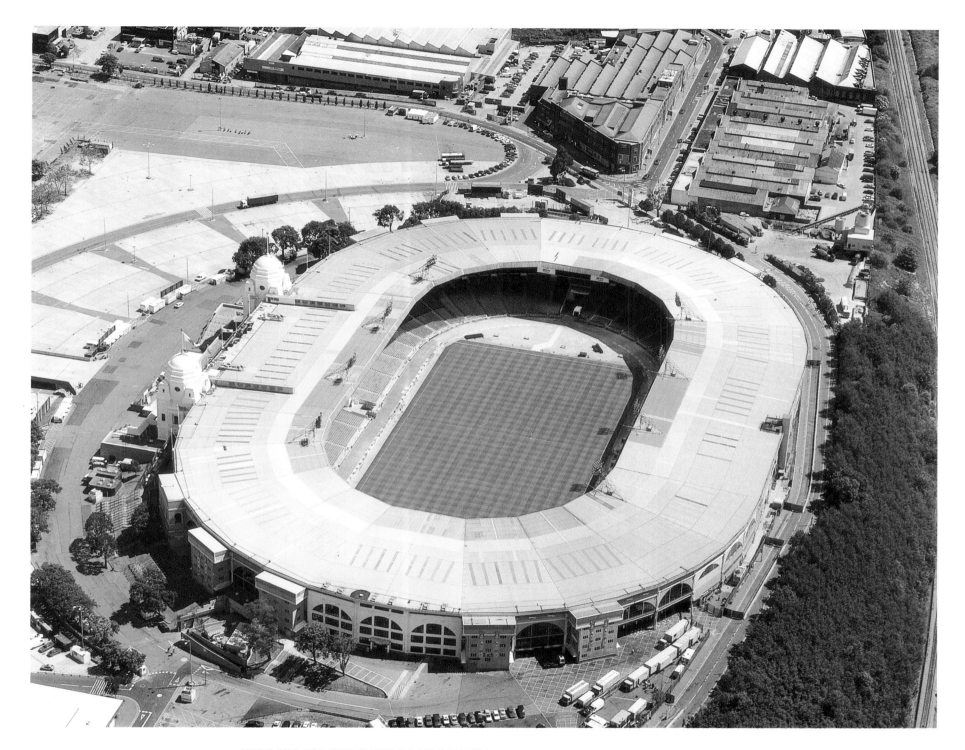

WEMBLEY STADIUM MIDDLESEX Wembley stadium
is the England national soccer stadium and for many fans worldwide the spititual home
of the game. It is said to be every football player's ambition to play at Wembley. Long
considered too small for international competitions, the stadium was scheduled to be
demolished in the year 2000 to make way for a much bigger, more ambitious venue.
This included, to much public outcry, the demolition of the famous twin towers.

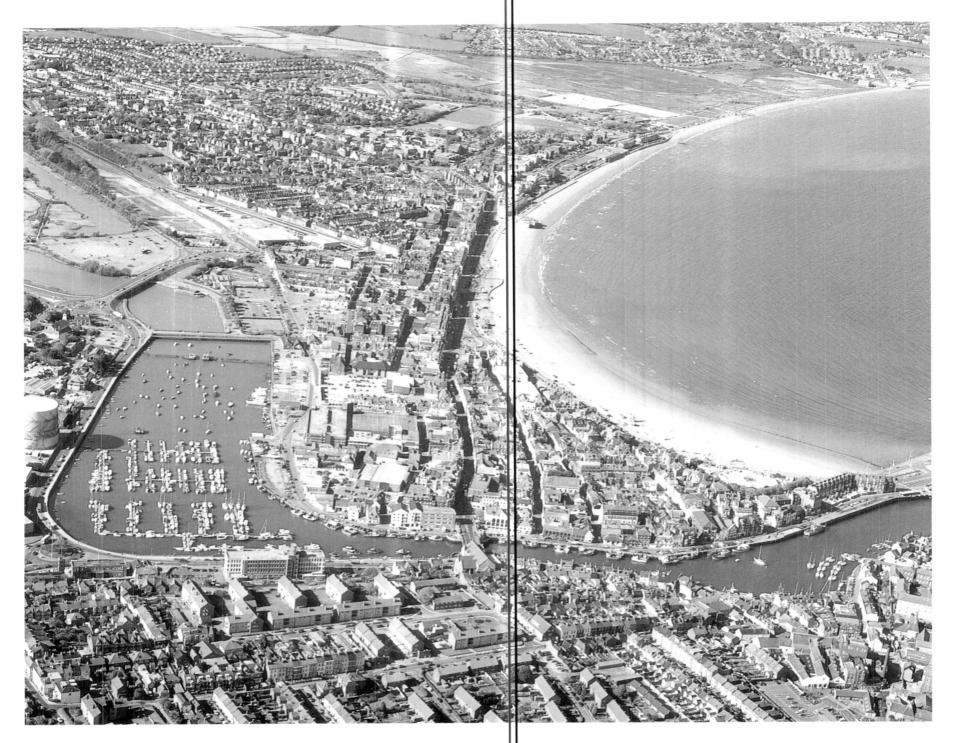

WEYMOUTH DORSET Glorious golden sands, an important natural harbour and a fine seafront promenade have made Weymouth popular since Georgian times, when George III came to try out a new invention—the bathing machine. Weymouth sits at the eastern side of Chesil Beach, joined to the Isle of Portland by the Nothe headland.

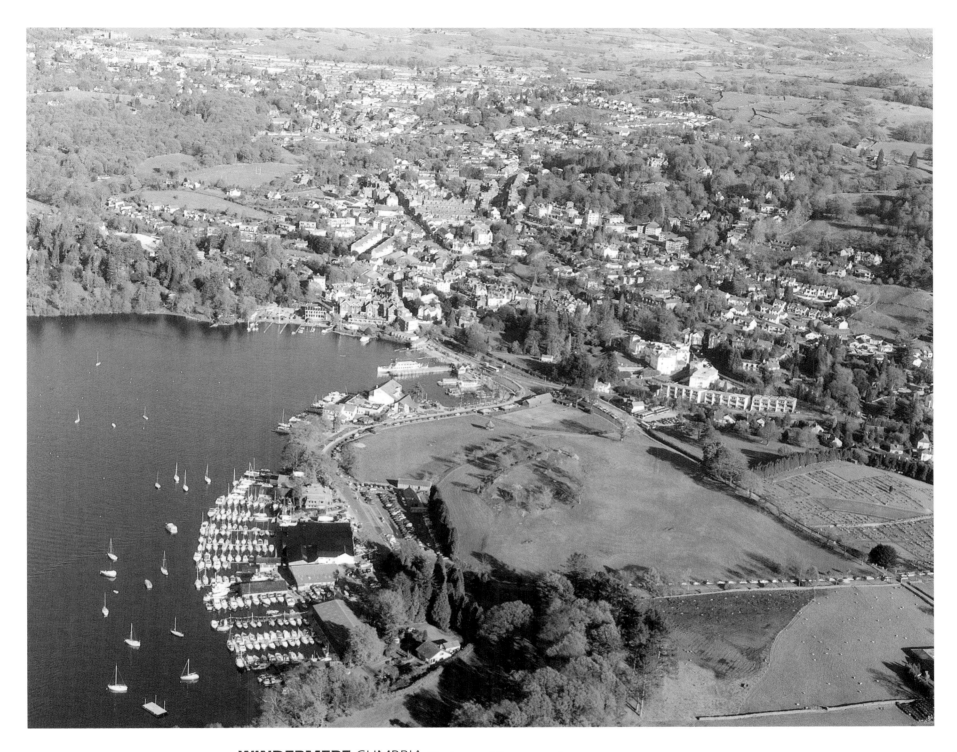

WINDERMERE CUMBRIA The towns of Bowness and
Windermere, midway down the eastern side of the lake, have grown into each other
and are difficult to disentangle. This photograph shows the ferry point at Bowness, a
good place to start an exploration of England's largest—and many would say most
beautiful—lake.

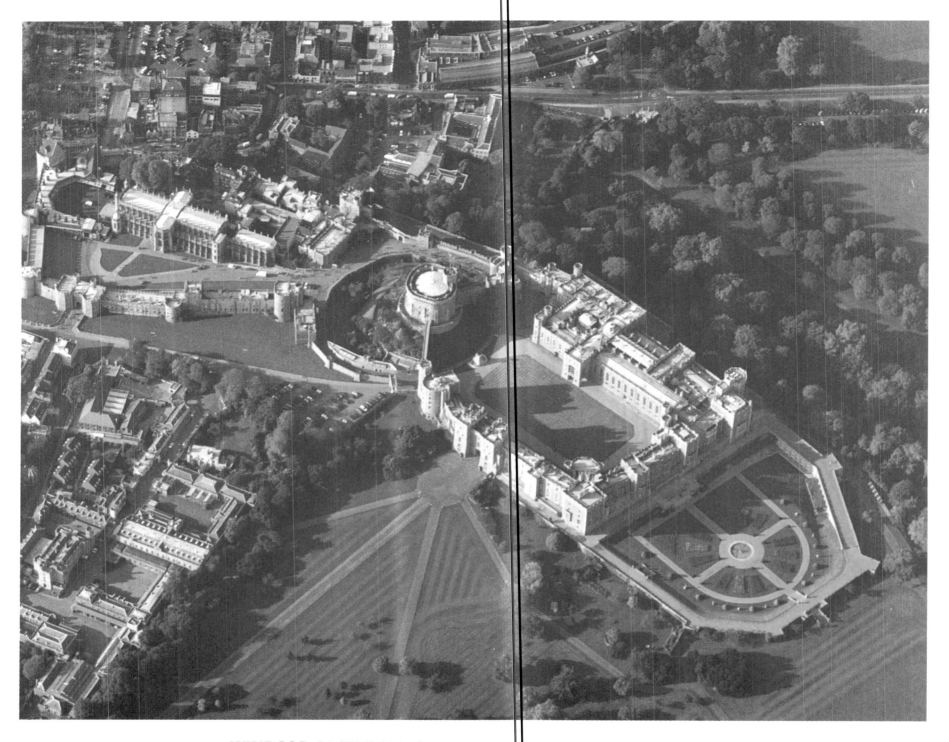

WINDSOR CASTLE BERKSHIRE The largest inhabited castle in the world, Windsor has been associated with the English crown since Norman times. Henry II put up the first stone buildings; Edward III was born at Windsor and founded the Order of the Garter there; St George's Chapel, begun by Edward IV in 1475, is the last resting place for many famous Britons—Edward IV, Henry VIII, Jane Seymour, executed Charles I, mad King George III, and more recently George V and VI. The castle has extensive grounds, including the beautiful Great Park, and a dominating strategic position overlooking the Thames.

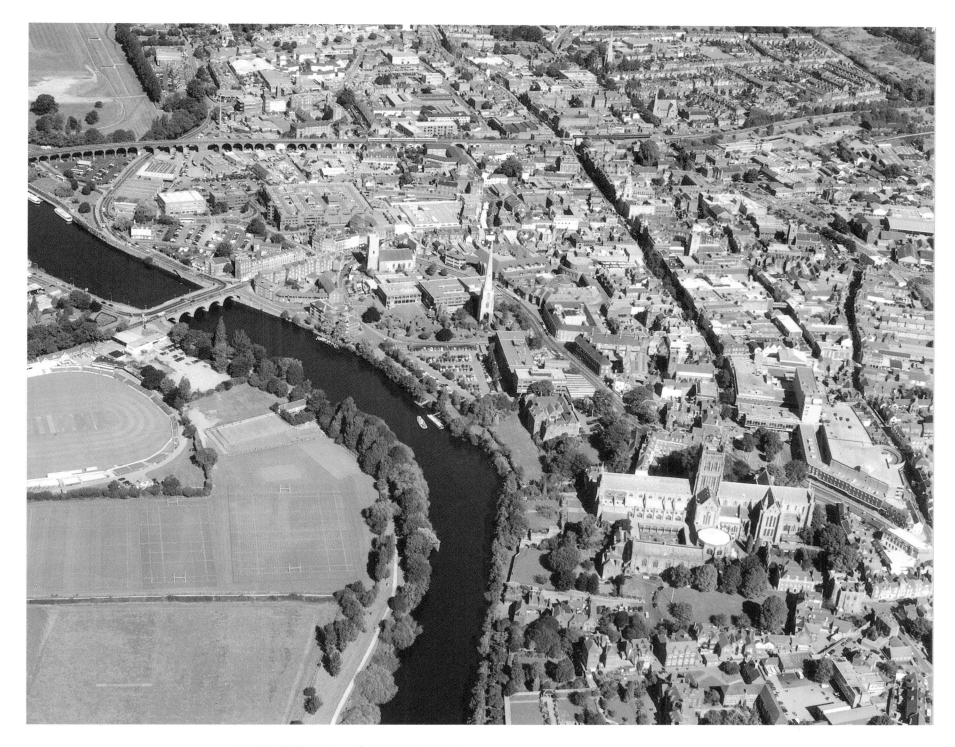

WORCESTER WORCESTERSHIRE An excellent view of
this lovely city shows off the cathedral at the bottom right (there's been a bishopric
there since the Saxon see of around AD680); the racecourse is at top left; and the
cricket ground, the most beautiful in England, is at left. Sited on cathedral land, the
New Road cricket ground has been home to Worcester cricket since 1899 and for many
years was the first ground teams touring England would use.

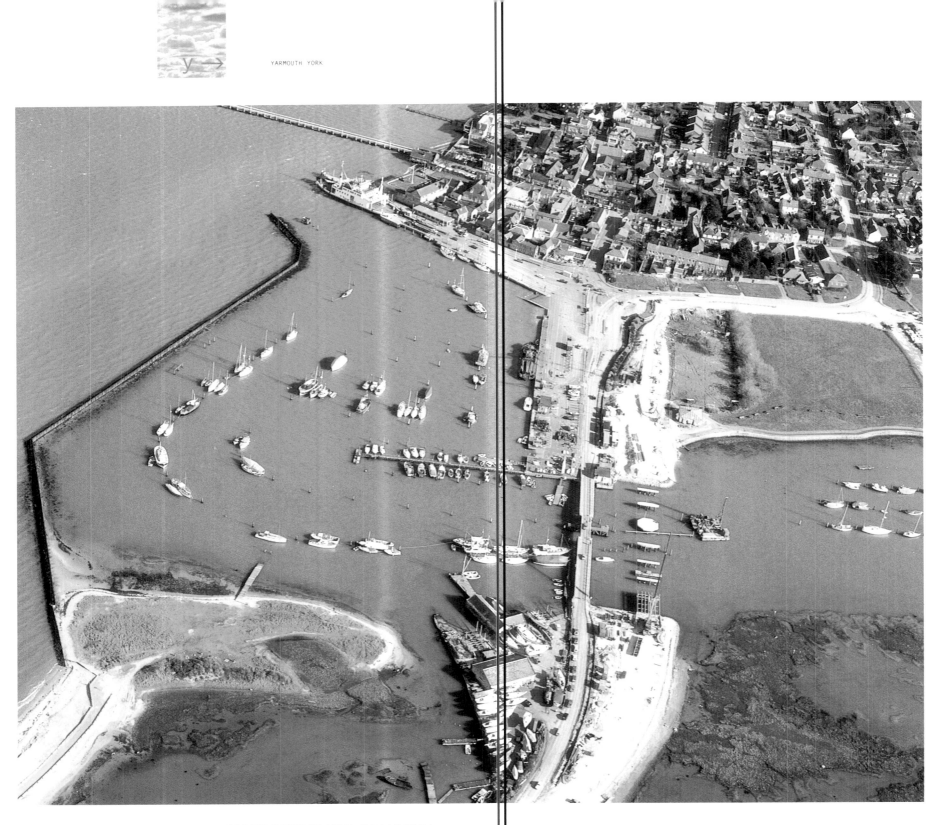

YARMOUTH ISLE OF WIGHT Facing Hampshire across the Solent on the western side of the Isle of Wight lies the small historic port of Yarmouth. Now a popular yachting harbour, it still has the remains of a castle started by Henry VIII in 1545 as part of his coastal defenses against the threat of Spanish invasion. The threat was eventually to culminate in the Spanish Armada which set sail in 1588 during his daughter Elizabeth's reign, although smaller Spanish raids were almost commonplace after Henry severed the English church from Rome.

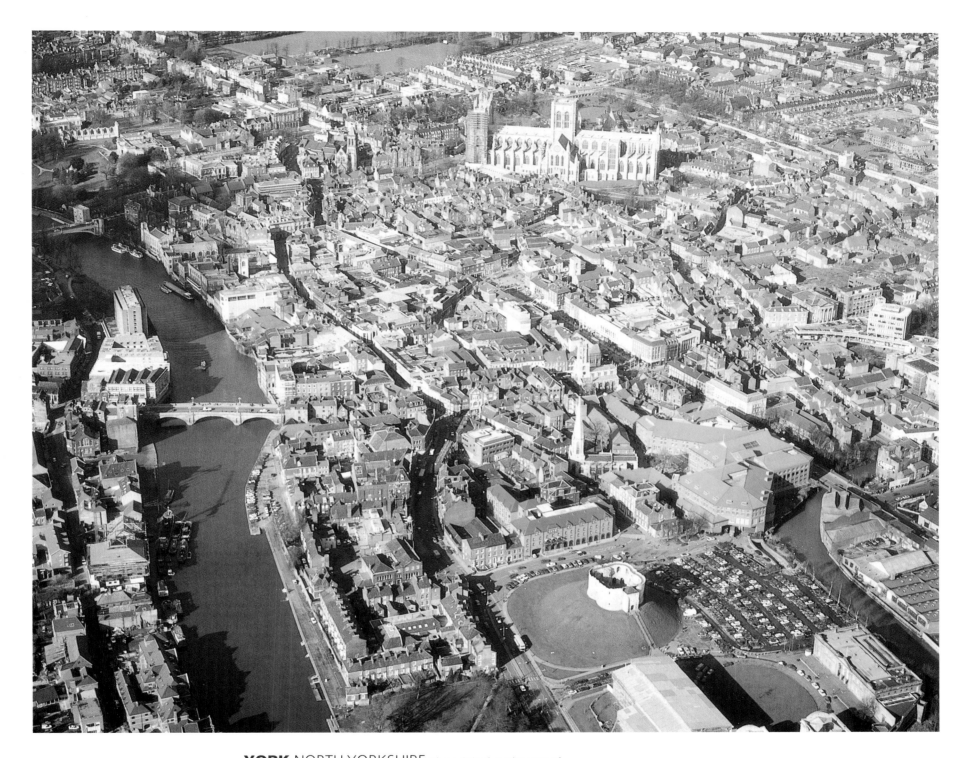

YORK NORTH YORKSHIRE The original settlement of
what was to become York was occupied for three centuries by the Romans who called
it Eboracum. Later masters, the Danes, named the city Jorvik, from which its current
name derives. The heart of the city still has a medieval street plan dating from the time
when York was the second city in the land, rich from its wool and commercial trades.
York Minster is the largest medieval church in northern Europe and still dominates the
ancient city as it has done for over 500 years. It was started in 1220 and finished in
1470. It contains probably the best medieval stained glass in the country.

y

YORK NORTH YORKSHIRE York is not just a quaint old city, bypassed by the Industrial Revolution; since Victorian times it has been a vital part of both the railway industry (first as a manufacturer and latterly because of its world-famous railway museum) and the confectionery industry, the latter exemplified by this picture of the Rowntrees Factory.

INDEX OF PLACE NAMES
Entries in bold indicate photographs

192